NEVER SLEEP

Graduating to Graphic Design

Printed in Thailand

Published in 2008 by de.MO
design.Method of Operation Ltd
123 Nine Partners Lane
Millbrook New York 12545

www.de-mo.org

First Edition
Library of Congress Control Number:
ISBN 9780979180019
Photographs and Text © dress code

Introduction by: Michael Vanderbyl

Essays by: Kelly Aiken, Bob Aufuldish, Alison Bailey,
John Bielenberg, Cara Brower, Kathleen Creighton,
Tom Danielson, Frank DeRose, Justin Fines,
Wyeth Hansen, Eric Heiman, Jimm Lasser, Paul Nini,
+ Emmi Salonen.

Art Direction and Photography:
dress code (Andre Andreev + G. Dan Covert)

Book Design: Melissa Scott
Read and Made Better by: Wayne Kasserman + Gibson Knott
Typeset in Arial + Courier (you know you love it)

Dan is Ohio. Andre is Bulgaria. They is dress code.

See for yourself at:
131 Essex St #5
New York, NY 10002
www.dresscodeny.com
www.neversleepbook.com

Authors' Note: Neither one of us is good at remembering
things. Why do you care? Well, though all of the events in
this book actually happened, they may have been recalled
or perceived differently than what happened in reality. Also,
we have taken slight liberties chronologically to make the
story read better.

If at any point while reading this book you are thinking, "Pfft,
that is not how this story went down, wow I am really mad at
how these idiots made me look," or even, "Why the hell am I
not mentioned?" let us apologize in advance.

Introduction by
Michael Vanderbyl

Written by
dress code

Read and Made
Better by
Wayne Kasserman
+ Gibson Knott

Contents

011 Intro

019 Before College

041 College

165 After College

250 Appendix

For those of you who are not aware, there is a major disconnect between the life of a design student and the transition to being a design professional. To demystify this gap, we are sharing with you the failures, successes and surprises we encountered during our years in school and progression into the field — the creative process, monetary problems, internships, interviews, mistakes, and personal relationships. We have included selections of work from our first design classes all the way through our most current client work, along with stories and interviews from our mentors, teachers and peers. This book will hopefully serve as a guide for design students, educators and anyone trying to break into a creative field, allowing you to learn from our mistakes so you can make more money and get more famous than Kanye.

—

Fun times,
Andre and Dan

Lessons From Students:
An Introduction by Michael Vanderbyl
—

Occasionally, people ask, "Why do you design?" My answer is something like, "Because it's what I want to do and I'm pretty good at it" and also, "Because other than designing, I'm unemployable." Both are true. So I design and I teach design because design matters (at least some of it does, to a few of us) and because I want to excite students to become serious creative practitioners who are passionate about the craft.

Then again, what occurs is often quite the reverse. When I teach, I learn. When a student has an idea that is fresh and funny and true or breaks the rules in a way that makes aesthetic convention seem irrelevant, the student gives the lesson and the teacher sees things anew.

As my students at California College of the Arts, Andre and Dan revealed an extraordinary talent — and endless energy and enthusiasm for design. Both were smart, hip and diligent. Both worked incessantly. Their nearly immediate success at MTV and in partnership at dress code is phenomenal, but not surprising. Of course, creative talent is only one part of the equation. A successful professional practice is something else again. Design as a business is driven by business factors and requires a whole other set of skills. Doing good work is hard work and demands attention to the less-fun jobs: drafting proposals, doing paperwork, negotiating with vendors and so forth. Andre and Dan grasp the complete equation. Within a very few years

of graduating, they have established dress code, a nascent design empire with an enviable roster of clients.

How did these two young entrepreneurs do it? Perhaps the title of this book is a clue: "Never Sleep." I would add: be informed and realistic about the complex world you are about to enter. Recognize the context of your work — otherwise known as "the big picture."

Students entering the arena of professional practice confront a steep learning curve. There are huge challenges — and potential stumbling blocks — upon leaving the sanctuary of school. The competition is tough. There are large numbers of people with some talent and lots of ambition. If you want your place in the design firmament, you need more than great style, because you have to meet criteria other than aesthetics. Design isn't a visual tour de force; it's a way of thinking, a way to solve problems. It's a way to solve your client's problems — because that's how you get paid.

What's it like to work with a client? School doesn't prepare you for the conflicting demands of mid-level managers or a recalcitrant CEO who dismisses your work with, "I just don't like it." Many of the people you will work for still don't quite know what design is or trust designers to keep their interests in mind. Chances are, even if you defend your work with perfect logic, the client doesn't really care how you arrived at the solution or why it makes perfect sense. Business decisions can be as irrational as personal choices.

At the same time, there are great clients who will help you do great work. Cherish them. Contrary to what many students believe, school affords the luxury of

time. You can very nearly stroll through an assignment unless you've created a frantic all-nighter by putting off the inevitable. In the real world, you have to be a design sprinter. There will always be brutal deadlines. You have to work fast and not panic when inspiration doesn't strike. You also have to recognize the solution when you've got it, then execute and move on. Also, know when to unplug and step away from your desk.

I loved my first job at Dean Smith's studio so much I worked for six months without a single day off, including weekends. I burned out. And I learned that designers need down time and the occasional good night's sleep.

Another thing. The maxim "know thyself" applies here, too. Know who you are and what you want and be realistic about what you're good at and, maybe, not so good at. Would you be happy as Creative Director at a big ad agency or would you be better off setting up a small studio?

After I left Dean Smith, I started my own business. There was a recession and I figured nobody was making any money, so I'd just be down and out in San Francisco along with the rest. To drum up work, I went to an established corporate identity firm to ask about freelancing. The president said they didn't hire freelancers, but did I want a job? Well, no, I didn't really. So, calculating quickly, I asked for a salary double that of my previous job; and to my great surprise, he said, "Okay."

I did take the job, but I'd go in at the crack of dawn to my own tiny office on the Pier, take a two-hour lunch and leave early. I was a terrible employee. Even more damning, that year my own designs earned eight awards from the San Francisco Society of Communication Arts

(this was before the AIGA) and the big guns I worked for earned just one. The awards event was on a Friday; on Monday morning there was a note on my desk, "Please see me." My employer said that no one who worked for him could work for himself and started to say, "You're…(fired), but I beat him to the punch and said, "I quit." Lucky for me, those rash words didn't kill my career. And I knew then that I had to make my own studio a success. But you have to have the drive and be willing to do what you have to do. It's not for everyone.

Students give me every reason for hope. This generation has an extraordinary visual sophistication and displays remarkable cultural and technological fluency, thriving on the cross-pollination of ideas, genres and media. I think that's a good thing. Designers have to be skilled in more than one thing. We have to be literate in subjects beyond design. We have to translate big ideas like sustainability into objects and processes. We have to tap into culture in order to do work that is relevant to people's lives.

As Dan and Andre know, the transition from school to your first job can be a baptism by fire and to write this book is hardly less daunting than the journey it describes. I admire Andre and Dan for undertaking such a task; yet, who better than these two? I think you'll find what they have to teach immensely useful. This book is theirs and I am honored they have asked me to write its introduction. I hope my thoughts have offered some small insight into the paradoxes and pleasures of design. Now, it's their turn.

—

Section 1:
Before College

Smuggle guns. Grow up in the eighties. Idolize Bruce Willis. Learn about relations. Wish you were the guy in the Simon commercial. Discover boxers. Learn to play chess. Run your mouth. Get punched in the face. Make a girl cry. Apologize. Listen to metal. Get suspended. Smoke a cigarette. Practice your New Kids impression. Grow up in the nineties. Play Magic Cards. Laugh at Pogs. Go to see Pulp Fiction with your Dad. Idolize Steven Seagal. Tell your brother you didn't wipe your ass out of protest. Go on a nature hike. Wish you had an accent. Fall in high school love. Play with ninja stars. Sell sugar on the Macedonian border. Actually have an accent. Hate sports. Love playing them. Go to the prom. Take drugs. Sell drugs. Visit your dealer in jail. Pick up leaves on your birthday. Build a birdhouse. Eat some popcorn. Buy a fake ID. Cut a jack-o-lantern. Love your parents. Crash your car. Love your stepparents. Go to shows. Ask if your shorts are too short. Shop at thrift stores. Run a fast mile. Lose your virginity. Don't pay attention in school. Go swimming. Start taking pictures.
—

GROWING UP DAN

THE MIDWEST

Cincinnati, Ohio is known for being rather conservative and Dan Covert grew up right outside of Cincinnati, in a small town named Montgomery. Of the 10,000 people living in Montgomery, 94% were white, with the next closest demographic representing a staggering 1.57% of the population. It wasn't fantastic or inspiring, but it was life.

Sycamore High School had better athletic facilities than most colleges and a parking lot filled with the kind of cars high school students shouldn't be driving. It was a typical yuppie suburb—run on cliques, but kept interesting by kids trying to avoid boredom. Dan's social status ranked somewhere just below the cusp of popularity and he was defined by his nerdish activities: Magic Cards, Boy Scouts and Dungeons & Dragons.

As he grew older, paintball, rock climbing and pumping iron kept Dan busy, leaving little time for school. Wrestling became an obsession after Dan, despite being freakishly tall, failed to make the basketball team. And when he saw an interview with Rico Suave singer Gerardo on MTV about getting washboard abs, Dan started an obsessive fitness routine.

He looked up to his older brother Jim, who rocked a pink mohawk and an imposing physique from his days as a JV football bench warmer. Jim was talented with a camera so, like any little brother, Dan wanted to give photography a whirl. Dan took every photo class offered in school and started taking art classes as well. Even though he couldn't draw, Dan still held onto the idealized notion of making Dungeons & Dragons paintings for a living. However, this didn't seem like a practical career choice for someone who came from a family of engineers and teachers with limited artistic ability.

STYLE WARS

Since Montgomery was not exactly a cultural hotbed, Dan and his friends migrated downtown to Clifton, the area surrounding the University of Cincinnati, to see shows and look for gear. They were after streetwear, mostly graphic tees, and Dan filled his closet with brands: Xlarge; Stussy; Extra Strength; Tribal; Triple Five Soul. One day they discovered Kowtow, a store with "Goods for the Urban Soul" painted on the wall outside. Dan identified with these words and Kowtow became the spot for Dan and his friends who were obsessed with street art, since there was nothing else like it in Cincinnati.

20

After wrestling practice, Dan would come home and fill sketchbooks with graffiti. At first he traced things in magazines, then he began to copy single letters and, eventually, was able to create the rest of a word on his own. He started stealing spray paint from local hardware stores to practice tagging the garage. This didn't make Mom very happy, so Dan and his friends relocated to a creek bed in the neighboring town to paint. Dan wrote the letters 'U' and 'S,' for "urban soul," a throwback to Kowtow and a reference to his, and many other kids, inner desire to escape suburban monotony.

REALITY IS GRAPHIC

In his careers class, Dan took a survey that helped chart his future. It indicated that he was destined to be a medical illustrator or graphic designer. Though both careers seemed like long shots, Dan signed up for a graphic design class, just in case. Mr. Inwood, a hippie with a soft spot for cats and marijuana, taught a class that covered the basics: logos; posters; airbrushing. Dan convinced Mom to buy him an airbrush for Christmas and he began to play. Every event or holiday was marked with an elaborate design, and every girlfriend's name became immortalized in graffiti.

Before senior year, all Dan had cared about was wrestling, art and his airbrush. He hadn't thought much about his future so, beyond the vague notion of passing, school hadn't ranked high on his list of priorities. The summer before senior year, Dad made Dan get a "real" job, the kind in a factory where the days start at 4:45 in the morning. He spent three months working ten-hour shifts alongside a narcoleptic forklift driver and a guy who could carry 100-pound boxes with a pimp limp. Suddenly college didn't seem like a bad idea.

SENIOR YEAR

Senior year started and older people started asking Dan what he was going to do with his life. He needed to think of something cool, something he could tell people to impress them. His answer was West Point. The odds he would get in were slim and the application process was intense, but he loved the challenge. And even more than that, he loved the look on people's faces when he told them his plan. To Dan's surprise, getting the necessary congressional appointment was not hard, since he was a young Republican and it was a re-election year.

Since West Point was starting to look like a possibility, Dan didn't explore other options and applied only to the standard local favorites, Ohio State and Ohio University. He took Advanced Placement Art, but mostly worked on his biceps. Dan's wrestling career ended abruptly with an unexpected loss in the District Wrestling Championships. He was devastated and began to wonder if all his time and energy had been wasted. In hindsight, wrestling had helped him stay focused, fed his competitive instinct and got him girls. All of which later made it seem worth the work. But at the time he did anything to take his mind off the loss.

A second major blow came and interrupted Dan's post-wrestling spree of partying. It arrived in a thin envelope with a serious looking crest in the place of a return address. He had banked on getting into West Point, but he had applied too late in the process and it turned out there were more qualified applicants.

The admissions counselors said that if he waited till next semester, Dan would get accepted into West Point. But suddenly a life of discipline and buzz cuts didn't seem as appealing and he began to ponder other options for his future. If he didn't go to West Point, Dan could stay close to Beth, his senior year sweetheart. Ohio State didn't sound like a bad plan for someone who didn't have a plan. Dan was ready for something different, even if he didn't know what it was. (Years later Dan has been known to tell people that he got into West Point, since this is a much better story even if it is not true.)

COLLEGE EH?

Tom Danielsen

Three of my friends and I headed off to the same college at the same time. I was the only one who ended up graduating. It wasn't that I was any smarter than the others. Anyone who knows me will attest to the fact that I am often dumber than a box of rocks. The reason I made it through all of the hoops and hurdles is very simple: I went in with a plan. In fact, in my high school yearbook, under future plans, it actually says, "to become a high school graphic arts teacher." When I started college I knew what I wanted to do, and knowing there was a light at the end of the tunnel made it a lot easier to get up for an eight AM class.

Our society has been doing a huge disservice to kids for a long time; as parents we have done one to our children; as teachers we have done one to our students. We have made entering college a life goal. Kids hear throughout their academic years that getting into a college should be their primary goal, and so once a kid is accepted to college, they feel they have achieved their only goal. No wonder the college dropout rate is so high. These same kids wander around from major to major with no direction. They have already met their life goal and have nowhere else to go.

What we need to tell kids is that a career should be their ultimate goal. Although we might imply this, we don't make an effort to formalize it. Kids should first find something they have an aptitude for and that they like, and then find a career that matches it. If a four year college is a step in reaching that goal, then so be it. A two year community college might be even better for some kids. Some will even be ready to start their careers right out of high school. In any case they now have a goal that is more purposeful. It is a hell of a lot easier to get up for an eight AM class when there is a good reason for doing so.

I had a student who was incredibly talented and took several of my graphic arts classes. He wanted to go straight into the industry. He was also quite close to another member of our staff. This other teacher and I had huge debates about what advice we should give him. I felt he was ready to start his career without college. After all, the kid had a clear vision of what he wanted to do and how to get there without additional formal education. The other teacher thought he should enter college for college's sake. After all, this is America. College should be a goal for all kids. Fortunately, I won the debate. Two years out of high school he was featured in Time magazine for his accomplishments. Four years out of high school he owned his own business and is one of the leaders in his industry.

Another student left high school and went directly to a four year school. She knew that she really liked the graphics industry, but wasn't certain which part of it she should concentrate on. After two years of struggling with general required classes she quit the four year school and enrolled in a community college that had a good two year graphics program. It was there that she found the right direction for her. A year later she was recommended for a scholarship to attend one of the leading programs in the United States. She completed that program, entered the industry and now works for one of the leading graphic arts software developers in the world. Dropping out of the original school had nothing to do with academic preparation and it had nothing to do with how smart she was. It had everything to do with her purpose and why she was there.

College for college's sake should never be a goal unto itself. Young people need to find out what they like to do; find out what they are good at. They should join those two things together and find a career that matches. If college is a step to their career goals, then great. If not, who cares? Spend time in an internship doing job shadows and taking career assessments. These activities will prove invaluable down the road.

I love my job. I could not imagine going to a job each day and not really wanting to be there. I knew from an early age that I wanted to teach graphic arts at the high school level. That was just plain lucky, but it has worked out for me. Now it's twenty-five years later and I still enjoy coming to work each day. Taking additional classes and jumping through bureaucratic nonsense may not be all that much fun, but it is a lot easier knowing that it will get me where I want to be. If all kids were to shift their focus further down the road than college, I think they would find all the little steps a lot more manageable.

Mr. Danielsen has been teaching the Graphics program at Sammamish High School for the last twenty years. During that time he has seen the industry change from mechanical paste-up to direct-to-plate imaging. He has managed to reflect these changes in his facility and curriculum by keeping up with technology and its changes. A graduate of Western Washington University, Mr. Danielsen worked in the printing industry as a print shop manager and in printing sales. He also freelanced in graphic design. As president of the Washington Association of Graphics Instructors (WAGI) Mr. Danielsen helped adopt Print-Ed Competencies as the states new skill standards in Graphic Communications.

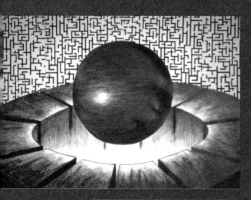

THIS IS WHAT HAPPENS WHEN YOUR
MAGIC CARDS AND ART COLLIDE. - D

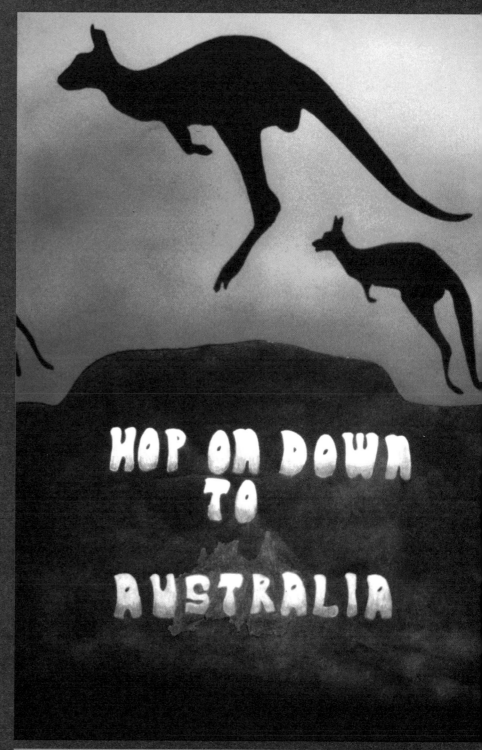

THE FIRST POSTER I EVER DESIGNED. WHY WOULDN'T YOU WANT TO HOP ON DOWN TO
AUSTRALIA? CHECK OUT THE DISCO TYPE. - D

SOMEHOW THIS WON AWARDS. - D

EVEN MORE GIRLFRIEND GRAFFITI FOR BETH. SHE HAS A
PILE OF THIS SHIT SOMEWHERE. - D

THIS OVERLY DRAMATIC LIGHTING WAS CREATED WITH MY DESK LAMP. - D

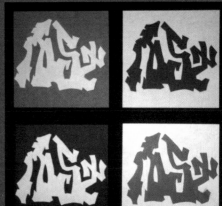

AFTER DOING THIS MY TEACHER SAID I MIGHT MAKE A GOOD GRAPHIC DESIGNER. THESE WERE WORDS THAT STUCK WITH ME, EVEN IF I COULDN'T DRAW. - D

GROWING UP ANDRE

Bulgaria is the best place in the world to be a kid. Neighborhood friendships last a lifetime, people go by nicknames and reputation is the key to success. Growing up in Pernik, Andre Andreev spends his days playing soccer and hanging out on the corner. His Dad, Krassimir, is a graphic designer who commutes to Sofia, Bulgaria's capital. On the weekends he does freelance work out of his "studio" in their apartment. Krassimir does everything by hand, from sharpening his calligraphy feathers to gluing type and photographing layouts.

Krassimir has a small photo lab in the basement of their building, filled with an enlarger and chemicals. He often allows Andre to help print photos. Krassimir's hands-on approach to design makes it look easy and accessible and the tools are simple: ruler, pencil, glue and ideas. By day, Krassimir designs school textbooks, which Andre proudly shows off to friends who refuse to believe his Dad has made them. Growing up, Andre never thinks he'll follow in Krassimir's footsteps.

Krassimir takes every opportunity to take his son to Sofia. Andre is fascinated by the big city and its fast pace. Krassimir works at a fancy studio with white walls, computers with colored screens and pretty girls. Krassimir has his own office where he contemplates designs and smokes cigarettes. Andre loves playing with the computer and Krassimir introduces him to two little programs called Photoshop and Illustrator. Andre isn't naturally talented at drawing but, with these programs, it looks like the computer does all that for you. He gets addicted and begs to buy a computer for the house, but it's too expensive.

Other than soccer and petty crime, there are little hobbies to pass time. Foreign languages require too much homework and music lessons get in the way of having fun. Fun usually equals stealing hood ornaments and getting high. At school, the art teacher gives out grades based on what art supplies the students bring. When asked to draw something, Andre draws the Metallica logo. This logo is the first piece of graphic design that has a memorable effect on him. Somehow, the letters feel exactly right for what Metallica embodies, bad ass metal.

Svetlana, his mother, works at the local movie theater and Andre gets to watch movies for free. He gets glimpses of American life through classics like Rambo, Die Hard and The Terminator. He also becomes fascinated with an American icon – Nike. Having the latest pair of Nikes is a status

symbol and the bigger the air pockets, the better. Not many kids can afford them and when someone gets a new pair, it's an event. These moments are few and far between, but it's worth saving every penny for them.

When he's in the 2nd grade, Svetlana takes Andre abroad for the first time. They travel to Germany and spend a few days in Frankfurt. Andre learns how to say "no" in German, has his first McDonald's and eats too many Kinder Eggs. His stomach hurts.

One day, Svetlana tells him she won a green card through a lottery to come to America. The news is not surprising for Andre. Ever since the trip to Germany, Andre realized how small Pernik was and had a feeling that they might eventually move on. Krassimir is upset and chooses to stay in Bulgaria. Andre says goodbye to his friends, his BMX bike and his Dad. They immigrate to Seattle just as he finishes the 6th grade.

SEATTLE

Seattle is dark and gloomy compared to sunny Bulgaria. Andre and Svetlana move to Bellevue, a quiet suburb where trips to the supermarket are as exciting as it gets. He quickly realizes things are different. There is no sense of community, everything is spread out and you need a car. Learning English is tough for Svetlana, but giving up is not an option. She applies to work at the local movie theater and brings Andre to the interview as a translator. Surprisingly, she gets the job and starts out working the popcorn machine. Many popcorns later, she becomes a manager and Andre visits her often to watch free movies.

Svetlana signs Andre up for the 8th grade, skipping the 7th. She figures what the hell, even if he fails he'll be with kids his own age. Andre's English skills are improving and writing comes naturally, but he has a hard time speaking. After the first semester he tests out of the ESL program and enrolls in a normal 8th grade class. A friend recommends Newport High School in the wealthier part of town. The catch is that Andre has to live in the district. This is easy to fix and Svetlana tricks the administrators by buying a mailbox in the area to serve as her "residence."

Newport has little to offer in the arts, but Andre enrolls in a photography class, which proves very influential. The teacher, Mr. Fernandez, wears a beret as a badge of artistic achievement. He explains the basics of photography and dark room thingamajigs. Andre doesn't have enough money for an SLR, so he shoots everything with a disposable camera. He struggles through the class, but takes away many valuable lessons — the main one about composition and the second about not cutting photo paper in the light.

High school Art seems irrelevant — it often involves popsicle sticks and glue. Andre takes matters into his own hands and convinces Mom to buy a computer. After loading a bunch

of pirated software, he starts playing with his old friends Photoshop and Illustrator. He gravitates toward filters and cheesy bevels and starts giving himself assignments, like creating fake ads for his favorite companies.

JUNIOR YEAR

Through a career counselor, Andre learns that there is a graphics program at the neighboring high school where he can take a few classes a day. During junior year, excited by the news, he signs up at Sammamish Graphics. The teacher, Mr. Danielsen, runs a student-based print shop where they do cool things like creating graphics, doing pre-press, and both offset and screen printing. Andre quickly realizes that this is the only valuable class on his schedule.

Printing is very much a science. You have to fan the paper, mix the ink correctly and measure the water. The right combination of all these things results in a beautiful print. Andre begins to spend his afternoons and weekends at the shop. Mr. Danielsen takes notice and teaches Andre every part of the production process. Instead of learning useless biology facts, Andre is mastering a skill he can use to make a living.

Andre continues to play around with Photoshop and eventually starts making silly webpages for fun. He practically abandons doing the homework for his real high school classes and barely passes most of them. One of his friends, Jon Dacuag, also gets into design and the web. They spend many late nights surfing the internet and exchanging Photoshop tricks. Andre and Jon become very good friends, friends who still work together, which is something that's rare.

Every year, Mr. Danielsen takes his best students to a graphics competition called VICA, for Vocational and Industrial Clubs of America. There are many competitions: graphic communication; nail care; commercial baking. Everyone wears the same red coat and white shirt. VICA is the antithesis of Advanced Placement classes; it's about developing a trade to get a job, not just to attend some fancy college.

The morning of the first competition, Andre steps out of the hotel for a smoke and a coffee. He meets a random man and they share a cigarette. The man has just been freed from prison, where he has spent the last 15 years, and Andre is the first person he has talked to on the "outside." The man wishes him success and Andre goes on to win regionals and state.

Now it is time for the big leagues: Nationals. They travel to Kansas City to compete for the title. Andre is aiming for the number 1 spot; the best Mr. D has done is number 2. They spend a week in Kansas City and the desolate city leaves quite an impression on Andre. Every break he gets, Andre walks around town photographing empty buildings. The competition day is intense and Andre is nervous that he

HAVE IDEAS.

GET CLEVER WITH WORDS.

USE MORE LENS FLAIRS AND GRADIENTS.

MAKE YOUR BAD DRAWINGS YOUR STYLE.

START TAKING AND COLLECTING PHOTOGRAPHS.

LEARN PHOTOSHOP OR ILLUSTRATOR BETTER THAN ANYONE YOU KNOW.

TRACE PHOTOS WITH A PENCIL OR A BRUSH.

BUY SOME CLIPART.

COLLAGE WITH SIMPLE PATTERNS AND SHAPES.

MAKE STUFF OUT OF OBJECTS.

HIRE PEOPLE WHO CAN DRAW.

EXCLUSIVE + INCLUSIVE: THE TWOFOLD NATURE OF GRAPHIC DESIGN

Paul Nini

One thing that continues to attract me to the study and practice of graphic design is the diversity of activities and roles it includes. Not only do we research, develop, refine and implement designed communications, but we also work with a variety of stake holders throughout the process, such as audiences, users, clients, suppliers, printers, fabricators, etc., each with differing needs and expectations. Clearly our field is not for those who seek simplicity and certainty. Instead, we must become comfortable with complexity, contradiction and ambiguity. We're required to trust in our process, knowing that in the end a solution will present itself.

As I have been working as a full-time design educator for a number of years, I've discovered another aspect of our field that seems contradictory — that the profession is simultaneously exclusive and inclusive. Specifically, gaining entrance to both study and qualify to practice in the field can be a very exclusionary process. On the other hand, the actual practice of graphic design is most powerful when an inclusive approach is used — i.e. the more input we have from various stake holders, the better our efforts serve the public good.

ON EXCLUSIVITY

It's no great secret that many of the better graphic design educational programs enroll only a small percentage of those who seek entrance. As an example, the undergraduate visual communication design program that I direct at The Ohio State University admits roughly 20% of its applicants, and the percentage of acceptances to the graduate program is even less. Other recognized programs would no doubt report similar results.

There are some good reasons for our exclusivity. A majority of design graduates tend to stay in a program's geographic area for a period of time before spreading out to other locations. Many graphic design students participate in internships with local firms which can, on graduation, then turn into full-time job opportunities. Obviously, the job market can only absorb so many new designers per year, so keeping the numbers low benefits everyone. Graduates don't have to compete against too many classmates, and employers are fairly certain that the graduates they employ are of a high caliber.

In addition, and at the risk of sounding snobbish, not everyone who thinks they should be a graphic designer is actually cut out for the job. While it's quite clear that there are well-qualified students turned away during our acceptance process every year, I'm not so sure that there are that many more that we'd accept, even if we could. It's been suggested that we double our numbers and take in two cohorts of students to meet the demand for our program. However, I'm fairly certain that only a handful of that second group would actually perform at the level of those currently accepted. As we have no desire to dilute the quality of our program, we've thus far resisted this notion, and I hope that we'll continue to do so.

So, to conclude this point — graphic design is not for everyone, and a certain amount of exclusivity concerning who is allowed to enter the field is, to my mind anyhow, mostly a good thing.

ON INCLUSIVITY

Apparently, "inclusivity" is not a word recognized in all dictionaries. But let's go ahead and use it anyway. It's my strong belief that the more inclusive graphic designers are of the requirements of those who experience our work, the better the results are for everyone. Audiences and users benefit from clear messages, our clients benefit from more satisfied customers and constituents and designers benefit from providing a valuable service to all.

Similarly, I believe that one of design's main contributions to society and our nation's public life is making communications easily understood by as many people from as many walks of life as possible.

One significant example of this role is seen in a recent project sponsored by the AIGA and coordinated by Marcia Lausen, a designer and educator in Chicago. This "election design" initiative entailed taking an inclusive, user-centered approach to the design of new ballots, election administration materials, polling place signage, absentee and provisional voting materials, and voter education and outreach literature. The designers involved made sure that all materials could be easily

used by those with limited abilities and from low-income backgrounds, along with individuals who spoke languages other than English. The success of this program has been documented in a book published in 2007, which I would urge all graphic design students and practitioners to read and consider.

The "election design" project is an example lifted from a graphic design educational program that takes a more user-centered approach. Others may involve more fine art or advertising. All are valid and necessary approaches, and many of these different programs use the exclusionary acceptance practices described earlier. My program at Ohio State has long been oriented to inclusive design, which is probably the most under-represented of the three approaches. I personally feel there is still much work to be done in this direction and invite other educators and practitioners to consider exploring this potentially more responsible approach.

So, by way of wrapping up, I'd suggest that we all think deeply about what our roles in society might be. Should our profession serve mainly the for-profit sector, or should we also put our considerable talents to use for the public good? The answer to that question may differ for each of us — but for students embarking on careers, it may offer an alternative to their expected career path. Our profession may not be for everyone, but that doesn't mean that what we do can't benefit us all.

Paul Nini is a Professor in the Department of Design at The Ohio State University, where he also serves as Coordinator of the Undergraduate Visual Communication Design program and Past Graduate Studies Chairperson. His writings have appeared in a variety of publications, and he has presented at numerous national and international design and education conferences.

might blow it. He starts out good, but manages to fuck up a print when a photographer pulls him aside. At the ceremony the following night, only the top 3 contestants are called on the stage. Andre watches as some of his friends jump with joy. He isn't one of them. Andre gets 4th out of 50, one place shy of a medal.

FOR SOME ODD REASON I WAS
TAKING LOADS OF PHOTOS OF
EMPTY AIRPORTS AND PARKING
LOTS. SO I THOUGHT IT WOULD
BE FUN TO MAKE A SITE WITH
THEM ABOUT TRAVELING. - A

socially Acceptable

weapon

THIS POSTER IS REALLY BAD. I STOPPED EATING MEAT
FOR FOUR YEARS AND FOR SOME REASON I THOUGHT I
SHOULD DO A POSTER ABOUT IT. THIS DID NOT STOP
ANYONE FROM EATING MEAT, IT WAS JUST A SILLY
PORTFOLIO PIECE. - A

MY FAVORITE PRE-COLLEGE PROJECT. I CONSTRAINED MYSELF BY DOING IT IN AN HOUR, USING ONLY PHOTOCOPIES. - A

ME AND MY DAD WERE WORKING ON THIS TOGETHER UNTIL HE GOT EXCITED AND FINISHED IT HIMSELF. MOM WAS UPSET AND TOLD HIM TO LET ME DO MY OWN WORK. - A

I DID THIS SOON AFTER MY DAD BOUGHT ME THE END OF PRINT. IMITATING SOMEONE ELSE'S STYLE CAN BE A GOOD THING WHEN YOU ARE BEGINNING. AT LEAST YOU GET IT OUT OF YOUR SYSTEM. - A

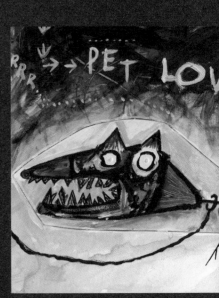

THE FIRST AND ONLY ILLUSTRATION I MADE BY HAND. THE TEACHER HAD 3 DOGS AND GAVE ME AN A+. - A

MY MOM HATED THIS TV. AS SOON AS I MOVED OUT OF HER HOUSE SHE THREW IT AWAY. - A

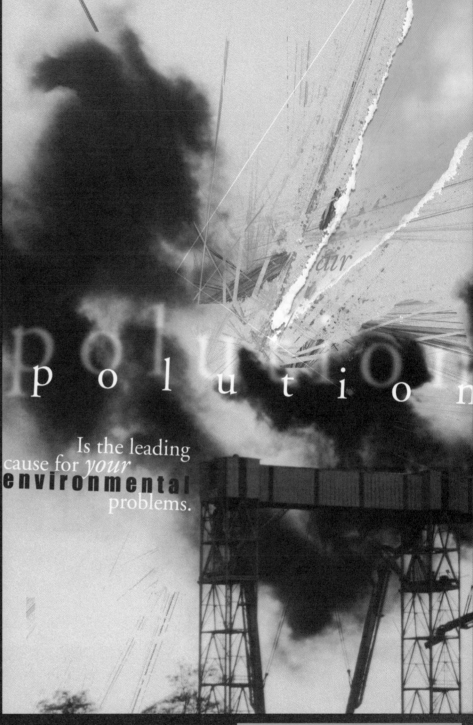

air

p o l u t i o n

Is the leading
cause for *your*
environmental
problems.

I WAS REALLY HAPPY TO MAKE THE PAPER RIP LOOK SO REALISTIC. AT THE TIME I THOUGHT THAT THIS WAS MY BEST PIECE. - A

I BEGGED MY MOM TO BUY ME AN
EXPENSIVE 35MM CAMERA FOR MY
BIRTHDAY. SHE DID. SO I TOOK THESE
TO PROVE HOW MUCH I USED IT. - A

A POSTER FOR A STUDENT EXHIBITION. IT WAS ALL ABOUT ME AND WHERE I CAME FROM. I WAS HOPING IT WOULD BE THE PIECE THAT GOT ME NOTICED AND I WOULD BLOW UP OVERNIGHT. THIS DID NOT WORK OUT. - A

Section 2:
College

Experiment. Get work published. Realize that getting work published means nothing. Make friends. Fail hard. See some lectures. Have sex. Think Wrong. Contemplate dropping out. Make some money. Discover David Carson. Buy books to look at pictures. Have a mid-mid-life crisis. Work for a few places. Read a book about design. Forget Mom's birthday. Discover Tibor. Look up to people. Stop eating meat. Clean the bathroom. Start drinking coffee. Take a class outside of the design department. Resent people whose work is better. Convince them to collaborate on projects. Think before making. Live in a dodgy neighborhood. Learn some history. Make before thinking. Go to museums for fun. Leave the country. Get political. Watch a bum shoot up in front of little school children. Then watch him take a dump on your stoop. Listen to rap. Move in with a girl and have fun. Realize that moving in too soon can be a bad idea. Live with friends. Change your lame email address to something cooler. Go to openings. Do projects that you think are genius. Realize they are not. Steal ideas from books. Realize that stealing ideas from art is better than stealing them from design. Question whether design is a waste of everyone's time. Hate David Carson. Start drinking. Try to sleep. Avoid exacto injuries. Do not put all your eggs in one basket. Have an escape plan. Graduate.

—

SMALL TALK

Dan's college experience started like most people's. He unpacked his life from his Mom's car, engaged in uncomfortable small talk with tons of people he didn't know, and had no clue what he wanted to major in. Following in his Dad's footsteps seemed like a natural place to start. But Dan soon realized engineering and math were not any fun and he somehow got the idea that marketing would be. Dan didn't really know what marketing was, but thought it might be something like advertising. Since he owned a Mac, Dan thought he was on his way to making Super Bowl-caliber commercials.

With approximately fifty thousand undergrads, Ohio State University is the biggest school in the country. The size is so overwhelming that lots of students join frats and sororities. Dan thought this would be a more entertaining way to occupy his time than attending class, and he enjoyed the parties. But he soon realized he was different than the typical frat bro. They enjoyed smashing things with golf clubs and getting in fights. Dan did not. He stuck close to a guy named Jay. Jay looked out for Dan and, during their fraternity initiation, helped shield him from meathead outbursts.

Jay was an interior space major and urged Dan to check out the visual communications program. Dan had just started to realize that marketing was not, in fact, another term for advertising, but just a lame career. This discovery came at the perfect time since he was already skipping the boring math classes and realizing he couldn't be one of the countless business school grads leapfrogging his way from cubicle to cubicle towards middle management.

VISUAL AND COMMUNICATION

The visual communications department was highly competitive. Each year there was an entrance exam and a few hundred people applied for only twelve spots. Students were selected based on their portfolio, GPA, resume and their performance on a series of drawing and problem-solving exercises. He had no idea what to expect from the exam, but Dan gathered up some of his computer graffiti and the best of his high school artwork in a little black book with shiny plastic pages.

In one exercise, Dan needed to redesign a logo and he chose a local restaurant called King's Pizza. He knew for sure that he could create a better mark using his graffiti skills. The last task was simply to explain why a great logo worked. To Dan there wasn't a finer mark than the one for his favorite rap group, the Wu Tang Clan. He wrote a few paragraphs about

how awesome it was and dropped the exam off at Hopkins Hall, home of the Visual Communications Department. Dan had walked by this building many times before, but now he wanted to find a way in.

Midway through spring quarter Dan got a thin letter from the Department of Industrial, Interior and Visual Communications Design. He hadn't been accepted. Dan was devastated. He told Jay the bad news, but it seemed Jay already knew. Word on the street about the fierce competition had spread because more people had applied than ever before. This didn't comfort Dan. He hated to lose and planned to bust his ass to get accepted the next time around.

So, Dan got a summer job waiting tables at a country club near home. The money was great, but faking like he was super peppy all the time proved troublesome. The old rich members were very demanding and did not have a problem telling him when they were unhappy, which they always were. Dan enjoyed being home, but began to miss Ohio State, as living under his parent's rule was starting to wear on him.

YEAR TWO

Fall quarter began and it turned out Dan could take design classes even though he wasn't technically enrolled in the visual communications program. So, he added them to his schedule. He was waitlisted for Introduction to Design and for Design History. Instead of just waiting to get into these classes like a sucker, Dan would show up fifteen minutes before they started with an add slip in his hand. He had no business being in either of these classes since many people were ahead of him on the waitlist, but the teachers liked his persistence and let Dan in.

Christmas came and Dan went home energized. His parents couldn't believe his excitement, or that he actually liked school. For Christmas, Dan's brother Jim bought him Tibor Kalman's *Design and Undesign* and David Carson's *The End of Print*. Dan had no idea at the time how talented either of these men were, or that their design philosophies couldn't be further apart, or that one of them was a surfer. But like most other designers of his generation, Dan studied these books cover to cover. Grades came in the mail and he got an A+ in Design History, the best grade he had ever received. His Mom was happy and his brother punched him.

When Dan got back from break it was time to take another stab at the entrance exam for the Department of Visual Communications. Since students were only allowed two attempts, this was Dan's last chance. He hunkered down for a few weeks. All Dan did was go to class, eat, sleep (a little), masturbate and work on his exam. Having a bit more design education under his belt, Dan realized that the Wu Tang Clan's logo might not be the best example of a well-designed mark after all. For this exam he chose the UPS logo. This time there was no doubt in his mind that he'd be accepted.

Dan couldn't wait to hear back about the exam. He had put in a lot of effort and couldn't imagine being rejected or what he would do if he was. The anticipation was agonizing. It took several days to hear and Jay had to check with his advisor to see if she had heard anything. In the end, for the second year in a row, Dan didn't get into the Visual Communications program at OSU.

For weeks afterwards he stayed in bed eating a lot of hot dogs and cereal and not changing his clothes. Eventually, Dan collected himself and got in contact with Paul Nini, one of the professors responsible for evaluating the entrance exams. Dan had envisioned someone who ate puppies and enjoyed crushing people's dreams but, after a few minutes, realized that Paul was not as fierce as he had imagined. Paul explained very nicely that a hundred plus applicants meant a lot of competition. Of the twelve people they admitted, eight had a 3.8 or higher GPA and impressive portfolios. Dan had neither. Paul said Dan's drawing ability was promising, but his design was not on par with the other applicants' work and focused too much on graffiti.

Dan began considering transferring schools to get into another design program. His school search took him to the American Institute of Graphic Arts website with its list of recommended schools. Paul looked over the AIGA list and urged Dan to attend California College of the Arts, if he could get in. Dan enjoyed talking about transferring, but wasn't sure he had the balls to do it. His parents were always supportive, but Dan's Mom advised him to stay in Columbus as she was not comfortable with risk or with drastic change. Dan wasn't sure if he was either, but it wouldn't hurt to apply to a few schools. There was nothing to lose.

Researching schools turned out to be loads of fun, and Dan wished he had thought this much about college the first time around. He requested applications from The School of Visual Arts, Savannah College of Art and Design, Rhode Island School of Design, The University of the Arts, Academy of Art College and California College of the Arts. The applications came fast and included color catalogs — catalogs filled with images of student work, campuses that put Ohio State to shame and people who looked arty. Things were starting to get interesting. The concept of starting over — of moving to a new city and a new life — now seemed a little less scary.

Most of the applications required the same information: test scores, GPA, a few letters of recommendation and slides of work. RISD, however, wanted a bunch of special stuff, but Dan didn't have time or energy for that. He also wasn't sure about sending out his graffiti-based work. After some thought, Dan decided to show the work he loved doing, regardless of its medium. This was the work that best reflected who he was and what he was into. He had no desire to go to a school that forced him to make stuff he didn't enjoy.

So, Dan shot slides of his best drawings and some recent class work. He compiled an impressive portfolio (to him at least) and showed it to friends and professors for advice.

Now all Dan needed was something to distract himself from the stress of waiting to hear back from colleges. He saw a sign in the cafeteria saying that The Underground, a campus radio station, was looking for a graphic designer. Dan thought he could pass himself off as qualified to the kind of person desperate enough to post such a sign. The Underground's manager, Jason, liked Dan's work and told him about Springfest, their annual fundraiser. He wanted to use Dan's design skills to promote the event. Finally Dan was going to have an actual client — and one in the music business. He tried to contain himself. Jason also wanted a graffiti wall at Springfest, but didn't have anyone to organize or build it. Dan smiled.

Dan remembered one of his frat bros, an "entrepreneur," telling him to "fake it till you make it." He had never built anything larger than a bird feeder, but told Jason he had. Even if things went totally bust and Dan couldn't figure out how to build the wall, he probably knew somebody who could. He made a simple drawing and took it to a hardware store where the clerk laughed at Dan, then kindly told him how to improve the construction. Along with his good friend Garrett, Dan spent a weekend making small sections that could be bolted together to form a fifty-four foot wall. Dan enjoyed the challenge of not knowing what the hell he was doing. Garrett did not.

A few friends showed up from all over the country to help paint. As they assembled the wall a crowd of onlookers assembled. Dan loved attention like this and he hadn't received it since his wrestling days. The team finished painting as the sun went down and sat back to take it all in. Springfest turned out to be one of the greatest days of Dan's life; the culmination of planning… and bullshit.

LIFE IS MORE THAN OHIO

After weeks of anticipation, Dan heard back from his first school. It seemed that Taya from California College of the Arts wanted to do a phone interview. She had an unbelievable amount of pep in her voice for a 9:30 AM call and Dan was usually skeptical of people like this. But skepticism had no place in an interview. At the end of their conversation, Taya told Dan he was accepted to CCA. He was ecstatic and began jumping around the apartment (something he didn't do very often). Dan also got thick envelopes from SVA and SCAD, and both schools offered him money. Decisions needed to be made, and made fast, since the fall acceptance deadlines were rapidly approaching.

It was too late to visit the schools, so Dan went back to the catalogs to see if they could help his decision.

In CCA's catalog Dan came across the work of Jon Santos. Jon had left a pharmacy program in Michigan to move to San Francisco and become a DJ. Along the way he ended up at CCA. Jon's posters were like nothing he had ever seen — and Dan wanted to create work like this! Suddenly he wanted to be in California studying design; he wanted to be at CCA. It just felt like the right move, even if he couldn't explain why.

Dan accepted CCA's offer and he and his Dad went to San Francisco on an apartment-finding mission. They got a hotel in the heart of the city and began the short drive to the school. CCA was quite impressive from the outside. It looked like a contemporary art museum. As they walked in, Dan knew he had made the right decision. The building had endless classrooms as well as woodshops, industrial design labs, a theater, fashion studios, computer labs and a library filled to the brim with goodies. He was excited to get started.

QUESTIONS TO ASK YOURSELF
—

AM I HAVING FUN?

DO I LIKE MONEY?

SOLVING PROBLEMS OR MAKING COOL SHIT? BOTH?

ARE IDEALS IMPORTANT?

WHY AM I DOING THIS?

WHERE DO I WANT TO LIVE?

WHO IS THIS NEXT TO ME?

JOB OR MY LIFE?

IS THIS WHAT I WANT TO BE DOING FOREVER?

HOW MANY LICKS DOES IT TAKE TO GET TO THE CENTER OF A TOOTSIE POP?

BE A TWO-HEADED MONSTER

Jimm Lasser

Who are you?

Answer that question before you start to work.

School will teach you about kerning and Paul Rand, but they cannot teach you the thing that will determine whether you will be good or great. That thing is up to you. In fact, it is you. Your work needs to have your unique point of view.

Go to a party. One full of people. People holding drinks and pretzel sticks and conversation. Who are you drawn to? Who stands out? Those who express something interesting, charming, reactive; i.e. NOT the standard boring banter about weather. They are the ones you are attracted to.

To stand out, you need two heads. One is the head you fill with all the fundamental skills you learned in school. Exacto cutting, font spotting, use of the word "juxtaposition," etc. This is the head everyone can fill if they take the standard creative professional path. But to really kick-ass and stand out at the party, you need to develop a second head which you should fill with the unique you.

Your work will stand out if you have a point of view. Everybody has unique life experiences that give them a special outlook on the world and you will find your POV in experiences that have nothing to do with your career. In fact, the more divergent these things are, the better. Maybe you were raised by a military family, or you once loved baseball, or you immigrated to the United States when you were very young. All of these experiences shaped who you are and how you see the world.

Before I was an art director, I was a lawyer. Also, I have a manic interest in history and politics. These pieces form my second head, the real Jimm, and guide me when I solve creative problems. This is the core of what makes my work my own. It makes the work interesting. It makes the work human.

Law school shaped the way I communicate. I was taught to make dense concepts simple enough to relate to a jury. My choice of words, colors and images is often direct and straight to the point.

My love of history and politics lead me to create sharpastoast.com, where I supply the world's nerds with cool T-shirts. These designs come straight from my second head and are informed by my love of history and politics. In these cases I am able to create primarily on instinct because the work is so personal to me.

Designers are professional communicators. Good creative work feels like a conversation between two people, and the more personal you can make your work, the more people it will touch. Everything starts with a knowledge of self. When this mixes with your craft, you will begin to create the work you always wanted to.

In the film "Boogie Nights," Don Cheadle's character, Buck Swope, spends a large part of the film socializing in different clothing styles and it is getting him down. He can't figure out which style fits his true self: Rick James or Rhinestone Cowboy. Finally his friend, Maurice, clues him into the solution:

"Do what you dig."

Jimm Lasser, Esq. (1974-) On the stormy morning of Sunday, December 9, 1974, Nancy Lasser, wife of Alan, gave birth to a boy. He was born on a bed of poles covered with corn husks. The baby was named Jimm, after Comedian Red Foxx. The birth took place in the Lasser's rough-hewn cabin in Winnetka near Chicago, Illinois. Alan Lasser was a dermatologist and a farmer. Nancy Lasser had little or no accounting schooling and could not write French poetry. Jimm spent a short amount of time in a log schoolhouse, before graduating from the University of Michigan, Vanderbilt University School of Law, and the Portfolio Center. Jimm attended school dressed in a raccoon cap, buckskin clothes, and pants so short that several inches of his calves were exposed. Jimm earned his first dollar ferrying passengers on a Lake Michigan steamer, and designing T-shirts for the 84-year old James Toast at sharpastoast.com. He spoke out against the Dred Scott Decision, has won many decorations for valor in battle and is now a "creative person of interest" at Wieden + Kennedy in Portland, Oregon.

STAYING OUT OF TROUBLE

Andre is bored with high school, so Svetlana enrolls him in a local community college to keep him out of trouble. The only open computer classes are Introduction to Animation and 3-D Animation. Andre likes messing around with this software that is way above his head, and the teacher likes his enthusiasm, in contrast to that of the rest of the students — mostly second-degree Moms and Dads who had just learned how to use a mouse. Andre spends his summer going to classes and making short animated movies. For his final, he models a small city with a plane flying through it. The movie is about 5 minutes long and he leaves 3 days for it to render on his badass computer. The clip takes 14 days to render and Andre misses the deadline.

Community college feels like high school with ashtrays. Even so, Andre is happy to be challenged. Most of the classes teach him how to use computer programs, but offer nothing about ideas. His classmates usually showcase their kids and/or cats in their homework, and after a few semesters it becomes obvious to Andre that this education will not go beyond Photoshop filters. Regardless, he keeps attending classes and eventually acquires an associate's degree and a love for the lens flair.

Andre turns sixteen and starts looking for work. Svetlana finds an ad for a designer in Seattle and signs Andre up for an interview. Andre has no experience and his portfolio consists of the self-initiated projects he has used to learn programs. Portfolio in hand, Andre dresses up and goes to the interview. The firm is one of the top 5 ad agencies in the city, but Andre is completely unaware of that. Their offices are high up in the sky and Andre thinks the front desk girl is cute.

He presents his work to the creative director, Steven. Even though Steven isn't very impressed, he likes Andre enough to give him a tour of the office. After a few handshakes, Andre is given a computer test to see how well he knows the software. Since this is his first ever interview, Andre thinks this is standard practice. The test questions are basic, like how would you change the background color in Photoshop or spec a PMS job in Illustrator. Andre has already told Steve that he is a master at the programs, but is unsure about most of these questions. When the test is over and he walks out of the room to get his score, Andre's results are below average and he feels like a fraud, his weakness exposed.

On Andre's way out, Steven casually mentions that they should get a drink the next time he is town. Svetlana is happy with this outcome. Andre is happy the interview is over. The next day Steven calls and leaves a message that there might be a job available, Andre returns the call, but the job has already been taken. A few weeks go by and Svetlana pressures Andre to take Steven up on the offer of a drink. They go to a swanky bar and Andre, a sixteen year old, is scared they will card him. So, he orders an orange juice. Steven gives Andre some advice and a few referrals, but this is the last time they will ever talk. Andre is discouraged and afraid to go on another interview.

After failing to land this job, Andre starts looking for minimum wage opportunities. Svetlana helps him get a job at the fast food joint where she used to work. Andre works twice a week, making $5.50 an hour cleaning the bathrooms and washing dishes. Two kinds of people work at the restaurant: high school kids and older immigrants. Most employees care a lot about their job and fear losing it. Andre finds this ridiculous since the most senior "manager" gets paid $8.25 an hour, not nearly enough to justify smelling like lettuce and pickles. The manager tells Andre that he is the laziest employee she's ever had. He decides to stop going to work.

Svetlana finds another ad in the paper, this one's for a wedding photographer's assistant — no experience necessary. Andre had fun in photo class and so he applies. He shows up for the interview, which is in a garage/photo-studio. The interview consists of putting together a tripod and Andre passes with flying colors. Laura, the photographer, likes Andre and he spends the rest of the summer eating wedding cake and listening to Steely Dan.

Andre starts high school again. This is an important year and he has 2 main goals: get a scholarship to a good art school and graduate high school. A few months before applications and portfolios are due for the art schools, Krassimir visits to help Andre prepare. He buys Andre *The End of Print,* a David Carson book, for his seventeenth birthday. The book is full of experiments and weird graphics — Andre is in awe of this Carson guy. Impressed by his use of typography, something Andre hadn't considered before, he starts imitating the images from the book.

For a month, both of them sit in front of the computer producing a total of twenty pieces. Andre tries illustration, identity, and even makes a "sculpture" from an old television. Svetlana thinks the TV looks really bad and begs Andre to throw it away. But Andre loves it — it's his art. Most colleges want a healthy mix of work, but all of them require some sort of drawing. Andre spends numerous weeks with Krassimir, desperately learning how to draw, but he isn't happy with the outcome. His biggest accomplishment is sketching an apple. Krassimir does three drawings, the minimum requirement, which Andre can

present as his own. Andre isn't proud of adding the drawings to his portfolio, but he needs any advantage he can get.

Come January, Andre goes to a national portfolio review at Cornish College of the Arts, the only Seattle school to which he applies. Most of his competition bring huge still lives or cheesy self-portraits. Andre has everything mounted on boards, dresses in all black and brings Krassimir as a heavy. After presenting his portfolio to a young teacher at Cornish, he gets accepted on the spot. Krassimir pats Andre on the back and sheds a few tears. Based on the recommendations of older students in Mr. Danielsen's class, Andre also applies to California College of the Arts, California Institute of the Arts and Northwest College of the Arts.

Back in Seattleland, Svetlana is worried that Andre might not get into most art schools. Even if he does get accepted, she is worried about paying the expensive tuition. She decides he should explore other options and sets up an interview with an Army recruiter. One of the Army's selling points is that they pay for college. Andre goes to the interview to please Svetlana. Andre explains to the recruiter what he wants from his career and the sergeant promises that he can find something similar in the Army. For the next six months, the sergeant keeps calling, trying to get Andre to come back and chat again, maybe even play some hoops. Thankfully, Andre never goes back. A year later the US invades Afghanistan.

Andre and his good friend Jon start exchanging files and showing off their latest Photoshop tricks. They decide to start a collective site called play-control to mess around and make cool shit. Matt, one of their friends, gives Andre his first freelance job. Matt is turning 18 and wants a big tattoo on his back. He puts his complete faith in Andre's hands and asks him to design whatever he wants. Scared shitless, Andre refuses the job. He likes the ephemeral nature of design and can't imagine making a graphic that anyone would like to sport for the rest of their life. Matt is disappointed and ends up piercing his eyebrow instead.

Andre starts receiving letters from the colleges, CalArts offers him 5k a year in scholarships; Northwestern, 3k; Cornish, 1k; and CCA, 8k per year. Even though he doesn't receive a full ride from anywhere, Andre and Svetlana are happy he got accepted everywhere he applied. Andre takes a trip to San Francisco to see CCA. There are people on the streets and the city feels lively. Andre visits the campus and falls in love. This doesn't look like a school at all, more like a big warehouse filled with a bunch of arty kids. All of the classrooms are open and you can see a fashion crit or a naked drawing class while just walking around. Andre likes the vibe and decides CCA and the foggy city are his next stop.

PAPER CUT-OUTS

BALLOONS

COAT HANGERS

DIXIE CUPS

POST IT NOTES

SEX TOYS

ICE CREAM

BOOKS

CARDBOARD BOXES

NEON

PRETZELS

CHEERLEADERS

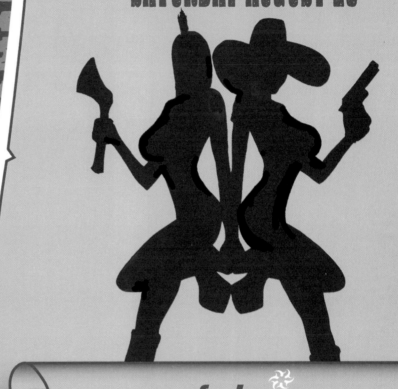

phusion projects

presents

COWGIRLS and INDIANS

SATURDAY AUGUST 25

fabric
lounge.nightclub

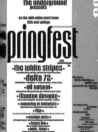

SUB CITY

june 1st 2001
the underground
presents

on the ohio union west lawn
12th and college

springfest

·the white stripes·
·delta 72·
·all natural·
tRonton duvante
·flux
·starlight mints·

·konos 8bc·
·phil, texas·

www.underground.tn/springfest

VOYAGE
THURSDAY NIGHTS

PAY US TO KILL YOU

THE THIRD POSTER I EVER DESIGNED. IT HAS BEEN PUBLISHED AND EXHIBITED MORE THAN ALL MY OTHER COLLEGE WORK COMBINED. - D

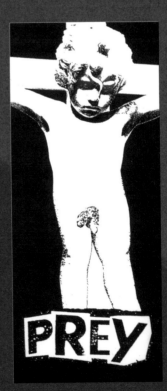

PREY

QUESTIONS + ANSWERS

I always have the hardest time photographing posters or three-dimensional work for my portfolio. Do you have any tips how to get a professional looking picture when photographing work?

—

Inva Cota

Hey Inva, you should Invest in a high quality digital SLR (around $500 these days) and a quality flash (around $200). It's best to shoot indoors at night or somewhere where you control the lighting. White balance the camera to the flash and whatever lighting you are using. When shooting, point the flash upwards so that the light bounces off the ceiling. Have a computer nearby to see the photographs and adjust settings like the white balance and ISO to get the best results. It's also nice to mock up work in the actual environment. Take street photos of posters and billboards and Photoshop your designs as though they were actually on the street. That will give your projects more legitimacy.

Are there certain types of internships that are more beneficial for students, other than the fact that they involve you more in the design process?

—

John Lui

Internships are a very personal thing John, so it's hard for us to say what is best for you. But they are a great way for you to test the places you want to work and the types of projects you are interested in without a huge commitment. The more the merrier actually because you will see what works and what is a bore, while learning how different sized companies are structured and operate. Then when you graduate you will know what you want out of your dream job. Or you can stay at one place and work your way up through the ranks. By all means, if you dig a place, stay on board because people love to hire their interns. They are checking you out just as much as you are checking them out.

plus, this shit is gonna be around for a while

yeah

and it is on when everyone gets off work

way after we gone

so big people will see it

not just kiddies

puffy

yeah

hah

get some bad boy work

uh uh dont stop

11:28 AM

dood

im so dead

y

tired

or busted

11:30 AM

?

do u mind uploading experimental jetset?

the sonic youth cd?

yeah

man, whatever

for what

we are still getting in

so i can "listen" to "it"

yeah

random request

Dan-

Whats up? Had a very exciting call yesterday. A person was driving and saw the billboard you designed and called to learn more about us! This was the first news we had that the boards were up. I put a call in to LAMAR to get the site map of all the boards. As soon as I have the info I will contact you and you can send your fam to check it out.

Hope all is well.

Jennie

its that kinda of a day

nice

CALIFORNIA AND ARTS

Dan was excited for his first day at a new school. But from
the looks of things, his first class, 3D Visual Dynamics,
was going to be a total waste of time. Dan spent the entire
session making life-sized sculptures out of cardboard. It
reminded him of a high school art class and was team-taught
by husband and wife architects who also operated their own
practice. Dan was curious how they could hang out so much
without getting sick of each other. Hopefully his next class
would be better.

It wasn't, and taking another art history class was a huge
bummer. This wasn't even fun art history. The class focused
on the early days of Western Art, with cave paintings and
shit. All Dan was interested in was Modern Art. Art history
required a whole lot of memorization, which to Dan meant
a whole lot of cheating. He didn't see how memorizing any
of these dates would help him become a better designer, so
he didn't do it.

Type 1 was where it began. His instructor, Patricia, had
designed the San Francisco phone book, which was pretty
impressive at the time. In the first class they learned the
difference between a serif and a sans serif typeface, something
Dan had never really thought about. He was blown away.
Dan left class and spent the walk home analyzing all the
type around him and looking at it with new eyes. Later,
they drew letters with chalk. Patricia was a stickler. She
wanted all the lines to be perfect and for them to respect
the letters. Dan loved both this and learning how to use
type to express simple ideas. Weights, sizes, fonts, colors
and composition — all exciting.

Dan didn't think a class could be more fun than type, but
Graphic Design 1 was. He was greeted by Mark Fox, a tall
man who used big words. Class started with a simple game to
"break the ice." Dan, never one to pass up a chance to
brag, overcompensated and talked about all the freelance
graphics he was designing. Later, Dan realized he probably
sounded like an ass, especially to Mark, who had designed
logos for sports teams and giant companies. Dan had
designed some rave flyers.

On the first day of class Mark bluntly told everyone why
school costs so much. They were paying — and paying a lot —
for access to leaders in their industry. So, Dan decided
that working hard to impress these teachers would not be
such a horrible idea, since they all probably needed
interns. Mark also clued them into the reality — that most

students would not end up practicing as graphic designers. This was not so bad, though, because graphic design was a way of thinking, and the principles and problem solving skills they learned in school could be applied to almost anything. To Dan, this seemed like a nice way of telling everyone that graphic design was a competitive field and they all might not make it. He was ready for the challenge.

The first assignment was to do three personal logos. But they didn't end up designing anything for weeks. All they did was research, and research was boring. Dan wanted to make things. Eventually he began to realize that the more he knew about something, the easier it was to design and, maybe more importantly, to sell his ideas. Dan had never thought about this before but, then again, why would he?

Everything in Mark's class — every piece of paper, every sketch, every presentation — needed to be designed. He stressed the importance of presentation and explained that if they designed these small things, their professors would take them seriously and eventually their clients would pay them more money. Everyone in the class was supposed to keep a sketchbook for doodles, funny notes and anything else that inspired them. They began sketching logos in these books and Dan found he loved drawing things over and over, trying to improve them. He had always been a bit of a perfectionist, the kind who would straighten stacks of magazines or organize his shampoo bottles by height.

In addition to Mark's identity work, he also created screen printed posters about sociopolitical issues. This work was well known and appeared in museums throughout the world. Mark was passionate about doing stuff for causes close to the heart, for things he was personally drawn to. This work existed on an entirely different level than his client work. To help illustrate graphic design's power to affect people's behavior, Mark challenged the class with an agit-prop poster assignment.

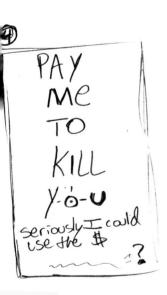

Dan's grandmother had just died of emphysema, and so smoking was something he hated. He had no idea why someone would risk their life for a habit even the cigarette companies admitted was deadly. Beth, Dan's high school girlfriend, was his inspiration for a simple tagline. Dan used to heckle Beth about how she was basically paying cigarette companies to kill her. But rendering his message with computer type didn't produce the right effect. As Dan zoned-out on his walk home, dreaming about pretty girls with tattoos, an idea came. He bought three packs of cigarettes, went home, and used them to spell out his message: "Pay Us To Kill You."

Dan couldn't figure out why this idea had come to him out of the blue. Was it because he had done lots of research? Was it because he wasn't trying to come up with a solution at that particular moment? Was it because he was relaxed? He didn't have the answer, but solutions continued to come to him when he was not trying to come up with them: in the

shower; walking to the subway; while he was staring at the wall. It was a blessing and a curse. He loved coming up with good ideas, but this also meant that graphic design didn't end when he left the office — it was always with him.

All Mark's assignments dealt with personal subject matter. This helped while learning, since it was usually easy for people to talk about themselves. Mark encouraged them to take these personal things and communicate them so that other people could also relate. He further explained how the public wouldn't respond to something too personal, but when designers succeeded at taking something personal and making it universally appealing, people would be drawn to it like they were to free puppies.

Dan probably would have moved back to Ohio if it hadn't been for Mark's class. Other kids in school hated their classes and bitched about teachers, but Mark became something of a mentor to Dan, and for that he was grateful. Dan reached out to Mark via email whenever he needed help or advice, and Mark would always make time to help. Taking Mark's class proved invaluable to Dan's education, and so, every semester he would ask students and professors for advice about other classes to take.

Since Design History was Dan's favorite class at OSU, he loved History of Visual Communications with Steve Reoutt. Every Friday, Dan would learn about designers he'd never heard of and was exposed to new styles and ways of thinking through their work. And, CCA's library was filled to the brim with books and magazines, so Dan would nerd-out and spend his weekends combing the shelves. He didn't read many of these books because they were badly written (like this book probably is). Instead, he looked at the pictures, analyzing why something worked or why it didn't. Dan's personal library began to expand as well, and his Mom would buy him books every holiday. Thanks Mom!

NEXT LEVEL

Michele Wetherbee was an outgoing and direct woman who had spent time in the publishing world, but got sick of it and opened her own studio. Her Type 2 class covered the basics, starting with a series of quick exercises in hierarchy, scale, cropping, composition, contrast, color and juxtaposition.

An assignment to create a concert poster forever changed the way Dan looked at design. The poster was for the Fillmore, a historic spot to see shows in San Francisco. Like most other creative people, Dan was obsessed with music. He chose the band Jamiroquai as his subject (a band that to many people's surprise had more than one good song). Michele pushed her students to do tons of research, as she didn't want the work to look anything like the band's previous stuff.

Dan chanced a hobo encounter and rode the bus to Amoeba Records, a giant store, where he spent hours sifting through

AIGA San Francisco

Covert, Dan

Your reviews are:

Review #1 Hinrichs, Kit Pentagra

4 STEPS TO IDIOCY (AND 1 STEP TO SHEER GENIUS)

John Bielenberg

Step 1
I went to college and studied graphic design. I managed to learn how to spec type, crop photos, use a waxer (don't ask), drink coffee, recognize Paul Rand, make comps with markers, steal ideas from design annuals and create a portfolio.

Step 2
I got a job. First at a little ad agency, then at a crappy little design studio designing 2-color pamphlets. After a few years of relative progress, I became a partner and eventually bought out the other guy. So…

Step 3
I had my own design studio. Now I was master of my own domain and, better yet, starting to win design awards. Things were going well and it felt pretty good. I was making decent money and driving a somewhat nice car. I wasn't at the top of the mountain, but I could see the peak from where I was standing.

Here's where it gets interesting.

Step 4
I realized that I was an idiot. We were working with a client that had hired a behavioral psychologist from Cornell University to help evaluate to what degree their competitors were victims of "heuristic bias." I had never heard this term before. It simply means that people are victims of learned biases or orthodoxies. As we develop, we learn things that become ingrained patterns of behavior. These synaptic connections allow us to survive in the world and make quick and efficient decisions.

For example, a useful heuristic bias develops from learning that swimming with great white sharks can be a tragic mistake: a dorsal fin next to you while surfing = get away fast. However, this same useful bias can also lead to poor decisions. If a shark attack off the coast of California is widely reported in the national news, people will stay out of the water in New Jersey even though the statistical probability of an east coast event has not increased due to a happening 3,000 miles away.

(Insert image of light bulb going off here.)

I realized that I was an idiot. Even though I thought I was a good designer, generating copious creative ideas at will, I was actually severely limited by my built-in biases. My brain was automatically short-cutting to solutions for my work without exploring the range of possibilities available, one of which could be brilliantly unexpected and effective.

Step 5
I learn how to "think wrong." Some people are natural wrong thinkers. They short-circuit normal biases without breaking a sweat. Picasso, Fellini, Phillipe Stark and Stefan Sagmeister are examples… damn them. The rest of us need to work hard to get our minds to break out of predictable patterns.

The bad news is that doing this is really tough. How tough? Try talking "wrong," out loud right now. Link words in a nonsensical sequence meaning absolutely nothing. It's probably possible but I can't do it.

The good news is just knowing that thinking wrong can be a useful way to generate alternative ideas is an advantage in itself.

The better news is that there are techniques and exercises that can be used to trick your heuristic mind into "lateral" thinking.

I'll describe one of them. Next time you're "brain storming" at the beginning of a project, get out an encyclopedia. Pick a number between 1 and 100 and another between 1 and 10. Say... 45 and 3, for example. Go to page 45 in the encyclopedia and find the 3rd word. Say... "brimstone." Now use "brimstone" as the starting point for brainstorming about your project. Since there are no incorrect answers, go in whatever direction you want. I guarantee that you will end up someplace new and unexpected.

It might not be the right answer, but then again... it could be sheer genius.

John Bielenberg is a partner and co-founder of C2, in San Francisco, with Greg Galle and Erik Cox, and founder and director of Project M, a summer program in Maine that is designed to inspire young designers, writers, photographers and filmmakers by proving that their work can have a positive and significant impact on the world.

Since 1991, John has produced an ongoing series of projects under the pseudonym Virtual Telemetrix, Inc. that address issues related to the practice of graphic design and Corporate America. Projects have included the "Quantitative Summary of Integrated Global Brand Strategy" booklet and video produced for the 1998 AIGA Brandesign Conference, the 1997 Virtual Telemetrix Annual Report satire of corporate branding and "ceci n'est pas un catalog" which parodies designer products. The San Francisco Museum of Modern Art has acquired 6 of the VT projects and staged a Virtual Telemetrix exhibition and mock IPO (Initial Public Offering) in 2000.

John is a member of AGI (Alliance Graphique International) and is Vice President and Director of the Pop!Tech Institute.

vintage posters. He walked away filled with inspiration. Sketching the band's name over and over seemed like a natural place to start and Dan noticed he could easily make the letters using only squares, It was hard to read, but Dan pointed out that pushing legibility was a tradition at the Fillmore. Luckily for him, Michele and the rest of the class bought this excuse. It wasn't entirely bullshit, but it wasn't the real reason Dan had drawn these letters. He just wanted to draw cool type and came up with this "concept" after the fact, based on his research. Dan discovered that the more research he did, the easier it was to convince people of his aesthetic or conceptual choices, as design was a subjective art. If he could remove some ambiguity from the equation, people were more likely to agree with his decisions.

Halfway through the semester, Dan got a letter saying that his "Pay Us To Kill You" poster was going to be in *I.D.'s* annual design review. He was ecstatic. Before this, Dan had only won stuff like wrestling trophies, tickets to *The Bodyguard* or "The Worlds Largest Christmas Stocking." He had never won anything artistic and it felt good to get validation, especially after being rejected from the design program at OSU — twice.

During school, Dan continued to enter his work in competitions and it continued to get published in books and magazines. Designers debate the significance of this stuff, but to Dan these were concrete accomplishments to put on the old resume, something tangible to help him stand out. Also, the people he wanted to work for might see the stuff and become familiar with his work, which was not a bad thing. Dan mostly submitted posters and logos, as they communicated ideas more quickly than a book. He also sent out actual work, rather than slides or digital files, which were easier for people to dismiss.

Doug "Ironman" Akagi was Dan's instructor for Graphic Design 2. He spent years in the industry and was something of a legend in San Francisco. He started off the semester with an assignment for a poster design fueled by simple allegories. For his design, Dan used a trick from a poster by Mark Fox. Doug was a fan of Dan's poster, but Dan wasn't sure if it was cool to reference another piece so closely. There were no set rules about what was homage, what was "inspired" by something and what was plagiarism. If he took someone's design but changed at least fifty percent, was that stealing? It was not generally acceptable to plagiarize, but Dan spent enough time looking through books to know that a lot of graphic design was plagiarized, whether people admitted it or not. Some designers were more obvious and ripped off contemporary design, others would buy obscure books and steal ideas, thinking nobody would find out. But the cleverest bunch looked to disciplines outside of graphic design to get their "inspiration."

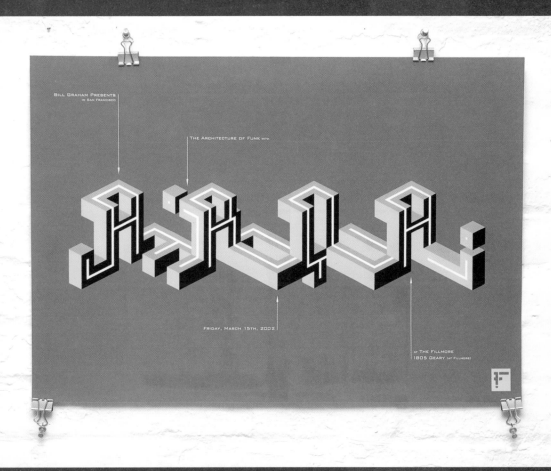

Within the poster (img_4):

BILL GRAHAM PRESENTS
IN SAN FRANCISCO

THE ARCHITECTURE OF FUNK WITH

FRIDAY, MARCH 15TH, 2002

AT THE FILLMORE
1805 GEARY (AT FILLMORE)

HOW DID I GET FROM THE SKETCH
ON THE LEFT TO THIS POSTER? - D

63

A FAILED ATTEMPT AT BECOMING THE NEXT SHEPARD FAIREY. - D

THE SOUL PATCH

VEHICLE

In the middle of the semester, Dan went to a lecture given by
Michael Vanderbyl, a West Coast design legend, about finding
a job. Vanderbyl equated the search to dating. The more you
went out, the better your chances were. And once you found
someone who had potential, it was best to put yourself out
there without seeming too overbearing or desperate, to let
them know you were interested, but not a stalker.

Dan did research on Bay Area design studios at the library
and on the Internet. He looked through design annuals for
work he liked and made a list of possible employers. Mark's
studio was at the top of his list and Dan reached out to him a
few months prior to the summer. Mark wasn't looking for interns,
but his friend Dennis Crowe was. Having limited to no
experience and only some time in factory work and as a sandwich
artist, Dan knew this recommendation was his best bet.

After a few semesters of learning how to present work, the
standard plastic book with shiny sleeves struck Dan as a
bit tired. Dan ended up buying an overpriced, customizable
book with screws for adding pages, knocked it off and
returned it to the art store. Mark helped him edit his ten
best pieces for the book and he practiced his presentation
over and over.

Dennis looked more like a designer than anyone Dan had ever
met. He was fashionable and had a soul patch (despite
trying very hard, Dan couldn't grow one). Vehicle, Dennis'
company did branding for just about anything relating to
youth culture. Dan spent a few nights before their first
meeting reading everything he could about Dennis and Vehicle.
He made an effort to drop a few things he'd learned during
their conversation and Dennis asked if Dan wanted to intern
for the summer. He also asked if ten dollars an hour was a
fair wage. Ten dollars seemed a lot better than no dollars.

Everyone at Vehicle was super nice and hip, plus they had a
foosball table. Dan realized that none of them had ever
really grown up, nor did they want to. He was responsible
for helping people do little stuff like clipping out
things, finding references, running errands, watering a plant,
changing toilet paper and making promotional books and
mailing them out. It was not the most creatively stimulating
work, but he was happy to have a job, one that paid.

Dennis took notice of his effort and soon enough, Dan was
working on bigger projects. Dan helped on logos for
video game boxes and got to work on *Soul Provider*, a book

celebrating twenty-five years of Nike Basketball. Some of his bad graffiti even appeared in the book. As a creative director, Dennis was great. He let the designers do their thing rather than micro-managing every little decision. When he did offer advice or ideas, they were always on point. The internship ended with an open invite for Dan to come back, something he would seriously consider.

ANDRE GETS CRAFTY

Andre and Svetlana pack their bags and fly to Oakland, where CCA's other campus is. He hasn't seen the Oakland campus or the dorm where he'll be living. Around every corner there are surprises: some "fuck Bush" graffiti over here, a wire sombrero hanging from a branch over there. Oakland is full of trees and sticky smells, the dorms are brand new and Andre is excited. On the second day, he meets his roommate, Ben — a short white guy with a fro, who plays the drums and pretends to be a painter. They seem to get along fine, but it's obvious they don't have too much in common.

Before Svetlana leaves, she has one mission to accomplish, placing Andre in upper-level courses. There is a departmental portfolio review to determine if a student can skip intro classes. This is important since it will save money and challenge Andre by placing him with more talented students. A lady with colored hair and a purple tie-dye shirt goes ahead of Andre. Her review's a disaster and the lady is upset. An older Russian guy named Steve Reoutt tells her she will have to start at the beginning. When his turn comes, Andre begins pulling out pieces and goes into his spiel. After the fifth piece, Steve tells him to stop. Andre is thrown off. Then the Russian tells Andre he'll start in the 3rd level of design courses. Since there are only 4 levels, this is an accomplishment. Andre enters ahead of the curve and Svetlana leaves Oakland with a smile.

Living with Ben is rough at first since Andre hasn't ever lived with strangers and their room is quite small. Ben is messy and does weird things like hanging out in his boxers, bringing smelly hippie girls home and stabbing the air with a kitchen knife. He also uses their room as a painting studio. His paint, canvases and brushes are scattered everywhere. Ben isn't a fan of cleaning and likes things natural. They never become good friends, but keep a level of mutual respect and don't get into major arguments.

THE FIRST CLASS

Type 3 is Andre's first class at CCA. He doesn't know much about the teacher or even what the class is about, but arrives early and finds another person sitting in the room. His name is Dan. Andre brags about getting out of the community college circuit, Dan replies with a smirk that this class will be much harder than community college. Andre is nervous about his skills being up to par.

Steve Renick, an older, lively man with a large beard and an obsession for drag racing teaches Type 3. Their first assignment is to illustrate a poem and Andre's work gets compared to David Carson. He grins with excitement before realizing this is not a good thing. Andre has some catching up to do. His typeface selection is poor at best, since he only uses fonts that came preloaded on his PC. Andre is behind and doesn't know the basics, like what paper to print on or to bring thumbtacks to hang his work. Unfortunately, Steve doesn't make it to the second class; he passes from a heart attack. Andre later wins a scholarship in his name.

Nola, the new teacher, is from University of California Press. She and Andre get along quite well, though he doesn't produce anything great in her class. Andre makes two books based on drugs, but they become visual experiments and don't reflect what the class is about. Rather than refining his typography skills, Andre is busy making stuff look cool.

Max Kisman calls his class, "Poetry in Motion." He is a funny character, a short man with black curly hair who dresses in bright colors. In Holland, Max is famous for his design, but in California his cultural caché doesn't translate. Andre likes having a foreign teacher and Max brings in rare books designed by Mevis en Van Deursen and arty magazines like *dot dot dot*. European design looks much cleaner and brighter, a fresh change from the dark and layered American aesthetic that's so popular.

For the first poster critique, Andre falls back on his image making skills. Everyone, except Max, is impressed by Andre's work. What Max is looking for are ideas, and Andre's designs, although beautiful, feel shallow. Max gives Andre his grade on the spot, in front of everyone, a B-. People get upset and Max stops giving grades out loud.

Later in the semester Andre produces two handmade books, one on the theme "Muse," and the other, "Static." For the books, he takes photographs and writes his own text, but uses them as formal elements instead of ways to convey meaning. Binding is the toughest part of crafting books. Andre is not a natural and ends up putting them together last minute, before class. He soon realizes that when his craft suffers, people focus on these flaws, rather than the design.

Hyped by the phrase "new media," Andre takes an Introduction to Video class on the Oakland campus. Most of his classmates are fine art majors and their work often focuses on awkward personal issues. With his community college software chops, Andre is ahead of the game. Barney, the chair of the video department, likes Andre's enthusiasm and encourages him to try more video experiments. Andre contemplates switching his major to film and video, but ends up sticking to what he knows best.

Midway through the third level classes there's a department-wide review. This is a big deal. But Andre doesn't understand what all the fuss is about since he thinks there is a review at every level. He is wrong and under prepares. Everyone gets wall space on a first come, first serve basis. Andre shows up so late that other people are already done hanging their work. He gets stuck next to all of the other slackers and quickly realizes that he doesn't have enough work.

As a quick fix, Andre goes home and designs a huge poster that will take up most of his wall space. Caught up in the moment, he pulls yet another all-nighter. The poster is so big that it requires nine giant pieces of paper and a complicated tiling job. Andre is exhausted after spending the majority of the night designing the poster. When he starts tiling the printouts he quickly realizes the measurements are fucked up. There are huge gaps and the poster looks horrible, so Andre gives up and goes to bed. In the morning, he needs to transport the huge poster to San Francisco for the review.

Stumbling through rapid transit, he dings the poster in numerous places and arrives minutes before the review starts. Everyone is having a good time drinking wine and chit-chatting about design. Andre is tired and grumpy; he looks like he hasn't slept in a while and so does his work. As the teachers start appearing, everyone tries to get their attention for critiques of their work. Andre doesn't know many of the teachers and is too shy to ask for reviews.

Finally he talks to Eric Heiman, a younger teacher Dan recommends. Eric gives him a good critique and mentions he is starting a design office that might need a summer intern. Since Andre doesn't know much about Eric, he pays little attention to the offer, something he will regret later. The rest of the review goes pretty smoothly, everyone likes his work, but nobody is overly excited. Looking around, Andre starts noticing the better kids. In every class, there are always about 5% of students who are really good, and it's usually obvious who they are. Andre hopes that he too is in that percentage, but suspects his craft and presentation may not be up to par.

COCKY GETS CRUSHED

Dan came off his summer internship a bit cockier than he should have. Until now, none of his teachers had busted his chops or really pushed him. They'd given him tough feedback, but always responded quite well to his work, which created animosity between Dan and some of his classmates. To make it worse, Dan wasn't always friendly in his critiques. He was trying to separate himself from the pack and wasn't paying thousands of dollars to make friends. Dan wanted the most from his education — to make connections that would further his career.

Eric Heiman was the first person to totally challenge Dan at CCA. Other students warned Dan about Eric, saying his class had an insane amount of work. They were right, and Eric was ready with a sock full of quarters to break Dan of his ego. His class, Graphic Design 3, was built around the bodies of work of different film directors. Eric ran down a list of 60 obscure directors and proceeded to give an almost encyclopedic rundown of their work, which would serve as the basis for a hypothetical film festival curated by the students. Dan chose Martin Scorsese, the only director he had heard of.

A self-authored thesis about the director's work was Dan's guide for the semester. Dan wasn't much of a writer, or even a film buff. He mostly watched romantic comedies, the kind starring John Cusack and lots of heavy petting. But Eric pushed students to the limit with insane deadlines, forcing them to work fast, relying on intuition and making bold moves, rather than spending time deliberating little things. Dan's natural process was very rational and he had a hard time working fast without second-guessing his second-guessing. He did everything for his "festival:" chose the films, named it Dark/Light, created a logo, a poster, a program and a trailer.

The task of creating the festival's poster did not come very easily since all of Dan's ideas were too simple. Scorsese's work dealt with universal themes, but his movies had a darker subtext. Dan was used to seeing things in black and white and Scorsese worked in shades of gray. When it came time for the final crit, Dan knew his poster was not up to par. Eric demanded a high level of professionalism and forced his students to take things up a notch. For final critiques he would bring in friends — designers, non-designers and, sometimes, his Dad — to analyze the work with fresh eyes.

Eric stressed presentation and emphasized that being a successful designer was not just coming up with "ideas" and making cool stuff. It was also about selling the work, and yourself. He encouraged students to dress up and rehearse their presentations. Dan stayed up for two nights in a row refining his poster and working on his maniac patchy beard and crazy hair. The critics still tore him apart. What Dan intended to communicate did not come through and he was taken aback. All of a sudden, this graphic design stuff had gotten a lot harder.

The critics told Dan to work in a less isolated environment and take more breaks. That if he took a walk or talked to someone every hour or so, he could come back with fresh eyes. And if he couldn't see what wasn't working right away, then he should ask other people, designers or not, if what he wanted to communicate was getting through.

Dan felt as if he had failed for the first time in design school and this was surprisingly refreshing. He put too much pressure on himself. This pressure built up and caused

MAKE A TYPE ONLY
SOLUTION.

MAKE AN IMAGE ONLY
SOLUTION.

MAKE AN ICON ONLY
SOLUTION.

MAKE A FUNNY SOLUTION.

MAKE A COPY DRIVEN
SOLUTION.

MAKE A DUMB-STUPID
SOLUTION.

MAKE A RIP-OFF THE
COMPETITION SOLUTION.

MAKE AN ILLUSTRATED
SOLUTION.

MAKE A SOLUTION THEY'D
NEVER PICK.

MAKE A CLEVER SOLUTION.

MAKE OR COMBINE SOME OF
THESE SOLUTIONS.

PUT A CAT IN IT.

Dan not to trust his intuition. Eric told Dan that he shouldn't be afraid to fail, and that he would learn more from going out on a limb and trying something new, especially in school where the stakes weren't as high. Eric said this was the time to find new ways of working, so when the time came to get a job and make that money he would have different processes to use.

Regardless of whether his work for Eric's class was successful, Dan learned a bunch. At the end of the semester, students throughout the department hung their best work for something called Level Three Review. It was a big deal because all the teachers walked around and critiqued. Dan spent a lot of time preparing and hanging stuff for the show. The only teacher he was worried about was Eric but, to Dan's surprise, Eric only said nice things. He also recommended Dan for something called Sputnik.

SPUTNIK

The only other person Dan wanted to critique his work at Level Three Review was Bob Aufuldish. Bob was quirky with an awesome sense of humor, something unusual in design. He ran Sputnik, the student-staffed design studio that produced most of the collateral for CCA. Bob gave Dan a great critique, but didn't mention anything about Sputnik. Handwritten letters seemed like a nice way to thank everyone who took the time to critique his work. He learned this from his Mom, who put embarrassing pink notes in his lunch with little hearts on them and always wrote him a thank you for anything nice he did. Dan sent one to Bob that expressed his interest in Sputnik. A few weeks later, Bob called and offered him a spot.

Sputnik was fun in a nerdy design way, since members learned print production and all the nitty-gritty stuff you were supposed to learn at your first job and not in school. Dan was also presenting to actual clients with actual problems that needed actual solving, an activity he had only heard important people talk about in passing.

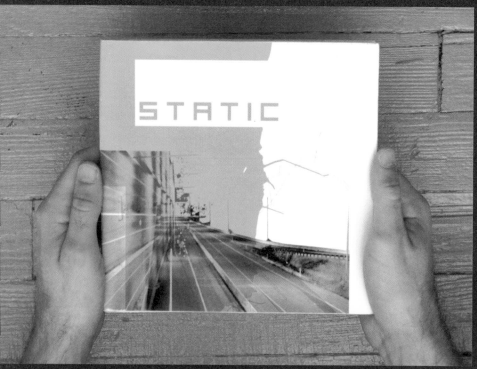

I WAS SO HAPPY TO SEE THIS PROJECT PUBLISHED IN
CMYK, I TOLD MY MOM AND SHE BOUGHT ONE COPY. - A

MAX KISMAN GAVE ME A B- ON THESE POSTERS. - A

I RUINED THIS BOOK QUITE A FEW TIMES WHILE TRYING TO BIND IT. - A

THE CONCEPT OF THIS BOOK WAS ABOUT THE EFFECTS OF DRUGS, IT TURNED OUT OKAY. - A

A SELF-PROMOTIONAL CARD I MADE IN A FEW HOURS. THIS DID NOT HELP ME GET MUCH WORK. - A

REHERSAL

ALISON TALKED A LOT OF NONSENSE IN THIS VIDEO. IT
WAS A PROJECT FOR BARNEY'S CLASS. - A

JON AND I MADE A SITE TO PROMOTE OUR COLLECTIVE WORK. WE ALSO MADE SOME SHIRTS THAT WE WERE SUPPOSED TO SELL, BUT INSTEAD THEY SAT IN MY CLOSET. - A

ALI'S POSTER FOR HER SENIOR SHOW. IT WAS ALL ABOUT TAP DANCING. I ENTERED IT IN A FEW COMPETITIONS BUT IT DIDN'T WIN ANY AWARDS. - A

THIS WOOD RECORD WAS THE FIRST THING I SCREEN PRINTED. IT SOLD FOR TWENTY DOLLARS AT AN AIGA FUNDRAISER. - A

DESIGN FOR A CCAC SWEATSHIRT I MADE IN 10 MINUTES. - A

A BROCHURE FOR ALCATRAZ TOURS I SET IN ARIAL. - A

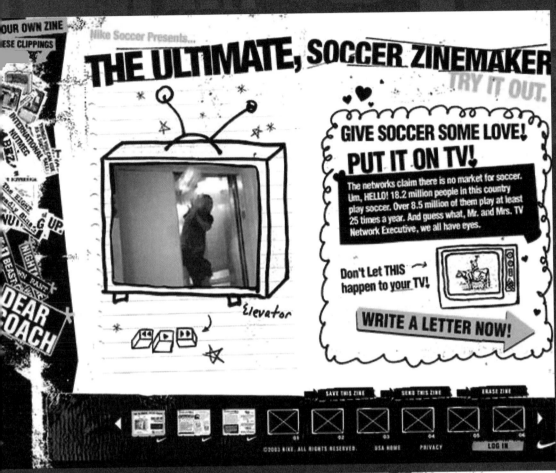

SOME DESIGNS AND BAD DRAWINGS I DID FOR A NIKE SOCCER SITE AT ODOPOD. - A

THIS SITE WAS ONE OF THE MOST EXCITING PROJECTS I DID AT ODOPOD. IT WAS A BIG DEAL AT THE TIME, DESIGNING FOR NIKE WHILE STILL IN SCHOOL. TIM AND JACQUIE ART DIRECTED ME A LOT, BUT I DID MOST OF THE DESIGN. - A

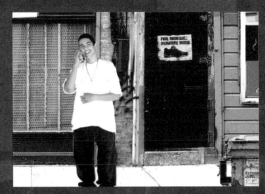

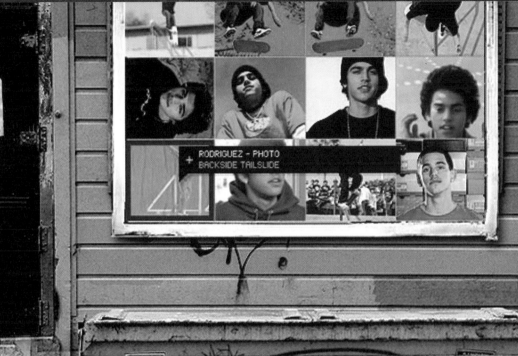

RODRIGUEZ - PHOTO
+ BACKSIDE TAILSLIDE

LOCKWOOD
Antwerp, Belgium

Lockwood is a nice, clean skateshop in the city center of Antwerp, Belgium. Sven Aerts, one of Belgium's best skateboarders, opened it a couple of years ago. Lockwood was Belgium's first Nike SB account. Nowadays, most of the core shops in Belgium carry Nike SB, but Lockwood still sells the most. Sven is about 30 years old but still skates with amazing pop and style. He recently also became the first team rider for Nike SB in Belgium. Read on to get to know more about Belgium's finest!

STORE LOCATOR
Nike Skateboarding shoes are only available at authorized skate shops.

SHOE GIVEAWAY
You look like you could use a new pair. Enter the monthly giveaways!

MAILING LIST
Find out about site updates, team news, demos, tours, new shoes and giveaways.

DOWNLOADS
Wallpaper, screensavers, and desktop icons. What else do you need?

CREDITS + LINKS
Friends, family, and all other things going related.

NIKE SB

NAVIGATION

November 15th
6:00 Mean Streets Runtime: 110 mins
9:00 Kundun Runtime: 128 mins

November 16th
1:00 Goodfellas Runtime: 146 mins
5:00 The King of Comedy Runtime: 109 mins
9:00 Raging Bull Runtime: 129 mins

November 17th
1:00 Casino Run
4:00 Taxi Dri

AT VEHICLE I GOT TO HELP OUT ON A BOOK FOR NIKE BASKETBALL. I DIDN'T DO MUCH, JUST SOME COLLAGE SPREADS, REGARDLESS IT WAS STILL COOL TO BE INVOLVED. CHECK OUT THE KILLER GRAFFITI I DID FOR ONE OF THE DESIGNERS. - D

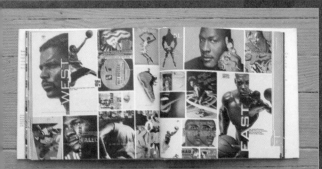

DARK LIGHT

the harsh reality of Martin Scorsese

TRUST

DOUBT

DARK LIGHT

A MARTIN SCORSESE FILM FESTIVAL

SPIRITUAL

MY FIRST PRINTED PIECE. IT WAS USED TO HELP OUR SCHOOL GET DONATIONS. THE CLIENT MADE ME TAKE OUT LITTLE ILLUSTRATIONS OF SURGEONS PUTTING ON GLOVES BECAUSE THEY DIDN'T WANT TO OFFEND OLD PEOPLE, THEIR PRIMARY DONORS. - D

ONE OF MY FAVORITE ANIMATIONS, I FINISHED IT IN THREE DAYS AND USED IT THREE YEARS LATER TO GET A JOB AT MTV. - A

FINDING THAT MONEY

ALCATRAZ AND BEYOND

Svetlana wants Andre to get a job since she is supporting him financially. She urges him to become a student worker. Andre hates the idea of working in the school's bureaucracy and desperately starts looking for design jobs on Craigslist. The type of work posted on Craigslist varies between designing brochures for dog walkers and working for bullshit startups. Most ads use keywords like, "great opportunity for a student" or "would make a good portfolio piece." In other words, non-paying work. Just in case, Andre sends his website to every company he can find.

A few days later, Andre gets a call. A company that does tours of Alcatraz asks for an interview. After a long ferry ride, walking for an hour, and almost getting hit by a moped, Andre arrives at the office. A frat guy opens the door, calling Andre "bro." The bro shows off a collection of vintage arcade games — Andre is unimpressed. He declines to play a round of Space Invaders and they go to the basement "office." The company runs tours of Alcatraz and does design on the side. This puzzles Andre a little. But they like Andre's work and tell him they push the envelope of "kickass design." Later, Andre realizes when people are hyping themselves as doing next-level work, they are usually full of shit. Andre goes home with an assignment to do a brochure for the Alcatraz tour. He does the brochure in a night and emails it to the bros. He never hears back.

The other call he gets is from a web guy called Francis who Andre meets randomly at an alumni event. Francis, funnily enough, never went to CCA and was only there for free food. Regardless, the two set up a meeting at a Starbucks. Francis is enthusiastic about the possibility of working together and promises a lot of money and free software. He shows Andre the cheesy site he just completed for a local restaurant and tells Andre there is much more work where this came from. Andre is unimpressed, but likes the promise of making money. Later, another thing becomes very apparent: when someone talks about the money before talking creative, it means they don't care about the final product and only about getting paper. Francis never calls back and Andre gets tired of looking for sub-par jobs. He promises Svetlana he'll find a better job for the summer.

FOUR

The second semester, Andre signs up for Level 4 design courses. This is the last level before the much feared thesis class headed by Michael Vanderbyl. Andre can't afford to fail any

more classes, even if his schedule is loaded with studios. The good news is that Ben ends up moving into another room and Andre gets the dorm room all to himself. The other good news is that he starts dating the floor's cute Resident Advisor. Her name is Alison (Ali, for short). She makes all sorts of art that Andre doesn't understand, and her crazy ideas, crafty projects and tales of edible things on sticks fascinate Andre.

Jeremy Mende is a Cranbrook grad that likes his shirts unbuttoned and his beard neatly groomed. He teaches a theoretical approach to typography in Type 4, something Andre sees as impractical since theoretical design often ends up being complicated and inaccessible. Jeremy introduces everyone to deconstruction and a deeper analysis of images. Andre likes these theories, but many of them fly over his head. Regardless, he often speaks up in class and enjoys participating in crits. Mende is impressed by Andre's image making skills, but critiques his shallow conceptual thinking. This is something Andre hears over and over from his teachers. Everyone is in agreement that his work looks good but lacks meaning and critical thinking. Andre is 19 and critical thinking is not really a part of his vocab.

Mende takes the class on a field trip to hear David Carson speak. Andre is excited to see one of the world's most recognized designers and the person who introduced him to the layered aesthetic he loves. David Carson looks like someone's not-so-cool uncle, and far from the rock star Andre had imagined. David is arrogant and cocky but, given his status, who wouldn't be? He shows some nice work, but it doesn't sound like critical thinking is part of his vocab either. At the end of the lecture, David shows some recent work, video screens for Nine Inch Nails concerts. He claims the transition from print to motion was natural, but it's obvious his video work isn't good. At the end of the lecture, he admits that some of his work looks dated, but he challenges the audience by asking, "Where is the next David Carson?"

Andre signs up for a class called Laika where students design websites for the school's various departments. The kids in the class are happy to get portfolio pieces and the school is happy to get free work. Andre jumps onto a project to do a virtual tour of both CCA campuses. Stella, the teacher, advises Andre not to take on the project by himself, but Andre is confident in his flash skills. Plus, he doesn't like working with partners as he wants full ownership of this project. Creating the virtual tour turns into a nightmare, and he needs the whole summer to finish up the project. Stella gives him a C-, the lowest grade he's ever had for a studio.

In his software classes, Andre is ahead. He likes to animate and teams up with his old friend Jon for the first assignment. The project is a short animation using all the tools in Flash. In two long days Andre creates an animation of a tree growing. Jon does the audio and Andre goes to

class confident. Everyone else shows elementary animations with squares and circles, one person uses a triangle. Andre's movie, titled "Nutura," is impressive, a little too impressive. He has been up for days and mistakenly writes down the wrong copyright year at the end of the movie. The teacher and everyone in the class think it is a reused project from the previous year.

LETTING GO

Type 4 and Graphic Design 4 were a bit spacey and pushed the boundaries of design. The semester was concerned more with intuitive form making, intangible results and visceral reactions, rather than anything traditional. This made Dan uncomfortable.

Jeremy Mende, who used SAT words in casual conversation, taught Type 4. Most of the class was spent making form and documenting it with a camera, the non-digital kind. Dan hadn't worked like this before. He usually took lots of time laboring over an idea before figuring out how to execute it. Creating form for form's sake was hard and challenging. In the end, it turned out there was a hidden reason for all the form-making after all. It was supposed to lead them to a concept. This was a way of working that Dan had never even considered, form leading to ideas.

Graphic Design 4 was built around scientific theories. Dan was struggling, trying to articulate an abstract scientific theory in simple terms. In came *Dummies' Guide to Relativity* to save the day. Now Dan needed to look for a physical site, document it photographically and create a narrative sequence inspired by his theory. This sounded like a complete waste of time.

He had no idea what he was going to learn from this crap assignment. A teacher earlier in his career challenged Dan to try and make every project something he would be prepared to show people. It was too easy for Dan to give up and blame the fate of his project on someone else. He needed to make the best of the situation and find a part of the assignment he could get into.

The project ended up taking on a life of its own when Dan's teacher pushed him to get personal. All of a sudden he was creating a hypothetical narrative that dealt with a hypothetical son trying to relate to his hypothetical father. The content was derived from Dan's family photos, covered up and framed by the paint used to cover graffiti on his site. The work caused personal issues about his parents' divorce to surface. Dan hadn't even started to work these out on his own, let alone talk about them in front of school friends. This made Dan super uncomfortable and his face red. His teachers were challenging his process, his form, his way of thinking and his content. Maybe this was where Eric was tying to push him the previous semester.

AN INTERVIEW

The semester is almost over and Andre is busy finishing up
finals. Svetlana keeps calling about his finding work.
If he doesn't find a summer internship, he will have to go
back to Seattle and help at her nick-knack store. Not only
does this sound boring, but it also defeats the whole
purpose of going to the Bay area to start his "career."
Frantically, Andre puts together a new website of work and
sends it to his teachers. Andre is under the impression that
his teachers will be very impressed by his work and offer
him jobs. He doesn't hear back from anyone. Instead of assuming
that he would get offers, he should have swallowed his
pride and politely asked if any of his teachers needed help.

He searches for San Francisco firms on a design site called
k10k and shoots ten random companies short emails with his
info. Most of Andre's friends already have internships
lined up and he is nervous that he's too late. Out of ten
companies, only one calls him for an interview, a small web
company called odopod.

Interviewing does not come naturally to Andre and he usually
gets nervous. The more interviews he goes on, the better
he gets. Sometimes he takes interviews just for practice.
After the silly jobs he applied for last semester, Andre
feels more confident. Odopod has a quiet and fancy office in
downtown San Francisco. Andre wears a tie and nice pants to
present his work to Jacquie, one of the partners. The
interview turns into a casual conversation, always a good
sign, and Andre loosens his tie.

The next day Jacquie sends an email with the subject line,
"How soon can you start?" This is one of the happiest days
in Andre's professional career. He doesn't have to work
for Svetlana, starts his career at a great web shop and gets
professional approval outside of school. Eating a carrot
cake with Ali seems like the only way to celebrate.

The end of the school year comes and Andre has to move out
of his dorm. Dan will be away in LA for the summer and
offers his room as a cheap sublet. This is great news and
Andre moves in. The room is filled with stickers, magazine
cut outs and one giant mirror. Dan lives with Mike and his
girlfriend, Michelle, better known as M&M.

On his first day at odopod, Andre eagerly gets to work
at nine in the morning. He spends the next hour waiting for
someone to open the door. Jacquie introduces him to the
other partners, Tim and Dave, all of whom are from Texas.
They met in architecture school and Andre is surprised
to find architects doing good graphic design. Odopod
is a small operation. In addition to the three owners there
is one project manager, one designer and Andre.

Andre starts with the general intern duties: running errands, doing image searches and dusting things. Jacquie gives him a small, quick project — animating a flying beer can for the Nike Skateboarding site. It's a simple task, but Andre puts all his energy into making that damn can fly. Jacquie is impressed. Being flexible and humble seems important while interning. Since Andre is odopod's first intern, he wants to set a precedent and get a job. Sometimes he animates a little banner and sees it live on the Nike website that day. The instant gratification of seeing his work in the real world makes Andre question going back to school. Why is he getting a degree to find a job if he already has one? It seems stupid to accumulate more loans.

Svetlana laughs at the idea of dropping out and she is right. By the time Andre graduates, he will have a lot more connections, better work, a beard and a degree. Andre spends most of his time at the office, often showing up first and leaving last. Jacquie and Tim give him more responsibility. After the first month of working for $10 an hour, they give him a $5 raise. Another month is rewarded with another raise bringing his hourly to $20. Andre celebrates by buying a bicycle.

Soon enough August comes and Andre, Dan, Mike and Michelle start looking for a flat together. M&M find a big place a few blocks from their old apartment in the Mission. The house even has an empty back room where they build a screen printing set up.

GETTING AN INTERVIEW
IS HARD
—

LIST YOUR DREAM JOBS AND DON'T GIVE UP UNTIL YOU LAND ONE.

FIND THESE DREAM JOBS IN BOOKS, ON THE NET AND IN YOUR MIND.

SEND MAIL, NOT EMAIL.

FOLLOW UP YOUR MAIL WITH A CALL.

CALLING PEOPLE BACK IS YOUR JOB, NOT THEIRS.

STALKING SOMEONE IS NOT EXPRESSING INTEREST.

BE NICE TO THE PEOPLE WHO ANSWER PHONES.

NEVER ROLL UP TO PLACES UNANNOUNCED.

DO NOT GET FRUSTRATED AND SETTLE ON A CRAP JOB THAT'S LAME.

DESIGN AND PROMOTE YOURSELF APART FROM OTHERS.

PRACTICAL

Bob Aufuldish

Perhaps you remember this scenario from attending a football game in high school. Your team scores and the cheerleaders throw small plastic footballs into the stands. On each ball is an ad from a local business. When I was in college at Kent State, my internship was pasting up mechanicals of those ads at a local printing company. Because you aren't in design school in the early 1980s, you have the blissful advantage of not knowing what "paste-up" is. Believe me, contrary to what old-timer curmudgeons would have you think, you really aren't missing much. While this internship was not the least bit glamorous, I got to refine my stat camera skills (see paste-up above) and watch the high speed letterpress that used a bed of open flame to dry the ink as it came off press in what I now remember as a Beavis and Butthead meets Fred Goudy moment.

Luckily, a few semesters later I was invited to be in Glyphix, a program at Kent where a studio staffed by students designed work for local non-profits. This was certainly more in keeping with what I was interested in, although in those days before computers it seems — in my memory at least — that lots of time was spent waiting for the typesetting to be delivered (see paste-up, above).

After years of teaching I am still struck by this unspoken reality: all the weeks of effort put forth in the classroom getting ready for a final presentation is the work that would be done in a studio setting preparing for a first presentation. We need to remind ourselves of that from time to time. So, when I teach I try to critique students from a variety of viewpoints: the reality of their work in class; how things might be pursued differently in a studio situation; how it might be even more different in presenting to a client; and how design is an inherently iterative process that continues well beyond the first presentation. I try to keep the students aware of these shifting conditions as I critique.

In 1995 when I was asked to start a Glyphix-like studio practicum for graphic design students, I thought it would be a great opportunity to teach from these multiple points of view in a setting where the outcome would be especially clear. Sputnik, as the studio is known, started with two students in the fall semester of 1995 and has grown significantly since then.

Sputnik's only client is California College of the Arts (CCA). San Francisco has a wealth of design firms with a strong sense of community responsibility and it seems that every non-profit has a designer — the last thing I wanted was to take work away (often fun and rewarding work) — from our local colleagues.

Besides, I can't image a better situation than designing for CCA: clients who are pre-sold on the value of interesting design, who are visually sophisticated and, well...it's an art school.

In Sputnik, the students work essentially as freelance designers in that they're assigned projects individually and are responsible for the design and production of those projects. They present sketches and comps in class and once those are approved they present to the client. The presentations are chaperoned — either I as the faculty advisor or the College's director of publications are at the meeting to provide backup. Presenting is often a good wake up call because the kinds of convoluted explanations often used in studio classes just don't work. Sometimes I need to gently prod the students during their presentations ("Maybe you can talk about why you're using this image." "And orange is a good color for spring because...?").

Every semester, the faculty nominate students they think would make good Sputnik staff members. I ask them to consider students who are reliable, articulate and mature while possessing excellent typographic skills, the ability to self-author imagery and the aptitude to effectively process criticism. This is a dream list, really, because very few students possess all these characteristics. I think I'm missing a few of them myself. We interview everyone and look at their resume and portfolio. When it comes to looking at resumes, I'm a big fan of students who have the sense to run spell check. And here's a hint. A resume is a nice simple typography problem. If you can't nail the design of your resume then things are looking dismal from the start.

It's interesting how the staff comes together each time. I'm one of three votes. Erin Lampe, the Director of Publications and her assistant are the other two. And we don't always agree. Erin, because she has far more contact with the students and has deadlines and processes firmly in mind at all times, is attracted to more mature students who she can be sure will promptly answer their email. I'm often more willing to take a chance on someone whose design skills are outstanding but whose organizational skills are questionable. Neither of us, however, want to deal with prima donnas. Things happen too fast to have senseless arguments with people, and we have to consider our clients as well. The students will move on after the semester, but we work with the same people year after year. We're trying to build trust and rapport so that the quality of work can continuously improve. If someone's attitude endangers that we have a big problem.

Other designers often say they're looking for an employee who's a good fit. This can mean lots of things — someone whose skills complement those of the office, for example. But what they usually mean is that they want someone who fits within the office culture and personality. You spend more time with your co-workers than with your family. No one wants to spend the majority of their waking hours with some jerk, no matter how talented.

I think being in Sputnik and having this extraordinary degree of support and independence beautifully prepares students for the working world. Even if you don't have the opportunity to participate in a program like Sputnik, there is a larger lesson here. Not too many people get full time jobs straight out of school. Most of the time there's a stretch of freelancing before landing a job. Having freelance experience can expose you to the possibility that you might not need a "real" job anyway, and that perhaps there's another way to manage your career. Freelancing is a perfectly fine option, and a good segue to opening your own studio. I wish I had realized this back when I first moved to San Francisco. I turned down a chance to design music packaging with Tom Bonauro (a hero of mine to this day!) because I wanted a full time position.

Bob Aufuldish is a partner in Aufuldish & Warinner and an Associate Professor at the California College of the Arts, where he has taught graphic design and typography since 1991. In 1995 he founded Sputnik, a student-staffed design office that produces work for the College.

With A&W Bob has designed diverse projects for clients such as Adobe Systems, Advent Software, American Institute of Architects, Center for Creative Photography, Chronicle Books, Denver Art Museum, Emigre, the Logan Collection Vail, Moore Ruble Yudell Architects, San Francisco Museum of Modern Art, the State Compensation Insurance Fund. His digital type foundry, fontBoy.com was launched in 1995 to manufacture and distribute his fonts.

He has participated in a number of exhibitions including, "CCA at 100: Fertile Ground" and "Icons: Magnets of Meaning," both at the San Francisco Museum of Modern Art. He has lectured across the US as far east as New York and as far west as Honolulu. His work has been included in competitions and publications sponsored by the American Association of Museums, the American Center for Design, the American Institute of Graphic Arts, Communication Arts Magazine, Critique Magazine, Design Net (Korea), dpi (Taiwan), Graphis Magazine, How Magazine, ID Magazine, Idea, the New York Type Directors' Club and Print Magazine, among others.

Bob has a BFA and MFA in graphic design from Kent State University, Ohio.

QUESTIONS + ANSWERS

Are great designers born or made? If they are made, when do you know to stop learning and start doing?
—
Justin McDonald

Hey Justin.
We think they are made for the most part.

We got to where we are by working our asses off. Neither of us claim to be supernaturally talented, though Andre is pretty close. It took us time to hone our abilities (as you can see from all the crap work in this book). Going to one of the better design schools in the country didn't hurt, and we were fortunate enough to study with amazing teachers. There were a lot of kids in school who had more natural talent then we did, but they may not have worked as hard, been as disciplined, or cared.

Knowing what we wanted from design and having an idea of where we wanted to take our careers was huge. If you don't know what you want it's easy to end up designing credit cards, or the phone book. Creating goals big or small is a good way to avoid settling.

Also, we are good at presenting ourselves. If you can't sell yourself and your ideas you will end up working for someone who can sell them for you.

Then comes luck. Luck doesn't seem to strike if you are sitting around smoking weed and tripping off your screen saver. When you work hard people will notice and in turn you will get better opportunities and be surrounded by like-minded people.

What's the difference between thinking too big and thinking too small as far as concepts go?
—
Matt Rappo

This is an interesting question to ponder Matt. Thinking too small can be lame — the expected solution or doing what everyone else is doing. Thinking too big can lead you to a great idea, but it might be too hard to execute on time. Deadlines and budgets play a huge roll in the creative process when you get out of school. So it's all about coming up with the best solution within the constraints that are given, or rethinking or reframing the problem so it fits within new ones. Think big when you have lots of constraints to try and push the envelope of what is possible within the parameters, and limit yourself when you have nothing holding you back or else you might get lost in a sea of options.

6:06 PM
how many times today?
6:10 PM
2

2:20 PM
cahp 2 yet?
too much beating off
hahha
ah vacation
just give up and enjoy the sun
heh
is it a nice day
yeah
so i hear
nice
i am going to go on the deck in my underware

i cant stop thinking of her

are u in love

hah

1:50 AM

haha

to be honest i dont know what it is

i havent felt like this in a long time

but its gonna take a while for me to be a master

like years

i am up for it

just get through the book

mussie

i will

mussie

8:39 PM

8:40 PM

heh

ook angry

PROJECT M

Mark Fox told Dan about Project M, a workshop run by John Bielenberg. Dan didn't really have any other summer plans, so he figured, what the hell. He applied and a few weeks later was accepted. Project M cost two thousand dollars. This sounded a bit pricey for a design camp, especially since Dan was broke, but luckily, Dan's Dad agreed to pay for half.

Being in such a remote setting, away from civilization, was going to be hard as he had gotten used to city life. Dan had no idea what to bring, so packing every book and T-Shirt he owned seemed like a good solution. He stuffed everything into a giant duffle bag, big enough for a large man. Before Dan knew it, he was bound for Bangor, Maine, a town in the middle of nowhere where Stephen King lives. Christian and Jimm, two other M'ers from the Portfolio Center, picked Dan up from the airport in a minivan with a giant masking tape "M" on the hood. They recognized Dan because, apparently, he looked like a designer. This made Dan happy, since he had been trying to accomplish this look for years.

They drove even further off the grid and met the rest of the crew. Dan felt like a cast member from *The Real World,* except not as tan and, hopefully, not as crazy. The "M'ers" came from all over: Portfolio Center in Atlanta, SVA in New York, MECA in Maine and CCA. Dan and a girl, Rachel, were the only ones still in school. Like Dan, nobody had any idea what to expect.

After everyone went to bed, Dan looked at all their program applications, which were sitting on the kitchen table. Everyone else had gone crazy, creating custom packages and books filled with their work. Their applications were clever ways of introducing themselves. Dan had submitted a link to his website and a few lame sentences via email. He felt lazy and stupid for not thinking like the others. Their work was also a lot more "professional" than Dan's, and he became worried that they would figure out he was not talented.

During breakfast the next day, a tan mustached man in full spandex rode up on a small bike. John had moved to Maine a few years back to escape the rat race in San Francisco. He'd spent about 20 years in the game, but operated on another level now and acted as something of a spiritual advisor to a San Francisco design shop, where he is a partner. Before he left San Francisco, John created annual reports, videos and collateral for a fake company called Virtual Telemetrix as an outlet. It was a way for him to mock and challenge the work he was making for clients. He was questioning the

role of design in our society, specifically design in service of corporations.

To Dan, Project M seemed like an extension of John's Virtual Telemetrix projects, a venue for John to share his experiences and philosophies with young designers, so that they could learn from his mistakes. It was a place to question the status quo and your individual process of working and, maybe, come to a realization that there could be more to design than annual reports. It was also a place to drink lots of beer and eat lobster (unless you were Nic, who was dangerously allergic).

Advisors would come to visit the group periodically and throw a wrench in the process. Dan loved spending time with Laurie Rosenwald and Art Chantry. Laurie was from New York and drew stuff. She was also probably one of the funniest people Dan had ever met. Her workshop began with everyone putting on giant garbage bag outfits and doing quick doodles inspired by crazy words on giant sheets of butcher's paper. Dan felt silly in the garbage bag suit, but it helped protect his all too precious T-shirt. Laurie wanted everyone to realize that drawing was not about literal representation or feeling silly. It was more about what they each brought to the table, even if they were crap drawings.

These drawings were used as jumping off points for solving rapid design problems. Working fast and without worry was very liberating. Dan would often agonize about making decisions, creating multiple variations of the same thing with very little difference between them. He needed to trust his intuition more and give into his analness less. This was what Eric had been trying to beat into him, that making macro strokes rather than worrying about micro details saved time in the early phase of a project and lead to spontaneous solutions. Dan could barely spell spontaneous (just now he even spell checked it).

Art Chantry had spent most of his career designing for bands in Seattle. He could be credited with creating an aesthetic and a whole movement in graphic design. He learned from lowbrow art: comics, porn mags, Sears catalogs, and was a walking encyclopedia of design. He loved being the underdog and had no desire to kowtow to corporate interest or stylistic trends.

Despite not "selling out," Art had done well for himself over the years, but he wasn't living insanely large. Being exposed to Art made Dan question what he wanted. Would he rather hold onto his ideals, grind it out and create work he loved and that was creatively fulfilling, but not necessarily lucrative? Or do work that he was not totally passionate about for some serious cash? He hoped things weren't this black and white.

The first few weeks of Project M were more about getting to know one another and learning how to work as a team. The

WORLD

only goal was to produce an artifact from their month in Maine. This was a learning experience, to say the least. The M'ers would sit around in a group and brainstorm for hours. Beer, liquor or John's anecdotes usually fueled these sessions. He was a great storyteller and everyone felt his "presence" when he walked into a room. His stories were usually about other designers, cool things done by artists, his experiences with clients or Stefan Sagmeister.

Over the years, John had devised a method called "Thinking Wrong." This was a way of challenging the natural process designers rely on to generate ideas. Our minds are trained to work a certain way, and once our way of thinking yields positive results, we repeat the process over and over. If our innate thought process usually takes us from point A to point B, what would happen instead, if we consciously threw a wrench in the system to take us from A to point G? It would probably yield an interesting or different result than we were used to. This result could be complete crap, or it could be genius. Regardless, it would be very different from anything that we created rationally.

The M'ers kept coming back to the idea of how to document their experience. A book seemed like the natural answer, but was also a somewhat stock solution for graphic designers wanting to tell a story. How could they "Think Wrong" about a book, about its form and about how it communicated?

Christian and Jimm woke up earlier than Dan and had been taking frequent walks around town. On one walk they met an old lady named Alice with a trailer home filled to the brim with arts and crafts. Totally isolated from society, she made crazy shit like pirates out of wine corks and paintings. Alice gave them a sculpture she had created by folding magazine pages to make a Barbie doll skirt. Regardless of how creepy it looked, her doll sculpture turned out to be the prototype for how to Think Wrong about a book.

The end result of Project M was a book of black and white photographs taken by the M'ers throughout their stay in Maine. None of the shots were amazing, but a few were slightly compelling and they served as a pictorial narrative of the month. But when the pages were folded like Alice's sculpture, "Think Wrong" was revealed, illustrating the idea of destroying a convention to find an answer (or make a cool skirt for your Barbie). John took the piece up a notch by sending out an email asking if everyone thought the book was relevant enough to be printed. He published their answers on the front and back covers.

Dan left Project M feeling enlightened. He had grown fond of John, who had imparted a lot to them from his years in the field. For sure, it forever changed the way he thought and designed, but Dan was not positive their book was more than design masturbation. Maybe the piece was successful just because it was a conversation starter? This was something John often talked about, asking how many good

SHOW UP ON TIME AND SOBER.

KNOW THE PEOPLE YOU ARE
MEETING WITH AND WHAT THEY DO.

DON'T DRESS UP TOO MUCH OR
DOWN TOO MUCH.

MR. ROGERS SAYS FIRST
IMPRESSIONS LAST.

TAKE NOTES.

FLATTER IF YOU MEAN IT.
DESIGNERS ARE EGOMANIACS.

TREAT THE INTERVIEW AS
PRACTICE EVEN IF YOU DON'T
WANT THE JOB.

DON'T MAKE EXCUSES OR
APOLOGIZE FOR WORK, IT
IS LAME.

MAKE FUNNY JOKES, IF PEOPLE
LIKE YOU THEY WILL REFER YOU TO
OTHERS.

BE VERY CLEAR ABOUT WHAT
WORK YOU DID.

BRING PRINTED SAMPLES, BUT NOT
GIANT OR STICKY ONES.

HAVE QUESTIONS READY FOR THE
ASKING.

IT'S A SMALL WORLD AFTER ALL.
DON'T HATE ON OTHER PEOPLE.

BEING INTO THINGS OTHER THAN
DESIGN NEVER HURT ANYONE.

EVERYONE LIKES CONFIDENCE,
NOT COCKINESS.

REMEMBER THEY ARE HIRING YOUR
PORTFOLIO AND YOUR YOU.

LEAVE STUFF BEHIND. IT'S SMART.

SEND A THANK YOU.

JOBS TAKE TIME TO GET.
(KEEP IN TOUCH.)

pieces of design have stories behind them. They can communicate and function if you don't know the story, but if you do they're even more successful and the message spreads like a legend, having a life beyond the work.

XLARGE

Project M only lasted a month, so Dan needed to plan for the rest of the summer. Something different than his internship at Vehicle and time with Sputnik seemed like a good idea. He had started looking into options midway through the previous semester. Dan's obsession with street art had introduced him to the work of Shepard Fairey. Shepard owned BLK/MRKT with Dave Kinsey, the creator of Dan's favorite logo, the one for DC Shoes. Dan applied for an internship, but didn't get the job.

Instead of sending hate mail to BLK/MRKT, Dan reached out to Xlarge, a clothing company partially owned by Mike D of the Beastie Boys. Dan rocked their tees as a kid, and became reacquainted when he saw photographs of their office in a design book. The walls were covered with tons of cool shit and it looked sunny. Dan took a long shot and emailed a url of his work to the general email address on their site. Luckily, he got a response the next morning from a friendly woman who passed Dan off to Jason, a senior designer. Dan was still nervous about making business calls, so he waited till lunchtime. His lame plan worked and he left a message for Jason who he'd figured would probably be getting a sandwich. Then Dan kept calling every few days until he got a hold of Jason, who passed Dan off to the Creative Director and owner, Eli.

Dan called Eli a few times in one week, but didn't hear back. So he kept calling — for three weeks. When they finally talked, Eli joked that he was going to hire Dan just so that he would stop calling. Dan suspected he might be serious and Eli agreed to pay Dan two hundred fifty dollars a week for his work. A calculator helped Dan figure out that this hourly rate was laughable. It didn't matter, though, because Dan wanted the experience and wanted to work for Xlarge. Interning was all about taking chances and testing different jobs, so he would have a better idea of where he wanted to start his career and how to harass people into giving him a job.

Xlarge was in LA, where, coincidentally, Dan's former frat bro, Derrick, lived and sold caulk. Dan asked if Derrick would mind a 6'3" man sleeping on an air mattress in his living room for the summer. Derrick was chill and would give his pants to someone on the street if they asked, so he didn't care.

Eli took Dan on a tour of Xlarge's office. From the outside it looked like any other corporate building. Inside it was filled with tons of shit piled in boxes, hung on clothing racks and stuck on the walls. The building was sectioned off into departments; graphic design, sales,

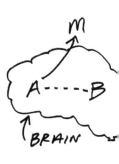

marketing, fashion design and a place for the people who made samples of the cut and sew clothing. This fascinated Dan since he had never before stopped to think about how clothes were made. However, it seemed like there was a bit of a miscommunication. Eli thought that Dan was going to stay for a few weeks. Dan thought it would be a few months. They decided to play it by ear and Dan started working (after he embarrassingly had to ask Eli how to turn on the brand new iMac). Like Vehicle, it all began with a menial task. This time it was making tiny vector drawings of all their clothes for line sheets.

Dan's life in Los Angeles was very different than it was in San Francisco. In LA he was super relaxed with nothing stressing him out. Xlarge was work, but nothing like the amount he did in school. And when he took stuff home from the office, it was fun, like designing T-shirts. Dan spent the summer doing things that people in their twenties do, like hanging with friends and getting wasted. Despite his having to bring girls home to an air mattress, life was great.

In school, Dan was surrounded by design snobs. At Xlarge nobody had gone to school for graphic design, they just did it. Dan laid out a catalog for their spring line. Even though it wasn't the most stellar design, it was refreshing because nobody really cared if the type was too big or wanted to argue the finer points of Helvetica versus Akizidenz. They just wanted to make funny T-shirts that they'd wear. This was a nice contrast to CCA and Project M, where everything needed to have meaning.

Dan's last week in LA, his friend Bonnie from school put him in touch with a girl named Signe who had graduated a few semesters before. Even though Signe was much older, they went out to a party and were attached at the hip for the rest of the week. Dan drove back to San Francisco, missing Signe and unsure if he wanted to be a design student again. He contemplated turning his car around, but Dan's parents would never let this fly. A week later he got a call. Signe was coming up to San Francisco for a job interview. Dan invited her to stay at his place for the weekend. The weekend turned into seven months.

To keep his relationship with Xlarge, Dan sent them a few designs every once and a while. One was inspired by the instructional drawings from an IKEA catalog that came with Signe's dresser. Dan Photoshopped the little diagram man putting together boxes in the shape of an "X" and an "L." Eli loved the design and wanted to put it on the cover of their catalog. Dan was excited and got four hundred much needed dollars. He couldn't wait to see it printed. The excitement faded when Dan got samples of the tee. They had changed Dan's design to make it "hipper." Someone put a bong next to the guy, who was now kneeling in a puddle of his own pee, speaking about being a twat and using poor grammar. Dan was glad he decided to go back to school and this would be the last time he sent designs to Xlarge.

COLLECTING MATTER: ADVENTURES IN MAGAZINELAND

Cara Brower

I'm a big believer in the power of friendships. When you have a best friend and you are both passionate about what you do creatively, you can achieve anything together. It's like an unstoppable force. Or, at least, that's what it feels like. Rachel was my best friend in design school at the University of Cincinnati. She was in Industrial Design and I was in Graphic, and we were full of enthusiasm, passion and naiveté — the perfect combination for taking on anything.

It was the Christmas break before the last stretch of design school when I got an email from her. "Hey," she said. "Got an idea for my thesis project. I want to make a proposal for an eco-design magazine. But not some old green granny crap. Mega dope shit." Now, somewhere along the way, we scaled this idea up. Way up. No longer was this a mere thesis project but, instead, a full-fledged independent magazine launch. And why not? The concept was to launch a hip magazine for a generation of young, fresh designers that highlighted the most imaginative design. It also had to be eco-conscious. But not all in your face about it, simply using eco as a regular quality of good design.

In our minds it was a win-win situation for everybody. We could spread the word about cool young designers of our generation while mixing it up for the audience and advertisers by throwing in a few big peeps *and* making the world a better place through green design. During the process we got to skip working for the man by starting our own business. We were still at university, but in our minds we were sipping margaritas on the roof of our Brooklyn office. Genius.

BUILDING THE FOUNDATIONS
Because neither one of us had any magazine or business experience, or THAT much practical experience, period, this was going to be a ground-up operation. But we weren't about to let lack of "experience" knock us down and, besides, how much *experience* does one really need?

So Rachel and I created an identity for our magazine concept by figuring out who our audience was, who the competition was, and other ad-agency/business-y stuff like that. After a few grueling sessions on thesaurus.com,

we christened the magazine *Collected Matter,* a name we thought sounded interesting, straight-forward and not all in-your-face about being eco. I'm terrible with numbers, budgeting and checking my account balance, so I was stoked that Rachel was on top of all that. Not that she was a business-planner extraordinaire, but her dad's friend was a lawyer (somehow that was enough).

With a registered name and identity behind us we were now in full-fledged business partner mode. Behind the television in the living room we set up our "office," which consisted of a plastic table with two mismatched plastic chairs. We were in overdrive and spent more and more time in the apartment, leaving only to hit essential classes and the grocery store. We were starting our days at 8 and working til 1 or 2 in the morning, not even taking time to get out of our pajamas or brush our hair. We were feeling big time.

A LITTLE STRENGTH
With the addition of each contributor, we became more and more confident in our concept. We were gathering tons of material, but knew we had to get on the ball with the actual publishing part. We needed a little *Strength*.

Strength was a skateboarding magazine that a few of our friends had worked for in Cincinnati. It had started out independently and was distributed nationally, so we thought, "these are the guys to get some advice from." Jeff, the intern-turned-editor who'd seen it from its beginnings, turned out to be amazingly helpful. He had tons of advice and answered all of our zero-experience questions without making us feel like idiots. He pointed us in the direction of a few good printers and told us how to figure out ad rates, etc. He even gave us a few dirty little tricks of the trade for beginners. His final words to us: "Best of luck and keep me posted! And hey, just so you know, this magazine stuff… it's pretty damn tough! I'm serious. Make sure you are really, really up for this… It's going to be hard as hell." I had no idea.

85 GRAND
Our next mission, in the fun world o' budget land was to find out our printing costs. Fair enough. Now, part of the whole concept of this thing was being eco-conscious

so, obviously, this magazine had to be, at least, printed on recycled paper or the whole thing was going to be completely hypocritical. We wanted the whole eco shebang — non-toxic soy inks, wind-powered presses, that melty-biodegradable paper. I made up my dream list and got in touch with an eco printing rep in NYC. We were going to go for a 10,000 to 15,000 copy launch — all eco friendly. And then I got the numbers back — an $85,000 quote! Four times a year!

Needless to say, our jazzy printing rep in NYC didn't hear from us again. We were moving on and cutting costs. Yes, we were shipping our business to good old Bob in Ohio. And maybe we could get some recycled paper with that? 40% recycled? Well. That's better than nothing.

EXCELLING
Rachel had Microsoft Excel on her machine and I didn't. Therefore, she was going to be in charge of this business-y stuff. We'd gotten our printing quote way down to what seemed like a semi-reasonable amount. We'd figured out our ad rates and now it was time to get down to business and sell some of these bitches.

I couldn't recall in my mind how many times Rachel and I had had these conversations. "I mean, Nike, right? They are *all about* trying to eco up their image. I mean, they'd be so into this!" In our minds, we'd just pick up the phone and they'd already be on the other line with a blank check in hand. Later, after we'd called up every ad agency in America, we realized that people in business really were just that, in business. Maybe the CEO of these corporations cared about going eco, but Joe Schmo working the link in the chain closest to the telephone did *not* care about helping some first-time magazine. In a matter of weeks we had worked our choosy list of cool, eco-friendly corporations down to the recycled toilet paper brands. We had sold zero ads. Something needed to give.

DADDY WARBUCKS
It was a Friday afternoon and we had just gotten the last polite "no thanks" from our now-exhausted list of potential ad buyers. "What the Hell?" we thought. It had been half a year since we had blasted full-force into our project, investing an incredible (and over-achieving) amount of time and energy into our magazine endeavor. We had an amazing collection of contributors, everyone we'd asked had said, "yes," no matter how big time they were. We didn't get it. Well, we did: we had the skills, but when it came down to it, we couldn't pay the bills. How the hell had *Strength* done it? Well, we'd found out that there had been a Daddy Warbucks. We did not have a Daddy Warbucks. Yet. Now that I recall this dark, dark period, I am sure that this was the closest to "losing one's grip on reality" as I have ever come.

The last granules of our dream were slipping through the cracks of our fingers. I didn't see the bright lights and big magazine surrounding us. Instead, I saw Rachel's messy pack-rat room. We had to do something; we couldn't let all of our contributors down. Well, it was partly this, and it was partly fear of failing in general. All the work was done, we just needed someone to publish it! I mean, they didn't have to *do anything* except fork out the money! But, who in the hell could we sell this thing to?

OUR COMPETITOR
Our so-called competitor? Maybe, just maybe, they would be interested in launching a younger, hipper magazine. So we dug up a copy of their magazine, looked in the table of contents, dialled the general number and asked for the big cheese. Was it really this easy? Yes. Yes it was.

And they really listened! They ended the conversation with "Well, it sounds like you have a really good idea. I really will think about it and thank you for thinking of me."

When Rachel hung up the phone we knew we would not hear back from them. Nor would we follow up because we had hit crazy level. It was time to get the hell out of the house and so we got dressed for the first time in weeks and took a walk. "I don't know, Cara, I mean I don't know if I can handle this! *I need health insurance.*" Good old health insurance. Whenever Rachel was having serious, SERIOUS doubts she brought up the old health insurance. I knew this was probably the end of our adventure in magazine-land. We had given it every last shot and for some reason we had hit wall after wall after wall. We needed to throw in the towel and admit defeat. Graduation was coming soon, so we decided just to enjoy our last week and then focus on getting REAL jobs. *Real* jobs. With health insurance.

BUT
But, of course, I knew we couldn't REALLY give up. So we gathered up all of our "collected matter" into a book proposal, just to see what would happen and, like magic, I found the way around the walls. It was like realizing that you just had to turn left and you wouldn't run smack into the crash barrier over and over and over again. So, *Collected Matter* became *Experimental Eco Design* and two years later was published all over the world by Rotovision. Of course, we worked nights and weekends getting it all together (after working our day jobs, Rachel's with health insurance*), and going a little crazy in the meantime—but that is another story alltogether.

*Cara still has never had health insurance, even though she has worked real jobs now for several years.

Cara Brower randomly ended up in the graphic design program at the University of Cincinnati, mainly because it was the nearest big city to her small hometown in Kentucky. She was very excited when she later realized that it also happened to be a really good program. With its unique (and extremely long) 5 year co-operative program, Cara was able to gain a range of work experience with Doyle Partners, Landor Associates, Stoltze Design, Paul Sahre and Open. After graduation, Cara returned to NYC to work at Scott Stowell's Open as a certified designer. Since then she has also worked at MTV and Nickelodeon and in 2006 published "Collected Matter" as "Experimental Eco-Design," with Rotovision. By the time this book has been published, she will have attended even more school and received her MA in Production Design at the Royal College of Art's National Film and Television School. She may, or may not, still be living in London.

PEE AND BAD GRAMMAR. NEITHER ONE OF THESE WERE MY IDEA. - D

ONE OF THE FEW SHIRTS OF DAN'S
THAT I WOULD BUY. - A

103

Project M 2007: Desmus Berry, Aaron Conreras, Brian Hurewitz, John Cordesman, Christina Watho, Alina Wheeler ...

Dear Project M designers:

The production of this book represents a huge effort and expense.

Two questions.

Is it significant enough to warrant this effort?

Or a self-serving one joke gimmick?

Best,
John

The actual content of the book certainly is self-serving in a sense. (Who would want a "photographic monograph" of us?)

However, I do think the importance of the book is in the truly original format. The story behind how that format was reached, and how the book says a great deal about graphic design without it being designed.

Taking away the photographs, the book's format has a unique statement to make. It tells a story of process (clawing our way through all the ideas). It tells a story of economy (being inspired by the indigenous environment). And it is interactive: not only physically, but it invites you to experience the sense of the struggle we took part in during our month.

Most importantly, we make the reader make the first step. There is a leap of faith that is required when the reader makes the first nasty crease in the page to decode the message. They have essentially "ruined" the book in the old sense. But they have in fact thought wrong. We have used the book to get them to go against their logic, and make a little magic.

Yes I am biased. But I truly believe the book makes a very fresh statement. I

WHAT HAPPENS WHEN SEVEN DESIGNERS ARE PICKED TO LIVE IN A HOUSE, WORK TOGETHER AND HAVE THEIR LIVES TAPED? FIND OUT WHAT HAPPENS WHEN PEOPLE STOP BEING POLITE AND START GETTING REALLY CYNICAL ABOUT DESIGN. - D

105

THIS POSTER MAKES NO SENSE TO ANYONE BUT ME. CAN YOU TELL WHAT THE TERTIARY LEVEL OF COMMUNICATION IS? - D

certainly is
would want a
of us?)

portance of the
nal format. The
format was reac
s a great deal
out it being des

photographs, th
nique statemen
y of process (cla
the ideas). It tel
being inspired
ironment). And
physically, bu
ence the sense
part in during

ost important
make the first
that is requir
the first na
the mess
the boo
in fac

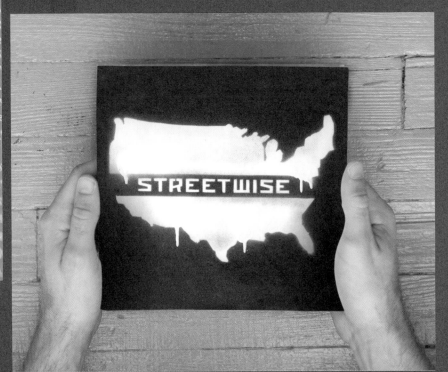

STREETWISE

RELATIVITY IS A HARD CONCEPT TO UNDERSTAND OR ILLUSTRATE. - D

106

THIS IS THE LAMEST THING ANDRE HAS EVER DESIGNED. - D

IT'S OKAY. IT'S A BAD IDEA, BUT I STILL PRODUCED IT. SOMETIMES I FEEL LIKE I JUST NEED TO GET THE BAD IDEAS OUT OF MY SYSTEM. - A

IN SCHOOL I WAS OBSESSED WITH MAKING SCREENPRINTS OF NINTENDO ICONS. WHEN I GRADUATED, TO FLUSH OUT MY PORTFOLIO, I PRETENDED THIS WAS A PACKAGE FOR AN ACTUAL BAND. IT WASN'T. - D

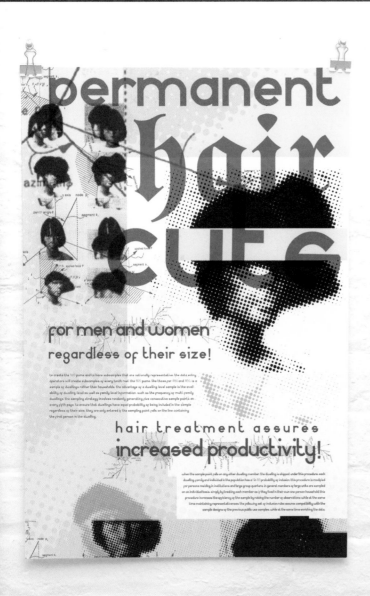

permanent
hair
cuts

for men and women
regardless of their size!

hair treatment assures
increased productivity!

ONE OF MY FAVORITE COLLEGE POSTERS. A BIT TOO CONCEPTUAL TO MAKE SENSE. THE ONE ON THE RIGHT IS AN EARLIER VERSION. - A

otobooth lies

ancille
the flash and hum

woj016

THE BAND ANCILLE WAS MY FIRST
ACTUAL CLIENT AND THIS WAS MY
FIRST REAL PROJECT. I SPENT ABOUT
SIX MONTHS MAKING THE CD AND A
SITE FOR THEM. SINCE A LOT OF MY
GOOD FRIENDS WERE IN THE BAND
I WAS SUPER WORRIED THAT THEY
MIGHT NOT LIKE IT. I HAD A HARD
TIME COMING UP WITH THE COVER.
MOST PEOPLE THINK THE BOOKLET
ILLUSTRATIONS ARE MUCH BETTER
THAN THE COVER. - A

I ENDED UP REUSING THE SAME
TREE ILLUSTRATION FOR A BUNCH
OF THINGS, LIKE THIS POSTER. - A

THE NEW MEDIA

ODOPOD

Andre starts to take on more and more responsibility at odopod. From picking new music for the office to handling little design tasks, Andre makes sure he is constantly busy. Jacquie and Tim take notice, and soon he is a vital part of the team. They want Andre to work as many hours as possible, which is a blessing and a curse. It's good to have steady money for the rent, so he won't have to rely on Mom. But it's not so good that Andre is less focused on his school assignments. He begins to think that doing work for actual clients, like Nike, is much more important than his fake school projects.

After working on banner animations, updating sites and fetching lunch for everyone. Andre is ready to tackle a project on his own. It's the redesign of a website for a music company called Winamp. He works with another designer named John who rides a lime green bicycle. They both design concepts for the site. Andre labors over the whole home page: the navigation, the layout and the design. John just shows little elements like simple icons and collages. Without doing much work, John creates a visual look for his site, while Andre bites off too much and gets criticized on his concept's look. Tim, Andre's boss, works closely with Andre and, after a week, they pat each other on the back feeling strongly about the site's direction.

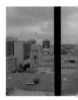

Its time to show the client, and Tim brings Andre to the presentation, introducing him as THE designer of the project. He starts explaining the direction of Andre's comps, but Winamp hates it. The look is too kiddy and doesn't appeal to their core users — nerdy dudes who like shiny things and aliens. Tim nods and turns to John's comps. They like this direction better and Tim nods again. Andre comes out of the meeting confused. Why didn't Tim stick up for Andre's idea? Andre often had to fight and defend his ideas in school — was "real life" this weak? Later, Andre realizes that Tim was doing the smart thing and running a successful business, choosing his battles carefully.

John ends up designing the rest of the site and Andre learns that sometimes it's easy to forget the core purpose or audience of a project. He often tricks himself into thinking an idea is brilliant when, in reality, it doesn't communicate anything to anyone but himself. Later Andre starts asking for Dan's advice and his work begins improving tremendously. To this day Andre gets bad ideas (which, to him, seem amazing) on a regular basis. He still shares them with anyone, even non-designers and girlfriends, for their opinion.

Andre is moving up and gets an opportunity to spend a few weeks concepting for one of the biggest projects at odopod, a site for Nike Skateboarding. None of his ideas end up making it. Instead he works on specific sections of the site. With Tim's direction, Andre makes a mockup of the skaters as interactive dolls in urban environments. Andre gets on his bike and starts taking photos of grimy streets in San Francisco. The client likes the idea and coordinates a photo shoot where Andre enjoys feeling important and gets to hang out with some of the world's best skaters. He begins to feel not-so-important when he realizes most of the skaters are younger than him and are close to being millionaires.

Andre quickly realizes that aesthetics are important, but having ideas and an ability to art direct will take him further. Most people can make something pretty, but not too many people have clever ideas that communicate. If Andre wants to get anywhere in the design game he will have to focus on coming up with better concepts, or he will be stuck working for someone who can think of them for him.

When everyone at the studio has their hands on a project it usually leads to a Frankenstein, made of bits and pieces of everyone's ideas. Andre likes having ownership, but this is hard to get while part of a big team. Odopod is growing fast and they begin hiring more and more people, expanding from five to thirty in less than two years. Because of school, Andre's job falls on the back burner and he isn't there all the time. Many of Andre's old friends don't come back and a new crew of freelancers start revolving. Coming in only a few days a week, Andre doesn't feel like he is contributing anything meaningful, except money to his bank account. Before long, work starts feeling like a chore and getting his degree seems more important.

WORK FOR MUSIC

Dan shows Andre how to screenprint on the set up they build in the back of their house. Soon he is hooked and Andre wishes he had learned how to print earlier in his education. Screenprinting gives his work a credible look and the tactile colors are extremely vibrant compared to laser and inkjet prints. This process changes the way Andre designs and he begins thinking in solid colors and vector shapes, which are easier to reproduce with screenprinting, instead of gravitating to four-color collage and photography like before. This helps simplify his concepts and forces him to make more economical choices with form and color.

Andre's good friend Kelly from high school asks him to create a limited edition CD package for a band he's in called Snow Cuts Glass. As always they don't have much money so they ask Andre to make something they can produce themselves. Kelly gives him some creative direction: they like birds. There is no apparent reason for this direction, so Andre decides to ignore it. His first idea is to make icons that represent snow, cuts and glass. The icons are clever, but too boring.

There is a song on the album about driving down the interstate in Washington, so Andre decides to recreate the Washington state map and have lyrics running along the roads. The songs would be scattered around the map and on the back there would be a key. Since many of the lyrics talk about finding connections in relationships and long distance separation, it makes perfect sense... to Andre, at least.

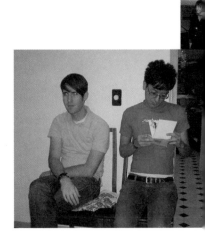

The band likes Andre's map idea and now he has to screenprint 200 booklets. Each booklet is 2 sided and each side has 2 colors. This equals at least 800 pulls on the screen. 10 hours later, Andre and Alison are tired. The printing makes a mess and Andre promises never to do something like this again. Dan is unimpressed by the look of the album and makes fun of Andre for agreeing to produce it. But Andre is happy he went through this process for such a specific concept. He photographs the package, taking a bunch of different angles and close-ups for his website. Dan is impressed that Andre can make such a bad project look really cool just by taking nice shots at odd angles.

SPUTNIK ONE MORE TIME

After a recommendation from Dan, Andre is invited to join Sputnik. He is excited to do some real print work and gain experience with both the studio and with Eric Heiman, who is teaching. The person who runs the operation is Erin Lampe. She has a behind the scenes role and is good at making things happen. Erin is always in a rush, but never misses an opportunity to stop and chat. Andre's big project is to design a small Financial Aid guide with roughly 20 pages of copy. It's the first and only time he has to deal with so much typesetting in his entire graphic design career. Eric only lets designers use 10 typefaces. At first, Andre is pissed, wondering why Eric wants to stifle his creativity. But eventually he becomes very fond of the faces and enjoys working with a limited selection.

The booklet is almost done and Andre still doesn't have an idea for the cover. He stumbles upon a Belgian firm who does rave flyers, and one of their flyers sticks in his brain, an illustration of an orange cut in half. Andre proposes 3 different covers, one of them using a drawing of an orange cut in half. Eric likes the orange and it soon becomes the cover, but Andre feels uneasy about ripping the illustration so blatantly.

Most of the time Andre jumps on the computer and starts making stuff before he has an "idea." This works out fine for things like music packaging, where the concept can be anything, but doesn't work so well when he has to communicate a clear idea. It's a time consuming way of working, since coming up with a perfect composition may take hours, days or even weeks. If there isn't a deadline, Andre has a hard time knowing when a piece is finished or when he should stop working. To help him speed up this backwards process, Andre starts making an image library to

BITS ON CRITS: A PRIMER TO GETTING THE MOST OUT OF YOUR CRITIQUES (REVISED)

Eric Heiman

As a student, I learned the most through engaged and passionate discourse, not isolating myself in a studio or the library. While the joy and struggle of making design is usually a solitary and internal experience, the process of understanding and making sense of what we create happens in the discussion of the work with others. This discussion happens in the arena of the critique.

You know the scenario: The class is huddled around the work on the wall, giving it the once over. Then the instructor says, "Any comments?" Dead silence. Eyes wander, looking for the one person brave enough to start. Finally, a lone voice breaks the tension and comments on the piece in question. And then — as if this person's bravado is a contagious airborne virus — a discussion has begun.

So *speak up as much as you can*. The excuses that I've heard for not speaking up are many and uniformly weak: "I hate the way I sound when I talk." "I don't have anything to say." Or "I hate those people who are always speaking up." The ability to verbally comment on design is a skill almost as important as creating the work. Inevitably, the quest to create great design depends on your ability to clearly and compellingly present the work — whether to an instructor, boss or client — and then to also be critical of its failings in order to make it better. There's no place more apt than the critique to practice and hone these skills.

Be honest. Give praise where the praise is due, but acknowledge weak areas as well. No one takes criticism well, but this process is about making better work, not making new friends. An effective way to approach honest criticism is *the good first, the bad second and humor all around*. Starting with positive aspects of the work being discussed usually helps any negative comments go down a little smoother. Design is a serious endeavor, but critiques don't have to take on a solemn tone. Humor and brevity help the person whose work is on the chopping block to relax. By endearing yourself to the presenter, he or she is more likely to listen to what you have to say. "While I don't love the image you used in the poster, you must have almost gone blind trying to hand set all that cool little type!" Laughter and sighs of relief ensue.

There is speaking intelligently and clearly, and then there is speaking to show off and exclude. We're in the communication business. No one benefits if your goal in commenting is to show off your advanced vocabulary skills and obsession with obscure postmodern theory. Critiques are about helping each other. This doesn't mean you're anti-intellectual, but is about speaking as smartly AND inclusively as possible. Don't make an analogy to an obscure Jean Baudrillard theory if you can instead cite an example in everyday life that is equally insightful and helpful.

Just because a fellow student made a comment about your work doesn't mean it's a good comment. Is your instructor's word the design gospel? Hell no! Stick up for your work. Yes, your instructors know more than you and have more experience. Yes, maybe that fellow student had an interesting point about your choice of typeface. But they impose their personal biases on your work whether they mean to or not. Challenge their assessment if you feel strongly that your design decisions are sound. Your reasons are as valid as anyone else's. The range of subjectivity involved in design begs for you to stick to your guns. Everyone's opinion can be disputed, even the instructor's. Your confidence is vital to convincing others that your ideas deserve notice. Avoid being too overly antagonistic, though. It's good to have allies in class, and your instructors deserve respect for their professorial status. No one is out to get you in a critique as much as it might feel that way at the time.

Lastly, your critique is your critique. So, direct it like a movie. Take control. Pass out a nicely designed project statement to everyone at the critique. If you want your work to be presented in an unconventional way, reserve that large wall space or courtyard outside. If a short interpretive dance will enhance our understanding of the project then screen a filmed excerpt or perform it yourself. The work is yours. Make your own show of it, too.

Starting in the hunter-filled woods of rural Pennsylvania, Eric Heiman embarked on a labyrinthine journey through the Carnegie Mellon architecture program, late nights of DJ spinning, record store employment and week-long vows of silence in the mountains of Maui that eventually led him to design school in the Bay Area. At the dawn of the new millennium he founded Volume (www.volumesf.com) with Adam Brodsley. Volume's work has been extensively exhibited, honored and published around the world, and Eric's writing on design has been published in Emigre, Letterspace and the AIGA's online journal, Voice. Eric is also a Professor of Design at the California College of the Arts.

LOOK FOR INTERNSHIPS
MONTHS IN ADVANCE.

SOME SCHOOLS HAVE
INTERNSHIP PROGRAMS, YOU
DON'T HAVE TO RELY ON THEM.

TAKE ON MORE
RESPONSIBILITY AND YOU WILL
BECOME ONE OF THE TEAM.

LOOK BUSY AND ASK PEOPLE
IF THEY NEED HELP DAILY.

EITHER GET MANY
INTERNSHIPS OR STAY AT A
PLACE FOR A WHILE AND
WORK YOUR WAY UP.

DESIGN EVERYTHING WITH A
SMILE. EVEN TOOTHPICKS.

PEOPLE LIKING YOU MIGHT BE
JUST AS IMPORTANT AS YOUR
WORK.

WORKING HARD PAYS OFF
EVEN IF YOU DON'T GET PAID.

SOME PEOPLE HIRE THEIR
INTERNS.

BOSSES CAN WRITE YOU A
LETTER OF RECOMMENDATION.

INTERNING HELPS YOU FIND
WHAT YOU WANT.

pull from. He collects found photos, old drawings, rejected designs, textures, wallpapers and brushes. Then when a project comes in, he is ready and can start pulling from his collection.

Andre decides to get more print work. He likes working on art projects for Sputnik and contacts local art galleries, offering his services for free. One of them, Southern Exposure, comes back with a possible project. It's a group show called Epic. Group shows are a rarity at the gallery and the curators want something new. After brainstorming for a long time and not coming up with anything, Andre turns to annuals for inspiration. He comes across a simple type poster depicting a giant 3D letter floating in space. It definitely looks very Epic. Andre likes the challenge of using a simple, iconographic symbol — something he's never done before. He renders the word EPIC in a similar fashion and sends it to Southern Exposure.

Southern Exposure is not impressed with Andre's solution. They are used to having their design look artier, maybe even a little crafty. Andre sticks to his guns and reassures them this is the right way to go. Since they aren't paying him anything, Andre figures he can say what he feels. They end up conceding and he designs the announcement, call for entries and wall signage. Andre is happy to have defended his idea and to get another actual piece in his portfolio. He doesn't receive any more calls from Southern Exposure.

Andre decides to submit 15 slides to *CMYK*, a magazine featuring student work. He gets a call from Curtis, the editor of *CMYK*, a year later and learns that one project will be published. Andre is more than happy. It's the first time his work is validated by anyone who doesn't actually know him. He calls his Mom and Ali. On the day of the release, Andre runs to the store to buy some copies. He finds the issue and quickly flips to his work. It's one of the books he did for Max's class and it has the whole page to itself. The only problem is that Andre's photos look washed out. Damn you, film camera! He swears to never take slides of his work again.

PORTFOLIO DAY

Every spring the local AIGA chapter organizes a portfolio day where students can show their work to prospective employers. It's the only event of its kind in the Bay Area and students from all over California show up. Most of them carry around huge wooden portfolios and some dress in suits with shiny shoes. Andre has a small portfolio, which he bound himself and some screenprinted posters. He wears Nike's. He signs up to see his three favorite firms, but will see only one — Battic. The other two are a small studio called Paper Plane and the National Forest and Park Association. Since not every student can get their top three firms, the AIGA makes sure you interview with at least one. This way, at least someone will interview with the Forest and Park Association.

After a short wait, he talks to the Battic guy, Rex. Rex has a shaved head and a cool tattoo. They start talking about screenprinting and skate shoes and make fun of the suit kids. Rex gives him some feedback, but the critique quickly becomes a conversation about bullshit. Andre realizes that at an interview it's best to become friends with your future employer. Rex talks about doing motion work and what it's like to work at his office. They exchange business cards and Andre celebrates by skipping his interview with the National Park Association.

A few months pass before Andre hears from Rex. He calls and asks Andre to come in and what his day rate is. At the time, Andre is making $20 an hour at odopod and gives him that as his hourly. Rex chuckles and says that they can do much better than that at BATTIC. He offers $30. Andre calls in sick to odopod and works one day at Battic.

The Battic office is near odopod's, but the vibe is quite different. It's 9 in the morning and the designers are already blasting cheesy euro techno. The first thing Andre notices is that it's a dudefest, and the second is the gunmetal steel décor. He helps finish the designs on a brochure for Virgin Mobile. Rex gives him some direction and repeatedly asks if Andre can finish the job. There is a fellow designer sitting to the right of Andre, an older indie rock guy who obviously dyes his hair black. The guy gets really pissed every time the project manager comes over and asks him for revisions. Rex in turn chews out the project manager in front of everyone. Andre doesn't understand what all the fuss is about — it's just a simple copy change. Nobody talks to Andre all day and he eats lunch alone, at his desk. After too much loud techno, Andre is more than happy to get back to odopod, even if it is for less money.

Guide to Your Financial Aid Package
California College of the Arts
2004-5

POSTER FOR AN ALFREDO JAAR LECTURE AT OUR COLLEGE. I WONDER WHAT HE THOUGHT OF THIS? A LOT OF THEM GOT STOLEN BECAUSE THEY WERE SCREENPRINTED. - A

THIS IS REALLY THE WORST JOB I HAVE EVER DONE. THE CLIENT INSISTED ON ADDING SOME LIGHTNING BOLTS BETWEEN THE REMOTE AND THE TV. - A

THE ORANGE ILLUSTRATION IS A COMPLETE RIP OFF. SORRY. - A

THIS SITE TOOK ME WAY TOO LONG TO PRODUCE. AFTER A FEW MONTHS I STARTED LOSING INTEREST. - A

117

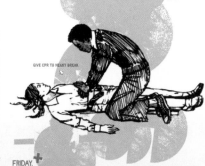

I THOUGHT I WAS BEING CLEVER BY COMBINING SOME SAYINGS WITH
OLD MEDICAL ILLUSTRATIONS. REGARDLESS, I MADE MYSELF LAUGH.
IF AT LEAST FIVE PEOPLE FOUND THESE FUNNY, IT WAS A SUCCESS. - A

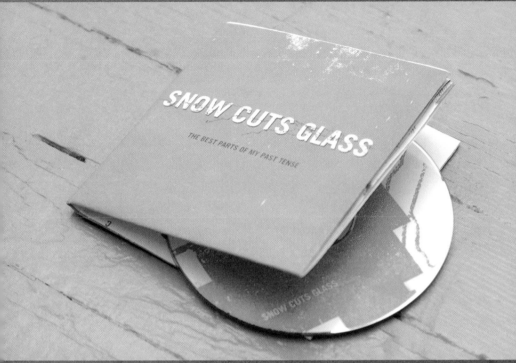

SNOW CUTS GLASS
THE BEST PARTS OF MY PAST TENSE

DAN HATES THIS PACKAGE, BUT I STILL REALLY LIKE IT. THE MUSIC IS QUITE GOOD AS WELL. - A

BUILT TO SPILL
RACETRACK
THE AMERICAS

FRIDAY
MAY 28TH

7PM $10 STUDENTS $14 GENERAL
VU MULTIPURPOSE ROOM
WESTERN WASHINGTON UNIVERSITY

FOR MORE INFORMATION OR DISABILITY
ACCOMMODATIONS PLEASE CALL 360.650.2846
TICKETS ARE AVAILABLE MAY 1ST AT THE
PAC BOX OFFICE AT 360.650.6146

I LIKE HOW SIMPLE THE BUILT TO SPILL POSTER CAME
OUT. I'VE SEEN THE RAINING UMBRELLA IDEA USED FOR
MANY OTHER THINGS. I WONDER WHO DID IT FIRST? - A

THE DIRTY GROOVE SERIES PRESENTS:

THE NO
LOW TRIO

H. SHARDA C. KOSTYKS J. JANNES

TUESDAYS 9-12
AT JACK QUINNS

IT'S 6 OFF AT 5TH, LEFT, GREENUP,
LEFT ON 6TH
118 E 4TH ST.

STYLISTICALLY DELICIOUS

JOE REALLY DUG THIS POSTER
BECAUSE PEOPLE FINALLY
"GOT THE IDEA BEHIND THE
NAME OF HIS BAND." - A

120

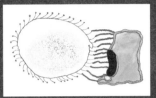

I ALWAYS WANTED TO COLLABORATE WITH ALISON ON SOMETHING. IT WAS HARD TO GET HER EXCITED, BUT SHE LET ME USE HER ILLUSTRATIONS. - A

THE COVER IS VERY OFF CENTER, I LIKE IT THIS WAY BECAUSE IT'S MORE EXCITING. THE BAND HAD SOME ISSUES AT FIRST, BUT I THINK THEY LIKE IT NOW. - A

R.I.P.
O.D.B.

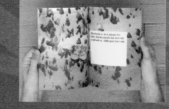

MY MOM'S BUSINESS CARDS. SHE
STILL USES THEM. - A

UNITED STATES
OF ELECTRONICA

SATURDAY, OCTOBER 29TH AT 7PM

hope

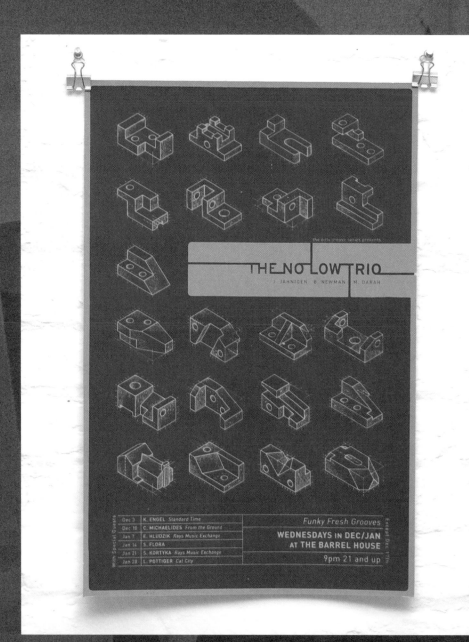

the dirty grooves series presents

THE NO LOW TRIO

J. JAHNIGEN B. NEWMAN M. DARAH

With Special Guests		Funky Fresh Grooves
Dec 3	K. ENGEL Standard Time	
Dec 10	C. MICHAELIDES From the Ground	**WEDNESDAYS IN DEC/JAN**
Jan 7	E. HLUDZIK Rays Music Exchange	**AT THE BARREL HOUSE**
Jan 14	S. FLORA	
Jan 21	S. KORTYKA Rays Music Exchange	9pm 21 and up
Jan 28	L. POTTIGER Cal City	

THERE IS NO CONCEPT TO THIS POSTER, OR AT LEAST THERE WASN'T WHILE I WAS CREATING IT. AFTER THE FACT I MADE UP SOME NONSENSE ABOUT RECONFIGURATION AND HOW THE BAND TRANSFORMS EACH WEEK. PEOPLE SEEM TO BUY THIS. - D

QUESTIONS + ANSWERS

What is an appropriate hourly rate for freelancing when you are a student? How do you make a system of pricing for yourself when you are not quite a professional, but are still putting in the work?

—

Matt Owen

Matt, this is a tough one since everyone is at different ability and skill levels. The first few times you quote your rate will be a learning experience since you'll figure out quickly whether you went too high or low. We usually just put it back on whomever we are working for since most of the time they will feel bad dicking you over. If the fee sounds too low ask for more. Money is always a tough issue though; in general, bigger companies and advertising agencies tend to have more money than smaller studios or clients.

We do not work for hourly rates because this is too anal and the design process is a hard thing to measure in such a tangible calculation. Like, if you come up with an idea at night in the shower, does that count as an hour? We are not sure.

For certain jobs, we will work for little or no money because we believe in the work or we can have total creative control or it's the type of work we want in our book. We have also been known to take on crap projects because they pay really well, but for these we ask astronomical amounts of money since working for stuff you aren't into can be a drag.

Hello!
I guess my real concern is if IS IT ALL WORTH IT? Is all this hard work, studying and paying really high tuition worth the hassle? Will it really land me a nice job? Will it make me better than most aspiring graphic designers out there? I have worked before full-time and I can say that studying is actually harder than working. Haha...might be a stupid question that everybody knows the answer to...except me. Cheers!

—

Johann Pascual

Johann, Short answer, yes it's all worth it. Longer answer, maybe it's all worth it. For us, hard work pays off for sure. As you mentioned, school costs a shit ton, so you might as well get your money's worth. Plus, the harder you work, the stronger your work will be, the more your teachers and peers will take notice, and the better opportunities you will have. Don't be concerned about being the best, just concentrate on being good and people will notice. Dream jobs are hard to get so if you don't land your dream job right away you shouldn't get discouraged. You can always concentrate on doing great work while freelancing at night and on the weekends to build up your portfolio so you can keep getting better and better jobs. There is nothing more fulfilling than falling in love with what you do, so yeah, long story short, it's probably all worth it.

GRAPHIC DESIGN IS

THESIS

Dan had been preparing for his undergraduate thesis since his first semester at CCA. It became something of a ritual for him every semester to watch the public midterms. They were intense and a lot of people broke down in tears. Michael Vanderbyl had created thesis as a largely self-directed class that would challenge students' understanding of what it meant to be a graphic designer. The semester — long projects started with a thesis statement and ended with a project in an appropriate medium. In the past, people had created poetry, books, videos, computer programs, plays, interpretive dances, lawn art, exhibits, videos, environments and lots of other stuff. It was a notoriously hard class and many people failed twice, forcing them to leave the program.

The first day of thesis was rapidly approaching and Signe and Dan broke up. Dan didn't get to prepare as much as he intended because he was dealing with a lot from Signe moving out. He had to work fast, something he was growing more comfortable with. He went to class with two ideas, one he loved and a fallback. Dan wanted to play with the idea that most T-shirts were, in essence, wearable ads. He thought the medium had potential for something more, something conceptual or thought provoking. Dan went into the pitch with a very good idea of how he would attack this problem, and with a plan to produce a line of clothing united by an idea rather than a brand. The committee hated it.

They questioned the project's limitations and didn't like that Dan already knew how to manifest it. Luckily, he had the fall back idea from the night before, even if it did suck. In this idea, Dan would investigate why, if graphic designers are in the business of communication, nobody else really understood what they did. The committee loved this idea and everyone in the class began to talk about how none of their Moms understood what design was. Dan hadn't anticipated anyone liking this idea. He thought it was more of a smart-ass observation than something to devote a semester to.

Thesis consisted of one on one discussions every week with Michael Vanderbyl, Jennifer Morla and Jennifer Sterling. They were all famous and Dan was intimidated. After a few weeks, Dan realized how huge his project's potential was and he set out to create a clear and concise definition of graphic design for anyone who cared to know more about the profession. Dan started by gathering mountains of

hic Design
al communications
l communication
media and webdesign
hic Arts
tal media
timedia
t graphic design
ual presentation and communication
aphic design and Multi-media
interactive media
mputer graphic Design
uer tising graphic Design
r various and interactive computer graphics Design
graphic / Information Design
communication Design
multi media Design and Development
Digital media Design
Design
Graphics and interactive communication
Art - Graphic Design
Digital media - graphic Design
Information Design
computer Graphics
visual communication and Design
visual communications Design — visual com.
Graphic Design / Letterform

definitions and attempts to define graphic design over the years (thank you Internet). He also looked into design education and noted how each program labeled their department and majors. Dan got personal feedback by mailing a survey out to one hundred designers and one hundred non-designers about the importance of graphic design as a discipline and its place in our society.

Since thesis was the only design class Dan was taking, he needed cash to support his habit. He decided to take John Bielenberg, the organizer of Project M, up on an offer to intern a few days a week at his company, C2. C2 was the antithesis of everywhere else Dan had worked and this was what drew him to the job. Xlarge and Vehicle were hip, youth driven companies and at Sputnik Dan created designs for the arts. But he had never done the corporate thing and wanted to check it out.

C2 was small, but did large jobs relating to the structures of huge companies and the ways they presented themselves. Dan was mostly in charge of making things easier to digest with charts reflecting ideas he didn't really understand. The work was very top secret and boring compared to designing T-shirts and sleeping on an air mattress. Dan was exposed to super smart people who, in turn, made him feel not so smart. Their ability to take in tons of information and ideas and then reorganize and articulate them was amazing. The designs, however, looked the same, regardless of the project. At C2, communication was more important than aesthetics, but they were fine with this. Dan didn't realize it at the time, but the few months he spent at C2 impacted his thesis tremendously.

Dan was incredibly nervous for his midterm critique. He had witnessed others attacked for not being prepared. Dan arrived at the crit with a series of little books developed for three audiences needing to be educated about design: designers, non-designers and the business community. The committee was skeptical that Dan could solve the problem of creating a piece that defined what graphic design actually was. They loved the idea, but their parting advice was only "good luck." They said that if Dan succeeded, he would have a lot of money. He left the critique confused. After a few more weeks of trying to create little books for different audiences, he decided instead to create one big book outlining, point by point, why nobody understood what the hell graphic design was.

He concluded his book with the statement, "We are taught in school that great packaging will not sell a bad product. If this is the case, then maybe our problem is not with how we package our profession, but instead the product we are trying to sell. Graphic design does have the power to help make the world a better place, but until we begin to exhibit this potential we will be plagued by the question — 'you do graphic design, is that logos and stuff?'

Dan's thesis project was embraced by the committee and he got an A for the semester. He didn't, however, win the class award for best thesis project, something Dan thought he was a shoe in for. A few months later, Claire Erwin from Adobe called and let Dan know his project won first place in the print category of the Adobe Design Achievement Awards, one of the biggest student design competitions in the world.

POETIC

PAUL RAND

CROP MARK

SYMBIOTIC

PANTONE

ETHEREAL

SANS SERIF

FANTASTIC

CONCEPTUAL

KERNING

AIGA

WORDS NOT SUITED FOR "NORMAL" CONVERSATION (ESPECIALLY ON DATES)

POETIC

MY THESIS PROJECT. THE RESULT OF TOO MUCH THINKING ABOUT OUR PROFESSION AND PROBABLY THE MAIN REASON I AM SO CYNICAL ABOUT GRAPHIC DESIGN. - D

QUESTIONS + ANSWERS

Is there any better way to keep myself awake apart from consuming caffeine?

—

Elizabeth Chiu

Do jumping jacks, Elizabeth, or push-ups, go for a walk, work for an hour and then take a break, or get up and move around. The more you practice staying up, the easier it will be. It's like a marathon; you have to warm up to it. Eating also helps, but be careful since mouse clicking isn't the most calorie intensive exercise.

What kind of designers are firms looking for?

This largely depends on the firm. Usually someone who is a good designer and has a nice personality. Many students fresh out of school get too cocky; let the work speak for your ego. Also being able to think for yourself and having something to say are two important qualities.

What would you do if you have a presentation in an hour, but you are about to pass out?

Present your work fast and to the point. Let the teachers ask you questions if they want to know more. Do not make any excuses about being tired or about your work and stay confident.

Hey guys,
Is it possible to be a successful graphic designer while still maintaining some semblance of a balanced life? While sleepless nights and pouring every little bit of energy into a project can produce amazing results — how do you balance working hard with simultaneously living a fulfilling life and having time for the OTHER things you love? I know this goes against the title of the book in general, but it's definitely been on my mind.

—

Ellie Clayman

To be honest Ellie, I was debating that same thing on the train home today as the deadline for our book has passed four times and we are overwhelmed with other projects, teaching, lecturing, our day jobs and my girlfriend complaining that she doesn't see me enough. Life is all about balance and doing things you love. I know some very accomplished designers who have balanced lives. Yes, they may have a sleepless night here or there, but they have families and do other things that don't involve a computer. What you do can be your life or your job. There is a gray area in between, but it's hard to navigate and realize when to unplug. Andre and I are banking on the fact that if we bust our asses we will reach a certain level of success that will allow us to slow down a little and let people do some of the work for us. But in all honesty I doubt this will happen, because it's like an addiction. My father is 56 and still works his ass off.

PLACES I'D LOVE TO WORK LIST

YES, A LIST

During Dan's last semester at CCA he made a list of people
he wanted to work for. He liked making lists. They made him
accountable for his dreams. Without them he'd have nothing
to work towards. But Dan only does this once or twice a
year, to help him make big decisions. Making lists about
little decisions made him obsess over his daily routine.
They killed all spontaneity, so he avoided them. There are
only four entries on his "places I would love to work list:"
Stefan Sagmeister, karlssonwilker, Cahan and Associates
and MTV. All but Cahan are in New York.

Dan took a lunch with Mark Fox, his teacher from Level 1,
and told him about his "places I would love to work list."
Mark was now the chair of the Graphic Design department at
CCA. He had an opportunity for Dan to go to the Art
Directors Club in New York for a portfolio review with some
cool New York design firms and some not so cool ones.
Only the top graduates from a select number of schools
would be there and CCA was willing to pay for the trip.

Mark also told Dan about a trip to New York he made, after
graduating from UCLA, to look for connections in the
illustration world. A week before his trip, Mark had sent
forty people postcards notifying them of his arrival and
interest in meeting. The post cards were a hit and Mark was
busy his entire trip meeting with big time art directors.
Dan took a mental note and began thinking of how he could use
this idea to get the attention of the people on his list.

As the Art Directors Club event approached, Dan realized
Stefan Sagmeister would be the hardest person on his list
to get a job with. He assumed Sagmeister got countless
requests from over-eager students who were better than him.
Plus, no matter how much Dan tried, he just was not
foreign and most of Stefan's employees were. He needed to
do something to separate himself from the crowd, so Dan
decided to send Sagmeister eleven screen-printed posters,
one every other day, starting a few weeks prior to the
ADC event. Each poster revealed a different reason why
Stefan should hire Dan. Dan's favorite being that Graphic
Design was fun — and so was he.

After the last poster had been sent, along with Dan's oversized
resume, he took a few deep breaths and phoned Stefan.
Matthias, the designer at Sagmeister Inc., picked up. He
told Dan that Stefan was out of the country. Dan had not
anticipated this and told Matthias that he had sent the
screen-printed posters. Matthias now seemed a bit happier,

and he told Dan he liked them. Sagmeister would be in Berlin for two months teaching a class, but he would tell Stefan that Dan had called. A few hours later, Dan got an email. Stefan had enjoyed the posters and was sorry he would not be able to meet up at the ADC event. Stefan also mentioned that Dan "definitely knew how to get someone's attention, which was half the game of design (or a quarter at least)." Dan agreed.

Dan moved down his list to karlssonwilker. They had just published a book and Dan had actually read it (rather than just looking at the pictures like he did with most design books). He thought his work would go over well with them. Like Dan, karlssonwilker shared a love for minimal form and sarcastic copy. He decided to send them random thoughts scrawled on giant yellow sheets of paper. The thoughts would arrive one by one until a secret message, "hire me," was revealed in capital letters of random words. He sent his resume, along with the final poster and a note that he would call the next day at noon. When Dan phoned he talked with Hjalti, the Icelandic half of karlssonwilker. He had an accent, but seemed friendly and agreed to stop by the ADC event with Jan, the German half.

This left just MTV, the last New York firm. Dan did not know who to get in touch with as MTV was a huge company. But he knew from checking the ADC website that they were scheduled to attend. Since he was out of time and still needed to make his portfolio, Dan decided to risk that he would just run into someone who worked there. The ADC event was in five days. Dan's graduation from CCA was in three.

Five days didn't leave much time for making his portfolio, considering that most students spent a semester or two putting one together. Some even spent thousands of dollars photographing, binding and creating elaborate presentation holsters. Dan just had some sub par digital photos and an Epson 1280 at his disposal. He hadn't taken the class devoted to making portfolios, because an entire class on interviewing and presenting his work seemed irrelevant. To him, this was what design school was all about, assessing a problem and figuring out the right method of communication. Now he just needed to package himself and to create a presentation different from anybody else's.

Dan always hated the phrases, "mini book" and "leave behind." They reminded him of the lame marketing terms he was trying to forget from his days at Ohio State. The idea behind these terms was fine — to create something he could leave at an interview to be remembered by, but Dan wondered why he couldn't just let them keep a copy of his portfolio. Why did he have to create a giant expensive presentation of his work, as well as a different, low budget one to leave behind when he could create one book that functioned as both?

Places I would love to
work (A List)
① Sagmeister
② Karlssonwilker
③ Cahan + Associates
④ MTV on or off

GRP COVERT
ELY078 LTN 11JUN
0352 2K 017061

The book Dan created could be produced for around twenty dollars and he made 10 copies. It was perfect bound, printed on French folded Epson paper and had a thick cover where he screenprinted some copy that made him laugh. It contained twenty-one projects and started and finished with his best work. He included letters of recommendation from Michael Vanderbyl and John Bielenberg, in case his design talent alone didn't impress.

The presentation was filled out with an 18" x 24" screen printed resume poster that folded down. The large scale was an attempt to get people to actually read and remember his resume. Dan is still not sure if this worked. On the back of his giant resume was a story composed of random thoughts such as, "I don't trust people who wear plaid." Together the thoughts formed a very bad drawing of Dan in his only outfit, a T-shirt. To package everything together, Dan bought a vacuum sealer from Wal-Mart that sucked out the air, leaving him with a brick-like object that could be transported without damage. He stole the idea of vacuum sealing the book from John Bielenberg, who probably stole it from someone else.

Graduation came and Dan's Mom, Dad, Stepmom, Stepdad, Brother and Aunt all flew to San Francisco to ogle and take pictures. Except for the moment during the ceremony when Dan was in the wrong place in line and had to run across the theater and jump onstage to get his diploma, he barely thought about graduating. Instead, he's thinking about the next day and his trip to New York.

A room full of the nation's one hundred "top design graduates" greeted Dan at the Art Directors club. Dan had been one of the better students at CCA, but was still intimidated and was anxious to see if he stood out. Everyone else seemed nervous too. Dan had thought very hard about how to present himself. Besides the portfolio books, giant resume, and tiny letters of recommendation, Dan had created a business card that still reeked of rubber cement. He also brought actual work, the flashiest, biggest, most colorful stuff, to grab people's attention.

Dan wasn't getting much attention and felt a bit like a puppy at the pound, hoping to be adopted. Finally, two people from MTV came by and introduced themselves as Romy and Rodger of the On-Air design department. After chatting for a few minutes, Dan handed them a copy of his portfolio and told them how interested he was in working at MTV. Soon thereafter, Dan spotted karlssonwilker across the room. He didn't want to wait for them to come by. What if they didn't? Dan collected himself and walked over to meet them. They seemed mildly impressed by Dan's work and graciously invited him to stop by their studio the next day for a chat.

I'M DEMO. HOW YOUR WORK BECOMES YOU (AND YES, YOU LOOK SMASHING!)

Justin Fines

That first printed piece is special. Like the first time you smush face with the neighbor in braces behind the garage; it's messy, it's confusing, mistakes are made…it's AWESOME.

Some back-story: in 1997 I was going to art school in Detroit and was generally bored as hell with it. Well, the first two years were fantastic, actually; I truly loved learning to draw, and my instructors were mostly cool guys with lots of funny anecdotes of dubious veracity. I had a job taking tickets at the local movie theater, I had clove cigarettes, I had no idea how I was going to survive outside of school…but I was 19, so what the hell? Around this time I lost all momentum in my schoolwork. I realized I was losing interest because I couldn't see myself following the design and illustration world's established path: learn the foundation design precepts; do an internship; interview for a position; climb your way up. I thought the first two 'foundation' years at art school were beneficial, but doing basic design assignments did nothing for me. I wanted to skip GO. I wanted printed work, I wanted my own studio, and I wanted it *right away*.

This urge happened to coincide with my discovery of the Detroit electronic music scene. Detroit techno was at the height of its popularity. There were parties every week and I thought it was the coolest thing I had ever come across. Every time I bought a new record it was a mini life-changing event. And the best part was that art and design were a huge part of the experience! From rave flyers to record sleeves, the music and design flowed together and swept me along in their current. It struck me that all of the great images I saw at parties and in record stores weren't created by someone at an agency with a boss and a title, they were made by people who LOVED the music they designed the sleeves for and who LOVED going to the parties they created flyers for. Some worked in small groups and some did their own thing. They actually lived every aspect of their art. And these were young designers. Some had gone to school, some never did, and I wanted desperately to be one of them.

So, when I overheard that one of the top local flyer designers was leaving Detroit, I nervously approached the party promoter he worked with and offered to take over. He asked to see my portfolio, and I lied to him to cover up for the fact that I had never designed a single thing outside of school and had used Photoshop for a sum total of 3 hours. Thankfully, he needed a flyer so quickly that he didn't have time to question me and just handed me the gig (unpaid, of course). Over the next two nights, working feverishly on a friend's Mac, I crafted my masterpiece…There were Lego spacemen, there was lots of Eurostile, and there were bubbles! SPACE BUBBLES! God, was I excited.

When the printer got the file, he called the promoter because he thought there was something *wrong* with it. That's how BAD this design was - the printer actually thought there was a disk error! I found myself sheepishly insisting this was exactly the way I had planned it. Those space bubbles and techno trimmings were there because I meant them to be there, dammit! When the flyers arrived from the printer, I was elated. Never mind the fact that they had a mysterious half-inch white border (my fault) and the colors had shifted from a sky blue to a sea green (I had provided the file in RGB format, natch), to me this was a thing of beauty, a beauty of my own creation! I practically wet my two-size-too-large khakis.

But there was another feeling that I hadn't anticipated: the joy I experienced in watching my work distributed. Whether they were handed out at a party or placed among hundreds of others at record stores, my flyers were part of the scene. The idea that I could pour my heart into these ephemeral printed moments, and that other people could share and appreciate them was addictive to me. And now I could synthesize the things I loved (art, music, Detroit) with my talent to create a thing which could, in turn, inspire and inform others.

Now, ten years after that first flyer, with many moves and countless projects under my belt, I am still excited when my design fulfills more than just an academic or monetary purpose. The work that excites me most participates in a commerce of ideas, memories, emotions, messages and meanings – design that reveals the hands of the designer and radiates with their excitement for the work.

As was the custom with rave flyers in those days, I had quickly added a moniker to the bottom of mine: DEMO. Needing something succinct and having no idea what was going to come of this design thing, I figured 'demo' stood for 'trying it out.' And, although that first piece isn't much to brag about, I am happy to say that all the work I have done is still undoubtedly and truly Me.

Demo was founded by designer Justin Fines in 1997. Born out of the love of his hometown of Detroit and it's music, Demo began by churning out flyers and ephemera for the then thriving Detroit electronic music scene. Nine years, three cities and countless projects later, Fines has found a home for Demo in New York City. In his work, the golden tint of suburban childhood nostalgia blends with the influence of the hulking abandoned factories and mansions of the Motor City. This combination creates a graphic language that balances between hope and cynicism. Fines' work has been featured in publications worldwide, and recent projects include an animation for Nickelodeon, a artist series skateboard for Zoo York, and a series of designs for the Truth Campaign.

G. Dan Covert

California College of the Arts (formerly CCAC), San Francisco, CA
BFA, Graphic Design, 2004

Project M, Searsport, ME
Participated in the inaugural session of Project M, during the Summer of 2003
at The Berlenberg Institute at the Edge of the Earth.

The Ohio State University, Columbus, OH
Marketing, 1999 – 2001

C2, San Francisco, CA
Intern, January – March 2004
C2, Creative Capital, is a small multi-disciplinary design firm, who helps companies get their
stories straight. I worked under the art direction John Bielenberg, Erik Cox, and Greg Galle.

Xlarge, Los Angeles, CA
Designer, July 2003 – Present
Xlarge is an international streetwear company. I work under the art direction of Eli Bonerz.

Sputnik, San Francisco, CA
Designer, Spring and Fall semesters 2003
Sputnik is a hand picked student-staffed design studio that produces collateral for CCA/C.
I worked under the art direction of Bob Aufuldish and Eric Heiman.

Vehicle SF, San Francisco, CA
Intern, May – September 2103
Vehicle is a medium-sized multi-disciplinary design firm, focusing on retail marketing strategies.
I worked under the art direction of Dennis Crowe.

83rd Art Directors Club Annual
New Talent Design Annual, published by Graphis, 2004
I.D. Fifty: Made in America, January/February, 2004, p. 69
New Talent Design Annual, published by Graphis, 2003, p. 209 and 212
I.D. 49th Annual Design Review, August 2003, Design Distinction Winner, p. 169
Hip.com, an educational case study of CCA
Vizual!, a newsletter produced by Communication Arts
Within 4 Walls an AIGA poster show
Frisco, Remix, an experimental typeface curated by Max Kuehan
Audiographic an AIGA album cover show
CCA/C open houses for the past five semesters

1902 Folsom St San Francisco, CA 94103
415-336-5967 dancovert@free.net

THE LARGE FRONT AND BACK OF MY
OVERSIZED RESUME. - D

PROJECT M JUNGLE TIME

Andre first hears of Project M through Dan and Eric Heiman.
It's like a summer design camp headed by the eccentric
founder John Bielenberg. This year the program will be
heading to Costa Rica for a bit and then to upstate Maine.
The application is straightforward; only one question stands
out — "Draw nothing." Andre thinks hard and writes
"everything" in the middle of the page. John calls and
officially accepts him into the program. Andre is juiced to
take time off and venture to the jungles of Central
America. He packs his backpack and borrows a laptop from
Dan's ex girlfriend, Annie. When Andre lands he meets John,
two advisors, Jim and Adam; two other participants, Bryce
and Preston, and one tag-along-environmentalist called
George (later known as "George from the Jungle").

Costa Rica is humid and hot. Andre only knows how to say
"hello," "nice to meet you" and "burrito" in Spanish.
Preston claims to be fluent, but freezes like a deer in
headlights every time he has to open his mouth. They will
be staying in the camp of Dan Janzen, a world-renowned
conservationist and scientist at the Guanacaste reservation.
Their dorms are simple, bunk beds, bug nets and concrete
floors. No hot water, no AC and lots of rice with beans.

It's the beginning of the rainy season, so all of the animals
and insects start coming out. Everyone is ill prepared for
the trip and nobody thinks of bringing powerful flashlights
for the night or high-top boots for stepping on snakes.
Instead, they bring flip-flops, sunscreen and tour
guidebooks. There are many dangerous animals like crazy
snakes, poisonous frogs, spiders and scorpions. The nights
are the worst because they have to fall asleep under threat
of a scorpion attack and covered in bugs. George has a
tendency to wake in the middle of the night, screaming.

After 10 days of hiking the jungles, drinking Empirial (the
local beer, costing a dollar a six-pack), destroying one
4x4 and badly damaging another, killing one giant iguana,
taking over 3,000 photographs, collecting stories and
interviews, surfing in the ocean, hanging out with a Ron
Jeremy look alike, misplacing one camera (and later finding
it), making rock sculptures, getting stung by poisonous
frogs, rat hunting with locals, miserably trying to speak
Spanish, chopping things with machetes, seeing a 10 foot
python, finding a secret contra hideout, playing soccer
with the locals, losing Preston to the forest, and parting
ways with George, the group heads to Maine.

Belfast, Maine is quiet and sleepy. There are many big white farms and lots of grass. Andre is the first to arrive at a big empty house John usually rents in the summer. Preston and Bryce arrive with two cases of the local beer and the group starts brainstorming. John comes over every morning to throw wrenches in their new ideas. This is his way of teaching them about "thinking wrong." Combined, everyone has over 5,000 photographs and just editing the material is a task in itself. Trying to derive a concept later, from all the raw research, is harder than going to Costa Rica with an idea and shooting only what pertains.

Three weeks later, the group scrambles to produce a book in the allotted last four days. After throwing out ideas of making a movie, a traveling exhibition, a piñata and edible sculptures, they decide to stick with making a book of their travels with text, photographs and drawings. After three days of non-stop work, John changes his mind and nearly kills the project since it's a travel journal at best and not really anything out of the ordinary. They come up with a new idea, but there is still a lot of work to be done. The group leaves Project M confident, with a solid idea involving ink that washes away from the pages with water, and Andre happily agrees to continue working on the book back in San Francisco.

He spends countless hours over the next 6 months redesigning the book. The rethought concept of wash away ink is eventually discarded because of funding and a new tear-away concept is adopted. After redesigning the book from scratch, it is again postponed due to lack of funds. Andre goes back to work at odopod for the remainder of the summer and the book is never produced. But even though there is no physical artifact of this project, Andre is happy to have made new friends, think wrong and get a new mentor.

Soy
Bolly
Holly
Script
Scene
Act
Recite
Freeze
Canned
Product
Placement
Boom
Mic
Joey
Money
Cashola
Desert
Dreams
Hills
Fan
Critic
Comedy
Office

12:05 AM
Direct Instant Message session started

12:10 AM

Get your film on.
Filming is funer than not.
Everything looks better on film
Film is not video.
Film is not television.
Film is to life like milk is to cereal.
Lead roles are for overachievers.
Let me film you.
What happens on film stays on film.
Filming gets better with age.
Making films is like suuuuper easy, dude.
Clap if you like films.

We are sorry that you
don't think your grade
is fair.

We gave it to you for
the following reasons
and have no intention
of changing it:

You never participated
in class.

You missed the final
crit for the type in
space class. When we
saw your project it was
not good, or even
finished and you had a
week more than everyone
else.

Your work hasnt showed
any improvement since
last semester.

You just do the bare
minimum in order to get
by.

Even if your final cd
was ok, you didn't
bring in anything the
previous 5 weeks except
some little sketches
and reference. Your
final piece was badly
trimmed as if you had
done it like 5 mins
before the class. The
purpose of this
assignment was to have
to design something you
are passionate about,
if you cant get into a
project you chose what
can you get into. We
didn't have a
preconceived idea of
what you should be
doing. We were just
trying to get you to
show us some sense that
you even cared about
the class.

Yes we could change
your grade but then you
would keep on not
living up to your
potential. Maybe this
will make you think
twice. Maybe not.

k cool

5:25 AM

damn

nothing was open

thats cold

i thought ny was open 24hr

stone cold

wtf

old people will be none the wiser

no way man

my grandpa is surely way cooler than yours

he aint rocking that old shit

haha

6:40 AM

WORKING
ON
GETTING
WORK

BUSTING ASS AND TAKING TIME

For Dan, life in California was about design. In school, he worked day and night for three years, without many breaks to get the most out of his education — and his parents money. When Dan finished school, it was time to relax, and to go to Europe. He took Stefan Sagmeister up on an invitation to meet in Berlin. Dan never drank coffee, but pretended to as Stefan flipped through his portfolio. Sagmeister prefaced his critique by saying Dan was obviously talented, but that his work was boring, too clean and dated. Stefan urged Dan to look at more contemporary graphic design and to let loose. Dan was taken aback. He was used to people gushing over his work, but finally someone was being brutally honest. As they parted ways, Dan asked what the odds were of Sagmeister hiring him. Stefan replied, "zero percent."

Dan flew back from Europe early for the Adobe Design Achievement Awards. It was a bigger deal than expected. Coincidentally, it was Michael Vanderbyl who presented Dan with his award and joked about how he looked too Midwestern and corn fed to be a designer. Dan got a shiny statue and five thousand dollars, which he desperately needed to start climbing out of the debt from his Euro trip.

It was probably time to find a job, so he looked at his list. Needless to say, he could scratch Stefan off and moved down to karlssonwilker. Dan decided to send them another giant yellow piece of paper with a little note. He had also sent Bill Cahan a few semi-stalkerish postcards from Europe and one more to announce his return home. Lastly, he sent an email to Rodger at MTV, who Dan thought he had met at the Art Directors Club, but wasn't sure, as he stupidly forgot to ask for a card.

Rodger phoned and was interested in hiring Dan to work for MTV On-Air Design. They did most of the motion graphics for the channel. The only catch was that, since he didn't know After Effects well, Dan would come in as a Junior Designer, with a reduced salary and zero benefits. Getting a job offer wasn't supposed to be this easy and he didn't know what to do. He asked Rodger for a day to think, as he was scared to take a job in motion graphics with so little experience.

In his gut, it didn't feel right, so Dan told Rodger he was flattered but more interested in print. Rodger passed along the name of Jim deBarros, the director of Off-Air Creative, the print department at MTV. Dan sent Jim a giant envelope with his portfolio junk and a big yellow piece

of paper that said, "I hope you are having a good Monday. I would like you to meet my work." Jim was impressed enough to email and tell Dan he wasn't hiring at the moment. Had Dan made the wrong decision by passing up a job with Rodger? He was interested in motion and thought MTV would be a good gateway to someday directing music videos, it just didn't seem like the right time.

Empty days were filled working with Andre on projects for friends' bands. Dan was happy to know Andre, since they seemed to work well together and talked about opening a studio one day. Soon the music projects started to run out, though, and waking up late everyday without much to do got old quick. After not instantly landing his dream job, Dan started questioning his abilities, and the novelty of sitting around all day turned into a harsh realization that he was unemployed. Luckily, Dan got a call from his thesis teacher, Jennifer Morla. He had loved Jennifer as a teacher and respected her work, but wasn't sure that she liked him. It turns out she did, because she wanted Dan to freelance for her studio. Dan quickly jumped on the opportunity and she offered to pay him twenty five hundred dollars for a month of work.

Weeks into his time with Jennifer, Dan got a surprise email from Hjalti Karlsson asking him to call. Dan was still not sure how to pronounce Hjalti's name, so he asked John Bielenberg, who was much smarter than Dan. An intern picked up the phone and Dan nervously asked for "Hyaltei." Hjalti wanted to know how Dan felt about coming to New York for a few weeks to help out. karlssonwilker had hired someone with a lot more experience than Dan, but she couldn't start for a bit. He offered to pay Dan $400 a week. This was what Dan made at his first internship, but he couldn't pass it up.

Nic from Project M rented Dan his spare room in the West Village for five hundred dollars a month. This was crazy cheap since the apartment was a five floor walkup in the heart of the West Village of Manhattan. Dan had never climbed this many stairs before and Nic's crib seemed tiny by San Francisco standards, but the location was amazing and he was in New York.

Summer was kicking and the city was alive with tons of beautiful women. Dan rolled into karlssonwilker and was greeted by Hjalti Karlsson and Jan Wilker. His chair was a barstool, his desk the bar. They had an intern, Frank, who was there a few days between grad school classes at Pratt. Frank was a super cool guy and probably one of the most gangster white guys Dan had ever met. He also smoked a lot and only seemed to wear oversized white T-shirts.

Hjalti and Jan were very busy juggling a lot of projects and needed Dan's help on a device that MTV could use to help navigate their ever-expanding empire. Since Dan didn't really know anything about motion design, he had no idea

where to start. He began by using a few tricks for coming up with ideas that he had learned in school: To think up a few solutions based only on icons, a few that relied heavily on photos, a few which used only type, some stupid, simple solutions, a few copy driven solutions and some formal stuff. Hjalti and Jan didn't really bother him. They told Dan to show stuff when he was ready, but Dan wasn't used to this. When he finally showed his ideas, Jan didn't seem impressed and Dan was taken off the MTV project.

Jan gave Dan an actual chair at an actual desk and asked him to design an actual CD package for the German instrumental band, Hattler. Referencing books before he started was how Dan began most projects. Hjalti and Jan had no books. This was probably the reason their design looked so weird and original. They were forcing themselves to create stuff that had never been done. Dan started to play in Illustrator and, after a few days, came up with some stuff that looked cool. It was a painful process as Dan sucked with form. The final piece was a series of compositions created by rearranging the same group of colored lines. Jan made Dan count the lines in each composition so that they were not lying in the liner notes when they said how many they'd used.

Dan was very happy working in New York for karlssonwilker and hoped he could someday have a studio of his own with Andre. karlssonwilker were an inspiration and it was surreal to be working with his idols. Jan and Hjalti busted their asses and Dan watched them work many late nights and weekends. But they also showed up to work whenever they wanted, played hilarious games, drank in the office and seemed to genuinely love what they were doing. This could not be said for everyone Dan had worked for. Every few days Jan asked Dan if he was having fun and said that if he wasn't, he was doing something wrong. Jan was right. Graphic design was supposed to be fun. This was easy to forget when money, bad clients and deadlines came into the picture.

As Dan's time at karlssonwilker wound down, Dan got an email from Jim deBarros at MTV, who he had kept contact with. Jim wanted to meet up. Luckily, Dan happened to be in New York.

IMPRESSING YOUR TEACHERS IS NOT A BAD THING. MOST OF THEM NEED INTERNS.

TRY ATTENDING CLASS. NO MATTER HOW YOUR PROJECT LOOKS.

TALKING IN CLASS WILL GET YOU NOTICED.

KEEPING UP WITH CURRENT AND PAST DESIGN HELPS YOU TO NOT REPEAT THINGS.

GRAPHIC DESIGN IS SUBJECTIVE.

GET INTO EVERY PROJECT SOMEHOW.

WORK HARD TO SCARE YOURSELF.

YOUR TEACHERS ARE NOT YOUR ART DIRECTORS.

STAND UP FOR GOOD IDEAS.

THE VERY MANIACAL CAMPAIGN TO TRY AND GET STEFAN SAGMEISTER TO HIRE ME. NOPE, IT DIDN'T WORK. STILL, THE PROJECT WAS FEATURED IN *COMMUNICATION ARTS* DESIGN ANNUAL. SOMEONE WROTE IN A LETTER TO THE EDITOR THAT THE REASON STEFAN DIDN'T HIRE ME WAS BECAUSE MY DESIGN HAD A TYPO. - D

THIS WAS MY BROTHERS IDEA. I JUST DREW IT BADLY. HE IS THE FUNNIEST PERSON I KNOW. - D

ANDRE ANDREEV 528 Haight Street 425.417.8490
San Francisco, CA 94117 andre@formisdead.com

EDUCATION

B.F.A., Graphic Design, California College of the Arts, San Francisco, California, 2005
Project M, headed by John Bielenberg, 2004
A.A., Visual Communications, LWTC, Seattle, Washington, 2002

EXPERIENCE

Odopod, San Francisco, California
Designer, Jul 2003 - Present
Designed, conceptualized, and implemented interactive projects for clients including as:
Nike Skateboarding, Nike Women's Soccer, Nike Cycling, Winamp, Macromedia and Redbull,
under the Art Direction of Jacquie Moss and Tim Barber.

Attik, San Francisco, California
Freelance Designer, 2004
Designed and produced collateral projects for Virgin Mobile, under the Art Direction of Stan
Zienka.

Freelance Designer, San Francisco, California
2003 - Present
Work closely with record labels such as West of January Records, musicians including Built to
Spill and Andrew W.K., gallery Southern Exposure and Jeremy Mende Design on various
identity, packaging and promotional projects.

Sputnik, San Francisco, California
Designer, Jan 2003 - Dec 2003
Designed and executed a wide range of interactive projects, publication and collateral materials
for the California College of the Arts and The Wattis Institute, under the Art Direction of Eric
Heiman and Stella Lai.

RECOGNITION

Honorable Mention in ID Design Review, 2005
Honorable Mention in ID Student Design Review, 2005
Published in Art Director's Annual 83, 2005
Type Director's Certificate of Typographic Excellence, 2005
Published in Type Director's Annual 26, 2005
Published in STEP Design Annual, 2005
Published in Graphis Poster 6, 2005
Communication Arts Award of Excellence, 2004
Published in Communication Arts, Issue 331, 2004
Published in CMYK Magazine, Issue 22, 2003
Exhibited in AIGA: Audiographic, 2003
Finalist for Macromedia's Editor's Choice Award, 2003
Finalist for South by Southwest Web Award, 2003

SKILLS

Excellent knowledge of pre-press, spot, process, letterpress and screen printing.
Excellent knowledge in InDesign, Photoshop, Illustrator, Quark, Flash and AfterEffects.
Advanced knowledge of Actionscript, XML, DHTML, and CSS.

References available upon request.

PAUL SAHRE WAS IMPRESSED BY THE LIST OF AWARDS.
NOTICE, IT'S ALMOST AS LONG AS THE LIST OF PLACES
I'VE WORKED AT. - A

SOUNDS FOR SIGHTS, SIGHTS FOR SOUNDS

Kelly Aiken

It was a couple years after I graduated from high school before I started to pick up on the fact that Andre really was more than just a dude who drew stuff. I was playing in a band, Ancille, with a bunch of our mutual friends and we had started working on our first CD. Not having any experience in creating a finished musical product, there were plenty of aspects I neglected to consider – the most prominent being the packaging.

Luckily for me, and my former band, Andre had volunteered to design the package. He asked me for some direction about what we were looking for. I tried to give him an idea of what I was thinking through the lyrics and songwriting. I even listed some examples of other art that expressed a feeling similar to what I wanted, but the idea of translating music into visuals is a tricky one, especially for me. As someone who is completely inept at any sort of visual expression I was extremely thankful to have someone else take the layout upon themselves. Nonetheless, I still felt a certain amount of stress; even if I couldn't communicate my vision, I still had a specific idea of what I wanted to see. I could share what I thought about the music, but I could not for the life of me actually articulate what I wanted to see when looking at the CD or lyrics. I just knew that I cared. A lot.

In the best cases, working with designers allows me to get exactly what I want, even if I don't really know what that is. I can't ever remember saying anything to Andre about trees or building skylines or earth tones. But when I saw those images, I recognized them as exactly what I wanted. Designers can figure it out for me, by understanding what I want better than I do.

Maybe it was less about trying to convert the music into art and more about assigning art to the music, rather than just transcribing it visually. We, as a band, had begun the process of taking what was essentially a hobby and trying to make it serious; the design took us one step closer.

The final product was a piece that, to be completely honest, stood above and beyond our music. Although I am quite proud of the songs we made and the lyrics I wrote, I am also realistic – my band, and the music we made, was amateur. I believe there's something to be said for expression and sincerity, whether it's amateur or professional, and to that extent I am proud of the things I was able to express through that music. But when I think about that album and those songs, I also get a very clear picture of the design work that accompanied them. Despite the fact that no one in the band actually created or even envisioned it, that artwork is now inseparable from the rest of the album. It's an aesthetic that broadens the scope of the band's artistic expression, and for that I am both thankful and impressed.

Kelly Aiken lives in Seattle, where he impresses the kids he works with by having tattoos, being in a band and riding a motorcycle. It's working great so far.

THESIS

Andre doesn't have many epiphanies until he is almost about to graduate. In a class about the history of women artists, the Eames daughter comes to give a lecture. She briefly touches on the idea of originality and says that everything is influenced by something else which, in turn, will influence something else. Andre has always tried hard to think of completely original and brilliant ideas without referencing the past. He doesn't care about design history because he is the history. Now, seeing design in a continuous line, he takes a deep breath and just tries to be good.

Finally, it is Andre's time to take the thesis class at CCA. A week prior to the first class he starts brainstorming ideas. Ideas are not so easy to come by under pressure and good ones are especially hard. The week quickly passes and he doesn't have much to go on. Andre is interested in all kinds of stuff: cultural phenomena, design process, political causes, media criticism, soccer and multi-nationalism. He doesn't know much about many of these topics, but they all seem interesting. Andre comes to the first class with 5 different ideas.

On the first day, every student lines up in front of the three teachers, Michael, Leslie and Jennifer, to read their ideas. Some people boil down their thesis to a simple word or, at most, a combination of 3. Andre presents his thoughts and two stick out. The first is on the process of graphic design and the other about media's influence on social behavior. The final decision is left up to Andre.

Andre starts doing research on his thesis about the mediocrity of media. He proposes that it's dumbing down American culture. Michael is not impressed by the research because Andre fails to point out any new arguments. Michael strongly advises him to switch his focus to the process of design. At least then he'll have a good understanding of what he is talking about. Andre thinks of a catchy name for his project — Process to Progress. He realizes the first step to a good idea is coming up with a solid name. This way people will remember it easily. Andre starts reading articles on the creative process and pulls interesting quotes describing the way people work. He begins with designers, then moves on to other professions: chefs, architects, lawyers, policemen, window washers and nurses. His idea is that if designers are aware of other processes of working, they might learn something new about their own process and maybe even try something new.

He assembles a little book of quotes and gets it bound at a place called Copymat. Copymat is the best-kept secret in San Francisco binding. It's a cheap step above Kinko's that delivers excellent results. The only catch is befriending the staff. These guys handle large, corporate clients and don't want to deal with pesky student projects. Andre rolls there with Dan, who has been going while working for C2. By association, Copymat thinks Andre works for C2 as well and they start binding his work. Andre learns the importance of having a personal relationship with vendors and keeping them happy.

Michael Vanderbyl always tells the class, "This is a design course, everything you hand to us must be designed." Andre follows his advice, showing up with his quote book and some hi-lighted articles in hand. Everyone is impressed by Andre's little book and his thesis idea is no longer an issue. At first, Michael doesn't believe Andre designed the book. It looks like something John Bielenberg might come up with, simple big copy in the middle of a page set in Trade Gothic. Vanderbyl advises Andre to start making his work more visually intricate and less "John-like."

Andre sets a goal to make a "process" book every week until midterm. These books will compile the processes of different agencies and firms, survey responses, as well as compile his own process and method of idea generation. For six weeks, he continuously runs between Copymat, his house, school and odopod.

The midterm crit is coming up and people are getting nervous. It's a big crit where the teachers invite other well-respected creative people to critique. Students get dressed up and over-rehearse their presentations. This crit, unlike others, is open to the public and many people come to watch. Andre has to give a twenty-minute presentation on his idea and convince everyone that he is a good designer. He knows that twenty-minutes is a long time for anyone to fill, so he thinks up a few tricks. Every semester someone does something memorable and weird. Andre has something in mind…

Since he has been doing well for most of the semester, over 40 people show up for Andre's presentation. He shows his little books and his research and everyone nods their head and seems interested. Andre proposes the second phase of his project: he will redesign an object through three different design processes. One process would be Clement Mok's 10 Step process, another John Bielenberg's Think Wrong, and the last…chance. Andre will be the constant in all these processes.

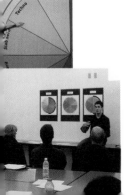

To select the "chance" requirements, Andre makes three different dart-like boards covered with little words. One is for color, the next for type, the last for production process. The dart throwing impresses the committee and people cheer. Afterwards, Andre proposes the object he will redesign. He starts pulling out famous posters, books and

CDs — the standard stuff. Nobody is feeling it, but Andre has a backup in his bag. He pulls out the National Security Strategy, the first document that outlines the actions to be taken after 9/11. People clap and the hardest part is over.

For the next few months, Andre works hard to complete his thesis. He redesigns his little books, orders a custom slipcase for them and constructs over 10 dummies of his redesigned NSS as his final presentation approaches. Andre is up for three nights in a row and finishes screenprinting his last design a half hour before class. He is sleepy. At this point his advisors and the committee are all familiar with his project. They love it and later Andre wins "Best Thesis of the Semester," along with a fancy iPod. It's a good way to end a student career and Svetlana is there, along with Alison. Andre goes to the podium to accept the award and thanks everyone in the room, except Alison. Ironically, she was the person who helped him the most (sorry, Ali). His initial goal, to get the project out into the real world, doesn't pan out. But at least a few people will read about it in the *I.D.* student design annual. Andre graduates from college, but can't even buy a beer to celebrate, since he is only twenty.

THIS IS MY THESIS PROCESS BOOK. IT'S A PACKAGE OF FIVE SMALL BOOKS. I SPENT WAY TOO MUCH MONEY FOR THE SLIP CASE. TRIED TO BARGAIN, BUT THE BOOK BINDERS WERE A TOUGH BUNCH. - A

THE UNCHARTERED
TERRITORY.
THE PART THAT
EXPANDS MY
HORIZON AND THE
PART THAT MAKES
SURE MY JOB DOES
NOT TURN INTO A
ROUTINE.

I SIT AT MY
DESK, EAGER,
I DON'T LOOK
AT ANY BOOKS,
NO ANNUALS,
NO MAGAZINES
NO NOTHING.

SOME SPREADS FROM MY PROCESS BOOKS. - A

THE NATIONAL SECURITY STRATEGY OF THE UNITED STATES OF AMERICA 132

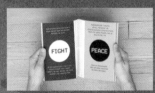

MY PROJECT WAS REDESIGNING
THE NATIONAL SECURITY STRATEGY
WITH DIFFERENT PROCESSES. - A

THE NATIONAL SECURITY STRATEGY
OF THE UNITED STATES OF AMERICA

THE
DRESS
CODE
IS CASUAL

COLLABORATING

Svetlana is about to start a new store selling pre-framed art and knickknacks. She promises Andre the handsome fee of five hundred dollars for his services. Andre and Dan start working on logos. They both come up with ten solutions, but it's obvious Dan has more experience with branding. Andre doesn't have fun with logos; in fact, they're a drag. He misses the spontaneity of designing posters and collages. Logos are too restrictive and take too much patience. After making a large presentation of their ideas, Andre decides to get advice from the smartest man he knows, Michael Vanderbyl.

After an all-nighter putting together the presentation, Andre shows up at Michael's address. His studio is very impressive, his office even more so. There are lots of white and square things. Michael flips through the presentation, but is not impressed. He gives Andre advice on how to make things better and asks him what he wants to do when he graduates. Andre replies that he and Dan want to start a studio. Michael laughs and gives him the following advice: "Your biggest promotion will be the work that you do. People want to see how you can make money for them; they don't care why something looks a certain way. If you do a good project for a client, get a bunch of copies and send them out to potential clients. When they see how well their competition is doing, they will hire you to do the same for them."

Andre goes back to Seattle to show the designs to Svetlana and her business partner. They love all of them. The store will be called Art Plus and the logo they choose has two dots. It's not a logo that Andre and Dan are feeling, but it'll do the job. They could have edited their presentation to only the logos they liked, but showing only a few options might make it look as if they were slacking.

Kelly, Andre's friend from high school, starts putting on concerts at a youth center in Bellingham and needs posters for the shows. Andre often teams up with Dan to design small runs of posters they screenprint at their apartment. Designing and printing the posters rarely takes more than a few days. Because of the short turnaround, Andre starts giving himself limitations, such as only using old medical illustrations or duct tape. He plays with scale and printing techniques, often printing on huge pieces of paper and using metallic or fluorescent inks.

One of the first posters is for Built to Spill. Andre loves their music and he jumps on the job since they are a well known band. After looking at numerous poster books and

websites, he comes to the conclusion that he needs to find a simple metaphor for the band. He has the visual of an umbrella stuck in his head and draws rain pouring out of it. Right away Andre knows this is the poster. He adds some simple type and calls it a day. As the years pass, he finds this same visual on different designs. Good job, but not so original after all.

Andre and Dan begin to collaborate more and more because together they can accomplish much bigger things than by working alone. They think on the same wavelength, for the most part, but bring different skills to the table. Andre is very talented formally and can make cool-looking stuff without trying very hard. He is very intuitive as a designer, while Dan is anything but. Dan's design centers on rationality and meaning since he is more calculated and restrained by nature.

Something that happens again and again is that Andre really likes something Dan makes, but Dan himself couldn't care less about it or vice versa. One of them will think an idea is genius and the other one will give him a reality check. Having each other to keep bad ideas in check and help take things up a notch becomes very helpful.

REGISTER TO ROCK

Joe, Dan's friend from high school, is organizing a rock show where smelly punk kids can register to vote. He needs help coming up with a name and a poster for the event. It will take place in Ohio, a major swing state, where getting the young and, hopefully, anti-republican voters registered is important. Andre and Dan brainstorm a bunch of names before settling on "Register to Rock!" It's simple and they like how it has an exclamation point.

After both of them work out a few ideas, they swap files and start working on each other's designs. What they end up with is a giant graphic speech bubble coming from a little guy. Something is missing. Since Dan and Andre only have fifty dollars to produce the poster they decide to print on the Wall Street Journal, a paper they think represents "the corporate agenda." They drive around the city stealing newspapers from all of the street dispensers. The final cost for paper is five dollars in quarters. Some posters are printed on big Viagra ads and others on countless rows of stock information. Every poster comes out differently. After the show is over, Joe calls to say 200 people registered, not enough to turn the state blue.

Register to Rock! becomes a symbol of the partnership. The poster is by far the most published of any piece Andre and Dan have done to date. The ease of working together and the rewards that follow show that working as a pair might be the way to go.

To take their collaboration to the next level, Andre and
Dan decide to think up a company name. This is harder than
it seems. They come up with lame names like Strategies of
Desire, Ghetto Blaster, Fancy Dan and Earl & Associates.
Nothing seems to stick. Dan and Andre each have a favorite,
but coming to a consensus is hard. They start looking
around the room and naming off objects, Andre suggests
table and Dan suggests lamp. After some dead air Dan comes
up with dress code from a book Signe left on their shelf
called *Dress Codes*. Andre starts imagining a business card
with a Hawaiian shirt on it that says something like,
"keep it casual." They agree, dress code it is.

HOW WILL YOU KNOW WHEN YOU'RE SUCCESSFUL?

Kathleen Creighton

One Monday afternoon in April, a few years ago, I was sitting on an empty beach preparing a final exam for my class. It was a spectacular day, ceiling and visibility unlimited. It seemed impossible that on such a day and as far as the eye could see, I was the only human present. After scanning the horizon, I looked back behind me and saw my house beyond the dunes. In it was my partner, a great companion and someone who truly enjoys and is occupied by his work. I realized that this being Monday, most people were at work. Many at jobs they disliked or by which they were not wholly engaged, challenged or fulfilled. Not only did I love my job, but it allowed me to have this Monday away from my desk, to sit on the beach and have time to think and write.

What might appear to be a rather simple set of observations was really rather earth-shattering to me. These circumstances represented a level of success I never realized I had, because it wasn't what I thought success would look like. I discovered it by looking in — instead of out — for approval.

Far from making me feel complacent about my career, this discovery freed me to take more risks. Somehow the idea that I had achieved success of some kind provided me with something to build upon. I began to produce prodigious amounts of photographs, take on new projects and change jobs with a confidence I hadn't known when I was in the early, striving stages of my career.

As I turned my attention back to the final exam, I thought about how much more difficult it is for today's students to sort out what constitutes true and lasting success, bereft as they are of real role models, as opposed to the current proliferation of "celebrities." I knew then what the content of the final exam should be. It would consist of one question: How will you know when you are successful?

The class — one of the best of my teaching career — was incredulous. After the initial "What's up?" reaction and grinning was over, I explained that it was a serious question and that I hoped they would take it seriously. They did. Many, actually most, of them wrote lengthy answers, taking over an hour to complete their papers. When it came time to collect them, I told the students to keep them, as there are no wrong or right answers. Success for one would — and should — be very different than for the other and is for no one outside of themselves to judge. I only hoped they would keep the papers and consider them from time to time in the course of their lives, if only to save them the time it took me to make the realization I had made that day on the beach.

Much to the disappointment of subsequent classes, I never gave that final again.

Kathleen Creighton studied Photography at Pratt Institute. She has worked professionally producing work for the editorial, publishing and entertainment markets as well as exhibiting her work. An associate professor in the Communications Design Department, she has taught for 15 years and developed new courses, including a number focusing on photography and professional practice. Prior to being appointed Chair of the department in July of 2005, she was the Associate Director of the Career Services office at Pratt, and also co-published RSVP, the Directory of Illustration and Design. A lifelong resident of Brooklyn, she is at work on a book of her photographs.

CALL FOR ENTRIES

EPIC

SOUTHERN EXPOSURE'S FOURTEENTH
ANNUAL ENTRY FEE-FREE
JURIED EXHIBITION OF WORKS BY
NORTHERN CALIFORNIA ARTISTS

Exhibition Dates:
November 12 – December 16, 2004

I THOUGHT THIS LOOKED LIKE SOMETHING DAN WOULD
DO, ONLY BETTER. - A

EPIC

Southern Exposure's
14th Annual Juried Exhibition

Juror: Magali Arriola
November 12 – December 16, 2004

In the OVERLOOK Project Space:
United Net-Works Mobile Archive of Wonders

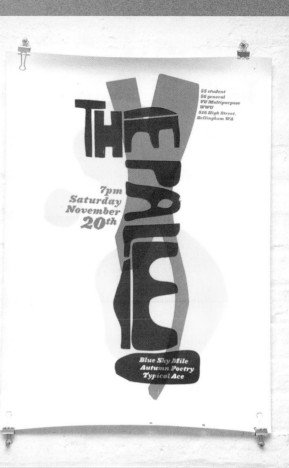

THIS POSTER HAS NO CONCEPT AND LOOKS REALLY COOL. - A

A COOL SITE DESIGN THAT I DID FOR SPEC AND NEVER GOT PICKED. I LATER SAW THE CHOSEN DESIGN AND IT WASN'T AS GOOD. - A

ANDRE TOTALLY COPIED THIS CARD. BUT NOW DENIES HE EVER SAW IT. HIS LOOKED COOLER THAN MINE. - D

EACH POSTER IS DIFFERENT BECAUSE THEY WERE PRINTED ON THE WALL STREET JOURNAL.
SOME COME WITH A VIAGRA AD. MOST OF THESE NEWSPAPERS WERE STOLEN.

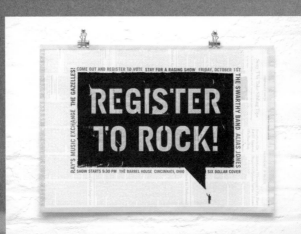

QUESTIONS + ANSWERS

What is the workload like compared to the one we have at school?

—

Mathieu Stemmelen

This really all depends, Mathieu. School is pretty intense since you are learning while juggling lots of classes and assignments. The project deadlines are unrealistic, though, and things move much faster outside of school. You will probably be juggling 5 or so projects at a time and the stakes are higher. If you mess up in school it's usually ok since failure is sometimes inevitable. At your job, however, this same mistake might cost the company a lot of money, your job or your reputation.

You can probably find a job where design is your career. You can coast and make ok money doing ok work. Or you can bust your ass and devote a lot of your time and attention to stuff, taking on freelance or doing self-initiated projects. It depends on what you want out of design. It doesn't have to be this black and white, but there is always something else out there you could be working on, reading, watching or looking at. It really just depends on when you want to call it a night.

Is it worthwhile to buy or make a fancy schmancy book to house your work, or is that just a stupid waste of money?

—

Matthew Eide

We find those big books pretty cheesy, Matthew. Both of us made smaller books, which we printed and bound ourselves. We created enough copies to let people keep them, so when they needed help our work would be fresh in their minds. The big wood or metal portfolio is pretty dated since most people look for websites anyways.

Hey guys. Did/do you ever go through phases where you question your decision to become a designer, and if so, how do you rekindle your confidence in your work?

—

Jess von Sück

Hey Jess. We never really question our decision to become designers because design has taught us so much about problem solving, aesthetics and presentation. However, we do question how long we will practice as designers. We love working in other mediums, like film, web, writing, but we still apply the same thinking we'd apply to design. This keeps things fresh so design is more fun to come back to. Rekindling confidence in your work is a whole other beast. When you have to constantly create new things and be fresh it is not uncommon to question your abilities or lose confidence in yourself. One of our biggest fears is that we will be uncovered and everyone will realize that we are hacks. We are sure other designers think this way as well, since most designers are quite self-conscious people. The key is to trust yourself, take on new challenges and not be afraid of mistakes — it's only design.

Section 3:
After College.

Move across the country. Live on the change in your change cup. Eat pasta for a week. Maybe some bread. Sleep head to toe. Find an apartment with a submarine staircase. Buy a couch. Take the train. Hate Times Square. Love your coworkers. Idolize your bosses. Stay up late. Don't drink coffee. Pretend to know things you don't. Ride in an elevator. Get mad at a girl you are seeing. Pretend to teach. Wake up not so early. Go to your high school reunion. Puke. Buy some pens. Question your career choice. Cheat on your career with a new one. Give some lectures. Miss some planes. Realize you are not tan. Lose a lot of weight. Buy some dunks. Cover up your bad tattoo with a good one. Make a movie. Start texting. Watch your pants get tighter. Realize you don't know what you are doing. Take a day off. Have your editor quit. Trade books for legal advice. Realize working with friends can end up bad. Have another editor quit. Stop shopping at the Gap. Pretend to be a writer. Pretend to be a director. Yell at someone. Get an intern. Take a class. Hang out with people. Spray a fire extinguisher in your friend's hall. Pretend you didn't. Don't trust your landlord. Make a list. Win a soccer championship. Publish this list in a book about yourself and your good friend. Convince people that they want to buy this book. Quit your job. Get a studio you can't afford. Wonder how this will end.

—

THE
MUSIC
TELEVISION

C

1515

The craziness of Times Square is overwhelming when Dan
arrives early at 1515 Broadway for his interview with Jim
deBarros. Standing in front of the building, Dan could see
where they filmed TRL with the MTV store beneath it. He
realized how massive an audience his work would reach if he
worked here, even if it was mostly thirteen-year-old girls
from the Midwest. All of the studios on Dan's "places I
would love to work list" did great stuff, but who saw it?
Designers in annuals, the corporate clients they serviced,
art snobs?

Jim was waiting for him as Dan stepped off the elevator. They
walked through a maze of walls covered by rock posters.
Jim's office was a museum of cool, stuffed to the brim
with design books, DVDs, action figures and other crazy
things. It was also bigger than Dan's bedroom.

Taking Jim page by page through his portfolio, Dan gave his
usual spiel and talked briefly about concepts. There was a
moment in the interview when it became apparent how much
explanation was necessary for each piece and who was going
to flip the pages. No set rules existed, but Dan liked to
drive. He made a conscious effort to get through the work
quickly, to leave enough time for talking about working at
MTV and for poking fun at the Republicans who were in town
with their silly convention.

Jim seemed into Dan's stuff, maybe because most of it was
actual work for actual clients. In Dan's case, "clients"
usually meant "friends," but Jim didn't need to know this.
Dan thought showing less student work would make him look
more professional and this seemed to be working. Their
conversation drifted to a discussion about the future of
graphic design and ultimately onto the topic of designing
for things you love.

Dan left MTV the same way he came in, without a job. He
would have to meet Jim's boss Jeffrey before there was
any sort of offer. This took a few weeks to set up, but when
they finally met, Jeffrey Keyton turned out to be a stylish
man with an addiction to high fashion, a habit of telling
x-rated jokes and a crazy knowledge of design history. Dan
started to go through his presentation, but it was clear
that Jeffrey wanted to drive.

Jeffrey seemed impressed with Dan, who made it very clear
that he wanted to work for Jeffrey. And in turn, Jeffrey made
it very clear that he would have to discuss the specifics

166

with Jim. Dan was tired of getting this run around. He wished that they would just offer him a job already. But this was not how it rolled. Jobs were not always sitting in the back room waiting for proper applicants. Sometimes they just took a while to get and Dan needed to be patient.

Time was winding down at karlssonwilker and Dan wanted to stay longer. This wasn't possible. They had already hired another designer — Emmi. Dan was a big fan of Emmi's, she was very nice and British, he couldn't hate on her. She also had a lot more experience and was much more talented than Dan. He got on a plane and headed back to San Francisco with a Statue of Liberty mug and an itch to come back.

After a week of *Sex and the City* reruns, Dan tells Jim he needs to know about the MTV job or he is going to take another position. This is not totally true, but regardless Jim offers Dan a job. He anticipates a long negotiation for a proper salary, but the number is much higher than expected. Dan is caught off guard and stupidly says, "yes," without even trying to bargain for a higher number. Now there is the issue of getting to New York with all of his stuff, as Dan starts at MTV in less than a month.

Things are moving fast, but Dan likes when things seem out of control and it's time to move on from the city of hobos and sourdough. Dan parties with a few close friends and packs his life in a small trailer to drive cross-country with his brother. He enjoys having this time to clear his head. Back in New York, Dan stays with Nic from Project M till Andre can join him. Nic is a good friend who reads thick books.

FINDING A JOB

Andre also makes a list as his first step to finding a job. It turns out this is much harder than expected. Most of the places that inspire him are in Europe, but Europe is far and Andre doesn't want to deal with being foreign again. There are no firms he wants to work for in San Francisco and he definitely wants to get out of the web industry. San Francisco is small, the design community even smaller, and the people who do good work could fit in your hand. Instead, his list includes New York firms like Open, 2x4 and Base. Dan had moved east, so migrating isn't hard to imagine. Andre decides to make a personal promo campaign and send it to his top ten firms.

He likes Dan's huge notes and decides to do something similar, only Andre's posters contain his life story. Since he has been through a lot for a twenty year old, Andre decides to use funny copywriting to solve the personal branding problem. Funny writing will later become a go-to solution for Andre and Dan. Andre writes the story, listing everything interesting he's ever done, and even some uninteresting stuff. There are three paragraphs — one about Bulgaria, one about immigrating to the states and one

about his special skills. He screenprints over 100 posters and is about to send them out when he notices a typo. On the bottom of each poster it says, "Andre is a Graphic Desinger." He has to reprint everything.

The posters are fine and all, but Andre decides to send something else announcing his arrival, a giant note that has "I want to work for you" written in chicken scratch. The posters are sent and Andre waits for a week. Some people shoot him emails asking to see work, others he doesn't hear from. Andre picks up the phone, sets up quite a few interviews and catches a plane to snowy New York.

Andre's goal is to see ten people in five days. He travels all over New York and meets some of the best designers in America. Andre gets an impression of each studio as soon as he walks in. Some places smell like fashion, others like screenprinting, and some of overpriced designer furniture. Scott from Open welcomes him at 8 AM. The guys at Graphic Havoc take him out to lunch. Paul Sahre generously gives him references. 2x4 people don't have time to meet and the Base people aren't interested.

Andre's portfolio still has the fresh scent of binding glue. He includes a mix of different work that isn't targeted toward any particular industry. This becomes a bit of a problem as many studios specialize in areas such as branding, publishing or packaging. It's clear that the work Andre shows is the kind of work he will be hired to make. Maybe he should have been more selective.

After a few too many awkward hellos and firm handshakes, Andre meets with Jim deBarros, Dan's boss at MTV Off-Air. Jim likes his portfolio, but doesn't have any positions. He tells Andre that Rodger, the On-Air design director, is looking for people. This is something Andre had not expected. He was surprised how many studios didn't have open positions but knew of people who did. With little experience in motion design, Andre is insecure about not knowing After Effects and almost doesn't take Jim's advice.

On the final day of an action packed week, Andre gets a few job offers, but nothing he's madly excited about. He ventures to the MTV On-Air design department in the heart of Times Square. Rodger is wearing red pants and rocking crutches. Despite his limp he is in a really good mood. They hit it off right away. Rodger likes Andre's book and offers him a job on the spot. Andre is shocked and accepts. He swears to learn After Effects and to get a reel to Rodger as soon as possible.

THE FIRST PROJECT

Twenty or so creatively dressed and attractive people greeted Dan on his first day at MTV. Kevin, the department's business manager, told Dan he was talented and at MTV for

desi: terminology.

The term ["desi"] refers to peoples of South Asian Indians, Bangladeshis, etc, into one big group. It [someone who is of the land.] If you know anyone fro this term is now widely used by almost all South Asians they usually refer to, but the slang, westernized definin Perhaps this started just because there wasn't anoth America. After all, Columbus already coined the term are... well, anything but [seeing as how they lived on th were also far away from India.]

card-

sland
Museum
onal Monument

a reason, so he should just relax and be himself. Dan was a
ball of stress, but Kevin's words made him feel at ease.

Dan's first assignment was a Christmas card for mtvU, MTV's
smart-ass college network. He sketched ideas for a few days
before getting a call asking for mock-ups. He panicked since
the ideas were still pencil sketches and a meeting was set
up for the next morning. Dan wasn't used to working this
fast and had to stay late. His favorite idea was a snowman
that peed the words "Happy Holidays." Jim loved it, but
the client didn't and they made him take out the snowman
pee. Dan was pissed. Without the pee the card was not funny.
The client also wanted parts of two comps fused together
into one. This "Frankenstein" killed the card design.

Jim had hired Dan because of his logo work (and maybe also
because he'd harassed him). Putting his logo skills to the
test, Dan's next challenge was to re-brand MTV books, the
small publishing arm of MTV specializing in fiction for
college kids and show-driven titles for young girls. Dan was
paired with Lance, a very talented and quirky art director
from Philadelphia, who used to work at Urban Outfitters.
Dan didn't like to take direction from people, so he tried
to work with Lance rather than for him. Dan was happier with
this arrangement because he could do his own thing without
constantly getting approval.

The constant barrage of work and juggling many projects
at once was new to Dan. He'd always fantasized that work
would be a lot more chill than school. Haha. On top of the
books logo, there were T-shirt concepts and a new
stationary design for Van Toffler, a senior executive at
MTV. He worked on this with Christopher, a witty, big idea
Art Director from Canada who covered his mouse with a paper
napkin that he changed daily.

Van was famous for his frat boy sense of humor and so this
would be a perfect time to come up with ideas like scratch
and sniff pictures of dildos or plungers or just comparing
Van to all the other famous Van's in the world, most notably
Jean-Claude Van Damme. The idea Van dug the most was a
series of forms for getting to know the friendly executive.
Each piece of collateral had different questions with blank
boxes that could be filled in or checked accordingly.

At MTV, Dan appreciated that his ideas were just as valid
as anyone else's, even though he was a lowly designer. He
paired up with Nick, the copywriter and went nuts coming
up with clever phrases for the stationary. Dan loved to write
and considered himself talented with short sentences and
non-SAT words. Being comfortable in many roles while having
an ability to think conceptually helped him stand out at MTV.
The holidays came and Dan was excited to see his family.
He was low on funds, though, and had to cash in change to
get to the airport. In Europe, Dan had maxed out two credit
cards and was now forced to sell some of his belongings to
make rent and buy Christmas presents. Even though he was

making good money, New York was expensive. He was living paycheck to paycheck, barely breaking even between expenses and debt.

After the holidays, when things finally settled it was time to present the MTV books logos. Dan and Lance did a bunch of smart-ass icons and some contemporary type. Most publishers' logos weren't supposed to pop off the shelf, but the MTV logo sold books. So Dan's favorite solution was a system he'd created with a bar holding the logo and some raver looking type. The bar would expand to the size of the spines width creating a band of color when the books were lined up at the store. Jeffrey and the client dug Dan's solution and it now graces such masterpieces as 50 Cent's *From Pieces to Weight*.

After the high of nailing the books logo, Dan started a spree of projects that didn't go anywhere: poster for a My Chemical Romance and The Used concert that everyone but the band's managers loved; DVD covers for Beavis and Butthead that everyone was feeling, except Mike Judge, the show's creator; a poster to advertise VJ positions that Dan commissioned photos for, but was never printed. All this rejection was hard. Budgets, timelines, the approval process, other peoples' schedules, project managers, briefs being changed, not winning a pitch and miscommunications were all variables that Dan didn't have to deal with in school and were now a reality.

IF YOUR PORTFOLIO IS COOLER THAN YOUR WORK YOU PROBABLY WONT GET HIRED.

YOU WILL BE JUDGED ON YOUR WEAKEST PIECE AND REMEMBERED BY THE BEST.

SHOW WORK THAT YOU LIKE TO DO. IT'S THE WORK YOU WILL BE HIRED TO DO.

A FEW COPIES OF YOUR PORTFOLIO IS BETTER THAN ONE; SOME MAY ASK TO KEEP IT.

START AND END WITH YOUR BEST.

SENTENCE DESCRIPTIONS ARE MORE FUN THAN PARAGRAPHS.

TWELVE TO FIFTEEN PIECES IS ENOUGH.

PRACTICE PRESENTING TO YOUR CAT AND/OR FRIENDS.

IF THE CRAFT OF YOUR PORTFOLIO IS CRAP THIS ISN'T GOOD.

PHOTOSHOP OR SHOOT YOUR STUFF IN ACTUAL ENVIRONMENTS TO MAKE IT LOOK MORE LEGIT.

PACE YOUR PORTFOLIO LIKE ANY OTHER BOOK; DON'T MAKE IT BORING OR PREDICTABLE.

IF YOU CAN DEVISE A SYSTEM TO ADD AND TAKE OUT WORK YOU WILL BE HAPPIER.

PEOPLE FROM THE FUTURE HAVE ALSO BEEN KNOWN TO SHOW THEIR WORK ON THE INTERNET.

SURROUND CUTS

DIGITAL SURROUND* PLAYBACK REQUIRES THE USE OF A DTS-DECODER

HATTLER

THERE ARE THE SAME NUMBER OF GREEN AND BLACK
LINES IN EACH ONE OF THESE DRAWINGS. JAN MADE ME
COUNT TO BE SURE. - D

NEW YORK LONDON TORONTO SYDNEY

	Water Filterer	Barfly
	Late Night Smooth Jazz Disc Jockey	Pep Rally Commiss...
	Junk Bond Salesman	Zinger Writer
	Naysayer	X Bad Ass Mo-Fo
	Roadie	Deal Breaker
	Insect Rights Lobbyist	Strike-Anywhere M...
	Experimental Drug Tester	Assistant District A...
	Envelope Licker	Cold Caller
	Dance Therapist	Weekend Santa
X	Some Kind of Wonderful	Professional Group...
	Stereotype	Superhero
	Museum Security Guard	Guy Behind the Guy
	Ozone Layer Observer	Totally Terrific Tem...
	Door-to-Door Meat Salesperson	Water Proofer
	Glove Repairman	Global Interventio...

JOB DESCRIPTION: Don't mess up MTV, VH1, CMT, LOGO, MTV Films, Overdrive ...

WHY DO PEOPLE LIKE YOU? (check box if applicable)

X	I'm a Little Bit Country		My Culinary Skills
X	I Have a Trampoline		I Am With It
	My Shrink Told Them To	X	I Can Freestyle

THIS IS MY HANDWRITING ON OF ALL THE STATIONARY, NOT VAN'S.
PLEASE DON'T TELL ANYONE. - D

	Rabbit Foot Collecting	Pimping My Ride
X	The DMV	Voting
	Playing House	Model Car Painting
	Collecting Ferns	Beach Combing
	Shopping	Paleontology
	Jumping Jacks	Bird Watching
X	Working On My Biceps	X Ranking People's Feet
	Cursing	Running Game
	Backseat Driving	X Teaching Spanish to Men
	Eye Exams	Looking in the Mirror
	Internet Disc Jockey	Gardening

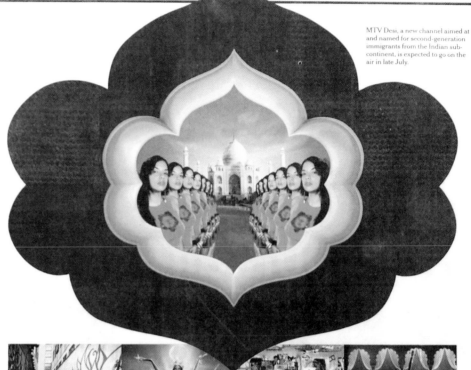

The New York Times

Arts & LEISURE

INSIDE

7

SAY, ISN'T THAT . . . ?

Elizabeth Berkley, now in 'Hurlyburly,' may be better known for lesser performances. But why dwell on the past?

27

SOPRANO OF THE SUBURBS

What is Renata Scotto doing at a Westchester D.M.V.?

26

A NICE PLACE TO VISIT

How Austin landed the new season of 'The Real World' (and whether it's worth the effort).

MTV Desi, a new channel aimed at and named for second-generation immigrants from the Indian sub-continent, is expected to go on the air in late July.

DESPITE HOW MUCH I LIKED THIS NOTE CUBE, NOBODY BOUGHT IT. - D

EVEN THOUGH WE HIRED AND PAYED A PHOTOGRAPHER FOR THESE PHOTOS, THIS POSTER WAS SADLY NEVER PRINTED, EXCEPT FROM OUR EPSON TO FAKE THIS PHOTOGRAPH. - D

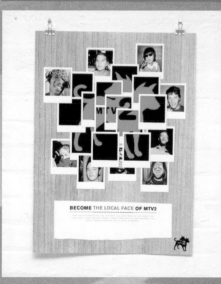

BECOME THE LOCAL FACE OF MTV2

173

WHEN IN DOUBT, CROP THINGS TO
MAKE THEM MORE INTERESTING. - D

MUSIC: HIGH DEFINITION MTV VH1 CMT

MORE VIDEOS ∧

VIDEOS

MUSIC SHOW CLIPS SHARTS

BUSTA RHYMES
TOUCH IT

TWISTA
HIT THE FLOOR

AGAINST ME!
DON'T LOSE TOUCH

MATISYAHU
KING WITHOUT A CROWN

FORT MINOR
BELIEVE ME

ARTIST
Busta Rhymes

TITLE
Touch It

ALBUM
The Big Bang

LABEL
Aftermath/Interscope
Records

DIRECTOR

BANDS A-Z

MTV2

VIDEOS
DOWNLOADS
SHOWS
SHARTS
NEWS

MIKE JUDGE HATED THESE COVERS.
EVERYONE ELSE DIDN'T. - D

HEY
THIS
SUCKS

UH
HEY
BABY

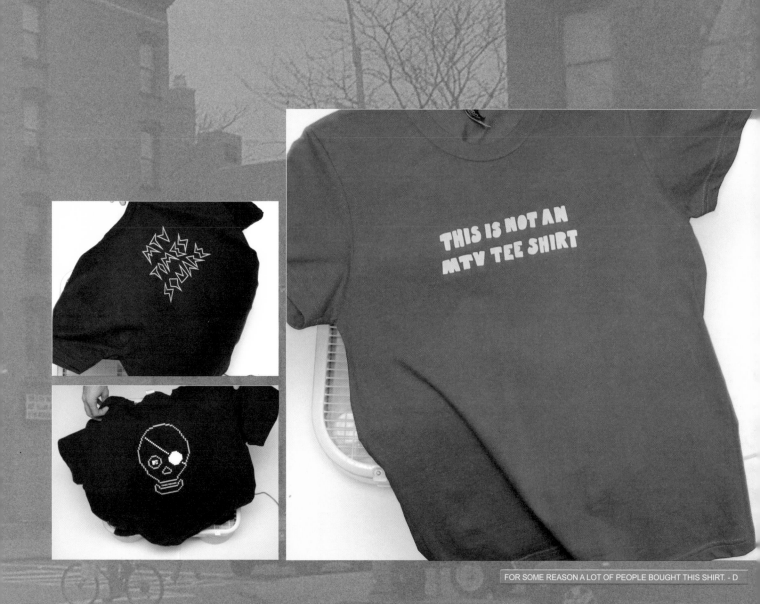

THIS IS NOT AN MTV TEE SHIRT

FOR SOME REASON A LOT OF PEOPLE BOUGHT THIS SHIRT. - D

MTV NYC

MTV TIMES SQUARE

2:35 AM

i love you man

i am glad we met eachother

ok

wtf?

just dont say it enough

ok

hug

air hug

4:42 PM

hows it goin champ

chillin

u

aight

i had to take one for the team

my girl wanted to hang tonite

boo

but you gotta do what you gotta do

yeah

tomorrow

tomorrow she busy, maybe teusday, we'll see

soon enough

she is leaving for 10 days to ireland after tuesday

fuck

so hopefully tuesday nite

4:45 PM

andre aint no bitches pet

haha

VIDEO MUSIC MUSIC AWARDS

MUSIC

THE VMAS

After his streak of unrealized projects, Dan was ready to nail something big. He got the chance with the Video Music Awards logo. Like every other big project at MTV, getting the logo was a competition where people pitched ideas and one rose to the top. Geoff McFetridge, an idol of Dan's, had done the previous year's logo. Lance did it the two years prior and he, Dan and Rich were asked to pitch concepts. Rich was by far the most talented designer at MTV and Dan was intimidated by his skills and sneaker collection.

The Video Music Awards were MTV's biggest event of the year, so winning this logo would provide some public exposure. The show would be held in Miami. Three outside firms were asked to pitch solutions, that along with those of the in-house team would be edited by Jeffrey and presented to the producers. Dan worked eighteen to twenty hours a day on his VMA logos, asking Andre for advice as he went. Andre was a harsh critic and pretty much hated everything. If Dan could get him to say it was ok, Dan knew it was great.

As usual, Jeffrey was not very impressed with the VMA logo concepts at all. He was a hard man to please and constantly forced everyone in the office to raise the bar. Dan and Rich kept trying and would stay late every night and even came in on the weekends. Jeffrey would pop in every few hours and Dan hated this, as he had a huge fear of people seeing his work in progress. With the deadline rapidly approaching, Dan could barely eat. He was insanely tired and broke out in a huge stress rash.

Inspired by the art of Takahashi Murakami, Dan drew a water drop, but everyone was leaning towards one of Rich's solutions. While Jeffrey was presenting their logos to the executives and producers, Dan and Rich both pretended not to care who won. Jeffrey emerged from his office and walked over to shake Dan's hand. His water drop was chosen. Dan was ecstatic, but ready for a break. The funny part was that he thought he would get one.

With little rest, Dan started applying his logo to every tchotchke under the sun: key rings, pens, dog dishes, towels, gear, cars and buildings. Then, for the first time at MTV, while working with photos to mock up ideas for the VMA advertising campaign, Dan realized he had no idea what he was doing. This was a foreign process to him. In school, Dan's designs weren't rooted in photography because of the amount of time it took to get a good image. As a result, he didn't know much about working with photos. Luckily, Jim

and Christopher were patient with Dan and taught him more than a few tricks, like rotating an image a few degrees to give it tension.

AFTER EFFECTS

Andre and Dan get an apartment that costs three thousand dollars a month. Unfortunately, they have to put down a deposit, the last month's rent and the broker fee in just a few days. The bill quickly adds up to nine thousand dollars. Andre and Dan find themselves with a new apartment and no money. Desperately they deposit the contents of Dan's coin jar for food, but the jar, which holds about twenty-seven dollars, runs out quickly. They now have three dollars between them and are forced to eat pasta without sauce for a week.

The whole Sunday before his first day at MTV, Andre spends learning After Effects. He understands the basics, but there are many parts he's unfamiliar with. MTV On-Air's offices are average, with cubicles, overhead lighting and general quietness. Andre gets a great seat next to a big window. Rodger gives him his first small job, animating a bug — a little logo that appears in the corner of the screen. Andre is terrified that this simple animation will uncover his poor animation skills. He doesn't take a lunch break on his first day and eats only candy from the vending machines. At the end of the day he leaves and continues work at home. Then, after a late night, Andre shows the bug to Rodger, who seems impressed and approves it. Andre is relieved.

PLAYING UNDERWATER

Andre's first real project is the Video Music Awards ancillary packaging — the promos announcing the show. The ten-second spots are basically extended logo animations. Andre has Dan's logo to work with and the general themes of "water" and "hotness." Rodger gives him a wad of cash to buy design books. Andre is pleased to have the time and resources to spend on research — his favorite part of design. Unaware of the budget constraints — or any constraints whatsoever — Andre comes up with ideas that cost hundreds of thousands of dollars to produce.

After a few weeks of design and research, it's time to present the storyboards to Romy, Rodger's talented boss. She is the vice president of the On-Air department. Rodger is sick, so Andre presents the boards alone. Romy is unhappy with everything and stresses that every idea is out of budget. She asks technical questions that Andre can't answer. He leaves the meeting confused and scared that he fucked up. This is his first major project, and messing it up might mean losing his job. The next day he is called into a meeting with Jeffrey, Romy and Rodger. Andre prepares for the worst.

Jeffrey's office is painted bright orange and it kind of
hurts to look directly at the walls. Andre is quiet at the
meeting, nodding his head as Jeffrey rants about another
project for the VMAs. The biggest project for the show is
the category opens — short intros to each of the individual
award categories that were given to three different
contemporary artists for a pitch. Jeffrey shuffles through
the boards and briefly shows them to Andre, who isn't
particularly impressed. Most of the proposals are too artsy
and lack the graphic sophistication expected from designers.

Jeffrey pulls out one of the ideas that Andre proposed for
the ancillary package. It's a simple idea — beautiful
models, dressed in couture, swimming and posing underwater.
Jeffrey likes it and takes the board to the producers.
Andre gets a pat on the back and he and Rodger leave the
meeting surprised. An hour earlier Andre thought he might
be fired and now he might be in charge of the biggest
campaign of the year.

A week passes and Andre slowly learns about the numerous
levels of approval at MTV. The good news is that his idea
for the ancillary packaging will be used for the category
opens. He and Rodger start pre-production for a big
underwater shoot. Andre begins by making a style reference
book full of underwater photos, different clothing,
jewelry, make up, styling, models and colors. This book will
determine who is cast, what they will tell stylists, guide
the director of photography and be an excuse for Andre to
stare at models all day.

After some Internet research, Andre finds a DP whose style
frames he's been using for comps. His name is Ric Frazier,
an underwater director from LA. Ric comes by the office to
chat about the project. Andre and Rodger imagine an old
school photographer, like a character from *The Life Aquatic*.
Ric turns out to be a young guy with a slight slouch, thick
long dreads, and flip flops for shoes. He doesn't say much
other than, "no problem" and, "yeah... we could do that."

Andre and Rodger fly out to LA to cast the shoot. They stay
at a fancy hotel with many flat screen TVs and expensive
cars in the driveway. On the day of the casting, Ric's
producer drives them to a small backyard pool where Ric is
waddling around in full scuba gear, waiting for the models
to arrive. The pool is in the back of a dingy underwater
store. It's nothing like the MTV casting Andre had expected,
more like a hidden camera show. Most of the girls are
surprised that they have to jump in the pool and many of
them don't even know how to swim. Andre and Rodger sit
on the side with notebooks, big sunglasses and lots of
sunscreen. They are referred to as the New York guys.
It's quite obvious who does well underwater, since most
people look like they are about to drown.

The next day, they drive to a suburban school with an Olympic
sized pool. The shoot's biggest obstacle is its time

ONE PAGE IS MORE THAN
ENOUGH, IF NOT, USE
SMALLER TYPE.

DEAR SIR OR MADAM COVER
LETTERS ARE STOCK. GET
PERSONAL.

PEOPLE WON'T CARE ABOUT
YOUR HIGH SCHOOL DAYS IN
THE ICE CREAM SHOP.

WHERE HAVE YOU STUDIED?

WHO HAVE YOU STUDIED WITH?

WHERE HAVE YOU INTERNED?

WHAT ARE YOUR SKILLS?

WHAT AWARDS HAVE
YOU WON?

HOW CAN PEOPLE CONTACT
YOU TO SAY THAT YOU'RE
AWESOME?

EVERY DESIGNER LOVES A
GOOD TYPO.

constraints. They only have one long day to shoot footage for 12 categories. Leslie, a producer from MTV, arrives in the nick of time and ties up all the loose ends while making stuff happen. There is no set schedule. This becomes a huge problem since there is little interaction between the stylist, make up, DP, models, Rodger and Andre. Communicating with Ric, who is mostly underwater, is achieved by shouting, repeatedly. The shoot is heading for disaster. Rodger is nervous — and he never gets nervous! Leslie is upset at the negligence of the producer. She takes the producer aside and they go back to the hotel room to work on a schedule.

Leslie returns with a neatly typed schedule telling when and where everyone needs to be. Being on schedule and getting the shots done is priority number one. No matter how creative and talented someone is, without the proper preparation they are screwed. Andre learns to over-prepare since over-preparing leaves room for mistakes and for having enough time to improv. The next day, Ric meets them at the color correction facility to look at the footage. It looks beautiful. Everyone is pleased and Rodger leaves with a big smile on his face.

When they get back to New York, the project takes an unexpected turn. The show's producer requests that his friends handle the category opens. Since the producer is in charge of the show, MTV has little to say. On a conference call, the producer's friends throw out ideas like adding explosions and underwater fire and having people burst out of air bubbles. After nearly three months of work, Andre is forced to put his project up for adoption.

The department starts preparing for the show. They will be making animations for huge screens behind the performers. Before heading to Miami, the team does over a thousand generic animations, about 40 of which will actually be used. Andre packs a bag and the team flies south.

Miami is excited about the VMAs. There are huge banners and billboards at the airport and on every major street. Dan's logo is everywhere and Andre calls to congratulate him. Days before the show, the department sets up shop in a trailer behind the arena. They will be working around the clock in shifts, making more screen animations for performers. Andre gravitates to his favorite rappers and does screens for 50 cent, Tony Yayo, Mobb Deep, Kanye West, MC Hammer, Ludacris and the dancers from Rize. He also stupidly volunteers to do all of the screens for the host — P Diddy. The screen producer calls Andre "Diddy's bitch" to his face. Even though it is a joke, Andre definitely contemplates punching him in the face.

After ten days of 16-hour shifts, the show is ready. The crew gets nice seats and orders drinks. The VMAs open with a montage of the underwater footage that Andre and Rodger directed. Both of them are far from impressed by how the other firm chose to edit the footage, but Andre is too drunk to care.

The VMAs were a long and arduous process but, in the end, it was worth the four months of work. Dan got to see his logo and the ad campaign he'd worked on, take over New York and other cities. And the on-air stuff Andre directed took over the channel. It was not a bad gig for two kids who were less than a year out of school. Dan flew down to see the show in Miami. He was happy and there was his logo, three hundred feet high, on the side of a stadium.

WORKING FOR YOUR STUDIO

Emmi Salonen

WORKING FOR MY STUDIO

I LOVE IT
I choose who I work for.
I get all the credit.
I design the layout of the studio.
I organize my day around what I want to/need to do.
If I like you and your work, I can ask you to work with me.
If I don't like you and/or your work, I can ask you to leave.
I make all the decisions.

I HATE IT
I make all the decisions.
When there's no work, there's no money.
I stress about projects… and money… and time…
and the future.
I have to fix the printer/light bulb/accounts/
internet/mistakes…
Nobody covers me on my holidays. Do I get a holiday?
I'm not getting enough feedback. Am I evolving as
a designer?
I can't switch off.

WORKING FOR THEIR STUDIO

I LOVE IT
I get paid every month.
I get paid when I'm ill.
They've got all the responsibility.
They have a cleaning person/accountant/IT guy…
When there's no work, there's no worries.
They have a lovely studio and they are lovely people.
I learn from them.

I HATE IT
I stress about the projects.
They get all the credit.
I have to work with whoever they hire.
They manage my time.
They make the final decisions on my design.
They choose the clients.
I think I could do better if I had my own studio.

Originally from Finland, Emmi Salonen moved to the UK in 1996. She graduated from University of Brighton in 2001 with a BA Hons in Graphic Design. Straight after, she moved to Italy to work at Fabrica, Benetton's controversial young designers' melting pot. After a year, she was back in London where she worked a couple of years at Hoop Associates until moving to New York in 2004. There she was with karlssonwilker, a company known for its wit and clever designs. In 2005 she relocated again and started running her own practice, called Emmi, based in a converted gun factory in East London, UK.

DEO
SIC
RDS

MTV
MUSIC TELEVISION®

05
VMA

SHOTS FROM THE VMA UNDERWATER SHOOT. DIRECTING WAS A LOT HARDER THAN I THOUGHT.
I HAD TO HAVE AN OPINION ON EVERYTHING AND BE THE AUTHORITY ON THINGS I KNEW LITTLE
ABOUT, LIKE STYLING AND WARDROBES. - A

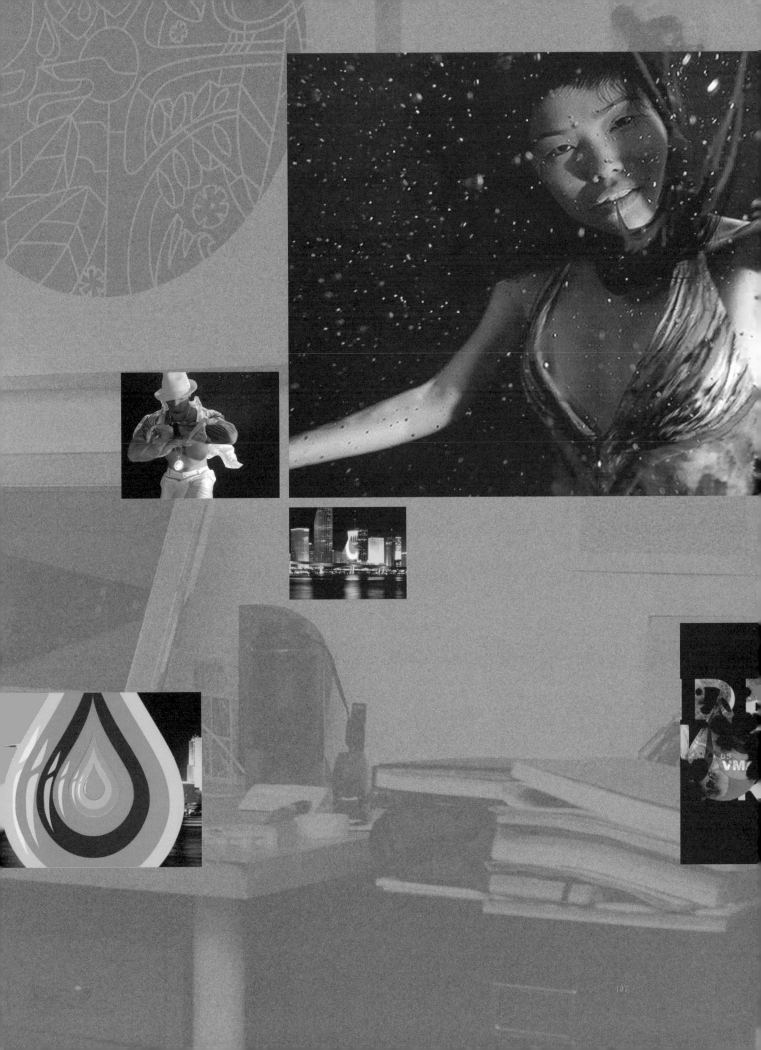

PRATTASTIC

Andre and Dan always talked about teaching, but never really thought about pursuing it. The news that Pratt, an art school in Brooklyn, is looking for type teachers comes from Lance. Dan and Andre figure there's nothing to lose and they apply. When the semester is about to start and they haven't heard anything, they expect the worst. Surprisingly, Kathleen, the new chair of communication design, shoots them an email. They're hired and their class will start soon after. Grateful for the opportunity, they promise not to disappoint.

Dan and Andre are very nervous for the first day of class and are worried about being exposed for their lack of experience. They decide to grow beards and wear button down shirts, to look more professor-like. They also try not to swear as much as usual. Andre is better at this than Dan, who feels that the students will think he is cooler if he swears.

They base their class on Eric Heiman's directors project that Dan did in school, since it was a turning point in his education. Instead of a film festival, their class will be focused on branding and promoting an indie band. They choose some of their favorite up and coming bands and pair students with bands opposite their tastes. This is a conscious effort to challenge the students to work with content they are not drawn to, a task they would face on a regular basis in their careers (or at least in the beginning). About 14 kids show up for the first class and 10 return for the second. Andre is usually too nice to everyone because he is afraid of hurting feelings. Dan is a bit meaner, but not enough.

Overall, the class goes a lot smoother than expected. Dan and Andre begin to feel comfortable talking in front of large groups and some kids even laugh at their jokes. As the semester progresses, they learn how to play off each other and compliment the other's contribution to the class. Teaching also helps them develop their voice as art directors, a skill that helps them order food in restaurants more decisively and translates back to their jobs.

SPANKIN NEW MUSIC

Andre's next project at MTV is an important one. He is tasked to design three show opens for an upcoming week of new music. The design will have to incorporate a visual device called the orb. The orb is exactly what it sounds like — a futuristic — looking gray thing. Since MTV has so many channels, this will be the one unifying element that lives

on all of them. The idea is that each open will represent a different genre of music. There will be a hip-hop, rock and pop version. Andre presents a variety of treatments. He does some animation ones, some live action ones and some that are just hilarious. Jeffrey likes the ideas and they decide on a very stylized concept with different stuff popping out of the orb.

Eban, the main 3-D animator, likes the boards, but freaks out about not having enough time. He takes many smoke breaks to cope, but they still only have about two weeks to produce three fifteen-second spots. This is usually the production time for one spot so the department hires a few extra animators to help.

They start working on the first spot which is centered on a giant piece of graffiti. In his boards, Andre uses graffiti by DAIM, a famous German writer. Andre tries to get in contact with DAIM about using his work. A few days pass and DAIM writes back; he is down. A good thing about working at MTV is that everyone wants to work for MTV. Even though DAIM has no idea who Andre is, MTV gives him credibility.

With time running out, everyone is on edge. Rodger warns Andre that if he pushes people too hard, they will turn against him. Andre is under the impression that Eban and the animators HAVE to do as he says, but for them to do a good job they also need to be happy. He bribes them with pizza and red bulls to get the job done. After two weeks of non-stop work, the project is a wrap. Rodger and Andre go to a sound session with Paul and David at eargoo. Andre has a great time working with the sound guys and they become good friends. Later, one of the spots wins an award for sound design and Andre gets a golden statue similar to an Oscar. It's big and flashy, eclipsing Dan's Adobe Award on the trophy shelf.

VIACOM

Dan and Andre work together well, though rarely get the chance to team up at work. Out of the blue they are pulled to work on a top-secret project together. Rumor has it that Viacom, the parent company of MTV and many other networks, is splitting from CBS and needs a new logo. They are on the project with Lance, Christopher and other outside studios. This is a big deal. Viacom is one of the biggest media companies in the world. Chermayeff and Geismar, an amazing branding firm, designed the original Viacom mark, so Andre and Dan have a huge opportunity ahead of them. Jeffrey, aware of the importance of the project, lets them work from their apartment for a month.

They start brainstorming possible ideas for the logo. In the beginning, ideas are easy to come by. They plaster their studio wall with sketches of chameleons, three legged monsters, boats, globes, flags, time travel, explosions, word marks, screens, antennas and a cloud with a flag on top.

During breaks they fantasize about asking Chermayeff and Geismar out to lunch after winning the logo.

Most days Dan and Andre work late into the night. They find some of their best (and worst) ideas come between 2 and 4 AM. During those hours they don't filter out stupid ideas, and some of the ideas are brilliant.

This month-long period of working from home is a taste of what life would be like if they had their own studio. The two can go watch a movie or play basketball, it doesn't matter as long as they get their work done. By the time the fourth week is over, their idea banks are starting to run on empty. They start naming off objects in the room as solutions for the logo. Since the company is so big and hard to quantify, pretty much anything will do: a house; a plant; Bruce Willis.

On mandatory home-office lunch breaks, they wander the streets, amazed at the number of weirdos who aren't at work. What the hell are these people doing roaming the streets of the East Village at three o'clock on a Tuesday?

Late one night, when they are feeling exhausted, Dan has the idea to play a game called "Pocker" where one person throws a paper ball at the other. The other person has to use his hands to deflect the ball and keep it from passing through them. The game quickly pumps up their adrenaline and suddenly they don't feel so tired. Andre becomes surprisingly good and wins two championship belts. Dan has a hard time catching up and doesn't win a single belt. Frustrated at his inability to win, Dan crushes the ball and throws it off their roof. They never play again.

After a couple of weeks, the walls are covered with ideas, some good, most bad and they edit them down to fifteen or so. Andre and Dan are a bit hesitant to present such rough sketches, but this was what Jeffrey wanted. The presentation goes great and their flawless mounting impresses everyone. Unfortunately, many of the logos get killed because they look like crap. Presenting sketches turns out to be a bad idea. The presentation was supposed to be about concepts, not logos, but their bosses are looking at the silly drawings as logos. If they had spent a little bit of time designing some of their favorite ideas, they might not have gotten killed. But a bunch of their ideas go on to the next round, though most don't materialize in the translation process. Slowly but surely all of their original ideas fall by the wayside and they begin to think of new ones. Their favorite is CEO Tom Freston's face stretched to make an abstract color pattern. Numerous revisions and two months later they are still going. An idea similar to one Dan and Andre pitched early on of mashing all of the Viacom logos into one crazy logo almost gets chosen when an outside studio presents it, but instead the project continues. The only idea they have in the running is a "content screen" representing all screen-based media. Dan takes the lead and makes hundreds

DAILY WEBSITES
—

HYPEBEAST.COM

MANYSTUFF.ORG

VELOSPACE.ORG

NAHRIGHT.COM/NEWS

SOHH.COM

MACRUMORS.COM

VVORK.COM

HEDISLIMANE.COM/DIARY

AS-FOUND.NET

NEWSTODAY.COM

HOMESTARRUNNER.COM

EVERYONEFOREVER.COM

VBS.TV

FFFFOUND.COM

CS.CMU.EDU/~TOM7

of revisions, but in the end it doesn't get chosen and he kicks a door.

Happily, Dan and Andre are taken off the project. It was beginning to drive them crazy anyway. They look at this as a missed opportunity, but have learned how to present better and won't repeat their mistakes. A second crew of even bigger celebrity designers like Peter Saville and Geoff McFetridge are brought in to clean things up. After countless rounds, a futuristic logotype that Lance draws ends up being used. Dan and Andre congratulate Lance, and laugh because the pattern made from CEO Tom Freston's face lived in the background of the Viacom website for a year, even after he is fired. They never invite Chermayeff and Geismar out to lunch.

PICTURES ARE LEGENDARY

Right after the first round of Viacom logo ideas are due, Andre and Dan get an email from Rich Frankel. John Bielenberg has recommended dress code as a "hot young design studio." Rich is looking to get a logo designed for a production company called Legendary Pictures. Legendary has their hands in the newest Superman and Batman movies and wants to hire a handful of small studios, rather than one big firm for the job. Along with Volume, their former teachers, dress code is one of the studios. On a conference call, the partners of Legendary refer to Steven Spielberg as "Steve" and Andre busts out laughing. The fee for the first round is ten thousand dollars. Andre and Dan are swamped with Viacom, but couldn't turn down the money. They only have a week.

It is a bit weird to be competing with Volume as a "real" company. This is real, though. Now that they've left school, dress code is just two guys with computers in a sea of people with computers. Nobody cares if they were hot shit in school, all that matters is their work and how they present themselves.

Rich tells them they can present rough sketches, but they aren't about to fall for this trick again. The terms "rough" and "sketches" seem to mean different things to different people. To work faster, they use ideas from old projects along with some new ones. A few of the treatments are pretty obvious, like big "legendary" type in perspective. Others are whimsical, like Paul Bunyan's Babe. Presenting via email sucks because they can't sell their ideas as well. They add funny copy to the presentation, hoping to make their work more memorable. Dan and Andre are confident with the ideas and begin planning what they will buy with all the money. Andre wants a new bike. Dan wants some dancers.

After a few days, they hear back from Rich. Unfortunately, their logos were not chosen. They get their kill fee, but this will be the end. Apparently, the board of directors

fell in love with a logo made by an LA company. To this day, this is the most lucrative job dress code has ever done; for two days of work Andre and Dan get eighty-five hundred dollars. It doesn't hit dress code what a big project this was until the Legendary logo airs at the opening of Batman Begins.

To get paid they need to establish themselves as a legit business, with legit paper work and a legit checking account. Their good friend Jimm from Project M was a lawyer in a previous life and gives Andre and Dan legal advice in exchange for coffee table books. He helps them make an official partnership agreement, the kind they have to sign. Dan witnessed a twenty-year partnership go sour while he was at Vehicle and didn't want this to happen between him and his good friend.

MAKING STORYBOARDS FOR ANIMATION CAME EASY; IT WAS JUST LIKE MAKING POSTERS THAT MOVE. SINCE THERE WAS NO LIVE ACTION IN THIS SHOOT, WE WERE IN CONTROL OF EVERYTHING. - A

BOYCOTT THE WOODIES

NOV. 9TH & 10TH
IF YOU CARE ABOUT THE RECORD EXECS

THIS IS WHAT WOULD HAPPEN IF THE CLIENT CHOSE THE FUN DIRECTION. - D

woodie
AWARDS 2005

THE BEST IN MUSIC
VOTED ON BY COLLEGE STUDENTS
NOV. 10TH ON mtvU
RECORDED LIVE FROM NYC mtvU.COM

THIS IS WHAT HAPPENS WHEN THE CLIENT CHOOSES THE SAFE DIRECTION. - D

DAN'S GRAFF SKILLS PLUS ANDRE'S PHOTOSHOP SKILLS = THIS LOGO.

A BILLBOARD WE DID SOMEWHERE IN OHIO. - D

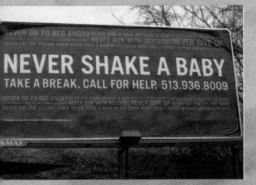

NEVER GO TO BED ANGRY NEVER RIDE A BIKE WITHOUT A SEAT
NEVER RUN WITH SCISSORS NEVER GIVE UP
NEVER EAT THE YELLOW SNOW NEVER JUDGE A BOOK BY ITS COVER

NEVER SHAKE A BABY
TAKE A BREAK. CALL FOR HELP. 513.936.8009

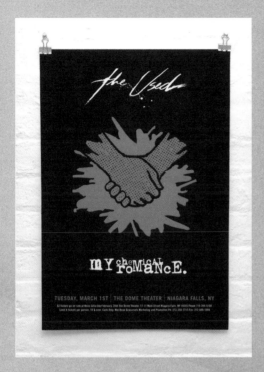

WESTMINSTER SOCIAL CLUB

CRAIG'S GLOW IN THE DARK AND GOLD PLATED BIKES. YO CRAIG, HIT US AFTER YOU GET BACK. - D

EVERY LOGO IN THE VIACOM FAMILY MUSHED INTO ONE.

VIACOM

LOTS OF IDEAS FOR THE VIACOM REBRANDING THAT NEVER WENT ANYWHERE BEYOND A PRESENTATION BOOK. THEY STILL MADE US LAUGH.

VIACOM
VIACOM
VIACOM

197

THIS PAGE IS ALL STUFF FROM OUR FAILED MAGAZINE.
THE RESULT OF A YEAR OF WORK AND LOTS OF DOLLARS.

HOME | ABOUT | RANTS | REVIEWS | THE REX
MADHEADS | GRAB BAG | CONTACT | ?

GOODHUMAN

PARTYWITHREX

REVIEWS MORE ▶

Upcoming Issue:

I Spit on Your Grave
(1978) directed by Meir
Zarchi

After watching this movie I
took a long cold shower
and couldn't talk to a
woman for about two
weeks. The film (also
known as Day of the Woman) while not the
most banned movie is possibly the most
difficult movie to watch even with heavy
editing. The heroine Jennifer (Camille Keaton)
travels to upstate New York to finish her
novel. The local men give her and hand and
then get a little out of hand, beating her and
raping her four times before she loses it and
takes bittersweet revenge. While it's hard to
say this is a "good" movie, it is pretty well
executed and as a dude I felt guilty for having
a penis. And while there are very little special
effects, the shit is gory and graphic, so you
might want to watch this one and go straight
to church after, just to chill.

RATE IT STEAL IT BUY IT

Layer Cake
(2004) directed by
Matthew Vaughn

In the tradition of great UK
gangster flicks such as
Get Carter, Lock Stock,
and Sexy Beast, Layer
Cake once again proves
that American gangsters are pussies. I mean
big sopping drippy pussies. They don't have
the same swagger or finesse, the same brutal
intelligence or restrained savageness. And for
god sakes they don't have cool ass accents.
Daniel Craig aka the new James Bond plays a
nameless cocaine dealer trying to get out of
the biz but gets pulled in for one last job.
Double crossings, fine suits and a beatdown
with a coffee maker; you can't possibly want
anything else from this movie save to be in it.
Slap your mother now for not being born
British and just start saying "Oi!" for the fuck
of it.

RATE IT STEAL IT BUY IT

Issue #1
From taxi drivers to prison
inmates, sewer inspectors to
black cowboys, strippers to
bus drivers - everyone has a
voice and everyone has
something to say.

GOODHUMAN celebrates
everyone invoved in the
hustle.

FEATURES MORE ▶

H.A.L.B.E.R.T.'s Universe
Halbert ain't no punk. He decided to board up his cubicle
forever and give the freshest of the web to the people.
HALBERT LOVES THE KIDS.
CHECK OUT THE DAILY FRESHNESS ▶

Follow That Cab
Man is only separated by six degrees. Ever wonder where
people are heading at 2 o'clock in the afternoon when they
yell "Hey, TAXI!!!!"? Well, let's find out.
YES, THIS IS NOT ILLIGAL ▶

MAILING LIST

Name Email ▶ Send

All rights reserved, GOODHUMAN syndicate © 2006

WHY IS IT THAT OUR WORLD IS
FILLED WITH SO MUCH POO?

INAPPROPRIATE HANDSHAKE

WRITE TO
GOODHUMAN

ANOTHER RECYCLED IDEA. BUSINESS CARDS
WITH A PLACE TO WRITE ON THEM.

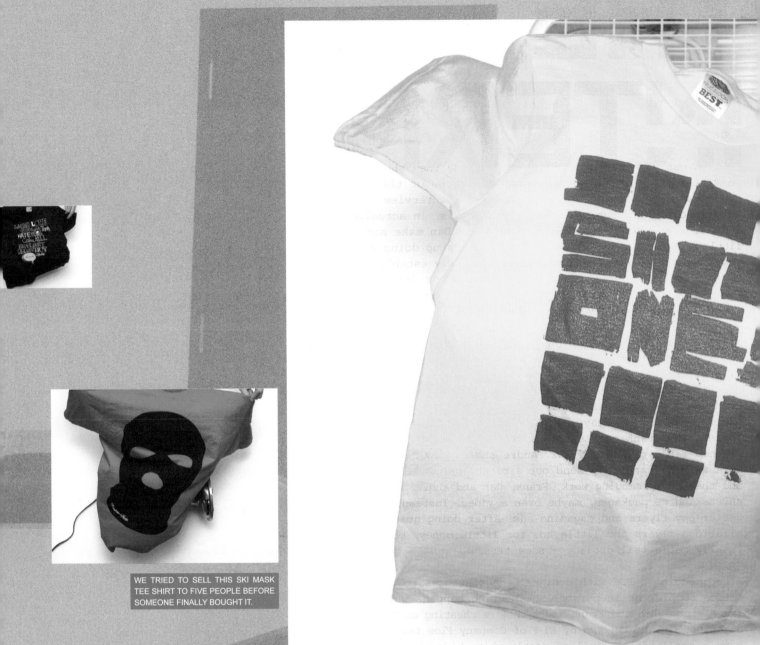

WE TRIED TO SELL THIS SKI MASK
TEE SHIRT TO FIVE PEOPLE BEFORE
SOMEONE FINALLY BOUGHT IT.

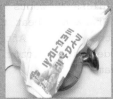

THE INTERN

SOME JOBS

Since dress code has a "studio" they decide they should get an "intern." Her name is Kate and she is one of their students from Pratt. Kate shows up for the interview and is surprised to find out that their "office" is, in actuality, a small East Village apartment. Andre and Dan make her a little desk and put a plant on it. She ends up doing a logo and a card for Preston from Project M's newly established business — Studio Aquatic. Andre and Dan aren't impressed. This isn't Kate's fault, though. When hiring an intern, Dan and Andre assumed they would be getting another designer of equal ability, but soon realize the large amount of direction interns need. Even though she works hard, it's not worth having someone come in just one day a week. Kate will be their last intern for a while.

Frank is a friend of Dan's from karlssonwilker. He is from Queens, has a deep heavy voice and thinks he is good at basketball. Frank needs help impressing a client, an indie hip-hop label called Def Jux. Andre and Dan combine their work with his and they send out a pitch. Def Jux likes it and they start sending work. Frank, Dan and Andre hope to get shirts and CD packages, maybe even a video. Instead, they get crappy flyers and magazine ads. After doing quite a few hilarious flyers and little ads for little money, they finally get a real project — some tees.

NEVER FALL IN

After sending a PDF with designs, the crew goes to the Def office to present in person. The meeting happens while they are taking lunch and Frank feels they're cheating on their day jobs. Def Jux is run by El-P of Company Flow fame. They have a small office, full of mostly white kids who look like they dropped out of college too early. In their conference room there is a giant portrait of El-P — no matter who is in the room, the photo is always watching them. The label guys like the shirts and pick three. They promise to print them right away and to print three more next season. They pay four hundred dollars a shirt. Def Jux goes on to explain that per album designers get fifteen hundred dollars at most for the package. Definitive is definitely cheap.

Frank begins to collaborate with dress code on other projects. He wants to be the third member, but there is only room for two desks in the studio, unless he wants the intern seat. Dan and Andre agree that if Frank can beat them in basketball he can have a share of the company. After a long hard game and one ali oop, dress code reigns victorious and Frank is forced to give up the dream.

Andre and Dan start thinking about ways to promote themselves and keep a buzz going. Andre has an idea. He contacts Curtis, the publisher of *CMYK* magazine. Curtis is excited to hear how well Andre is doing. In every issue there is a section called "Where Are They Now?" and he wants to interview Andre. Andre and Dan find out how easy it is to get something if they just ask for it. Later, they ask the editor of *Communication Arts* to be in their "Fresh" section and it works, even though they don't technically have a company yet.

WESTMINSTER SOCIAL CLUB

Andre and Dan meet a guy named Craig after a drunken night with friends. He is about to start a company called Westminster Social Club to make specialized BMX bikes, and he needs branding. Craig doesn't have a business card, but writes his info on a dollar bill. A few days after they sober up, Craig calls. He has two bikes, one is glow in the dark and the other coated with gold. Dan develops a few different directions for the logo. He and Andre like a simple drawing of a bowler hat with serif type on the bottom. Craig is harder to convince. He answers questions with questions, changing his mind constantly. Dan feels like every time they meet, Craig is testing their character. Finally, Craig has a dream about Clockwork Orange and loves the bowler hat.

It is amazing how many connections come through Andre and Dan's friends. In fact, dress code has never really worked on a project that didn't come from a friend. They don't try to "network;" they just meet friends of friends who need design. Even old friends from Andre and Dan's childhoods and college days are coming out of the woodwork.

Westminster sounds like an amazing project and, like most amazing projects, it doesn't pay. This is fine since they are used to working for free for bands and have day jobs to pay the bills. To ice the deal, Craig offers Dan and Andre a share in his company. Working for smaller clients was a lot easier than MTV and much more chill. Andre and Dan don't hear from Craig for a while. He seems to disappear and then suddenly appears again asking for designs due the next day. Andre doesn't like working on someone else's schedule, especially when it's for free. Just as they are about to pull out of the project, Craig sends a photo of the gold bike. It's beautiful and they realize this could be a good opportunity.

Craig wants to do a small photo shoot with his glow in the dark bike and he needs help finding a photographer. Andre and Dan call in a favor from their friend John, who is very talented. Andre's job is to work with John on setting up shots and Dan's is to keep Craig away from John. A few hours later, Craig flips the light switch to find that the bike doesn't really glow. Individual parts glow substantially, but the frame doesn't as Craig has kept the bike in the dark for days prior to the shoot, forgetting to charge it.

Since it omits little light, the bike looks blurry and blown out. John starts worrying because there is no way he can think to fix it. Craig pulls Andre and Dan aside and tells them that he isn't feeling the shoot and questions John's skills. They have no other option but to end the shoot. John agrees to re-shoot everything under one condition, that Craig isn't present.

Craig finally comes over with presents. Andre and Dan now own 5% of his company. They contemplate cashing out for the work they've done, but the prospect of making loads more money in the future is better. Craig ends up going on vacation and they have yet to hear back from him.

WE COULD NOT THINK OF ANYTHING FUNNY

Designers often hate designing for themselves and some agencies even hire outsiders to design their promos for them. The argument is that it's hard to separate yourself from your work and judge it objectively. This is not the case with dress code, self promotion is one of Andre and Dan's favorite things. Since they don't have an office, an actual business or even cards, they decide that a website is the way to go. The name of their firm is quite literal — evoking images of clothing, patterns and fashion. But this seems like a stupid direction for them.

Andre starts designing the website with a simple grid, a big logo and a large viewing space for their work. The site is decent, but nothing super different from any other portfolio site. They agree that it's a little boring, but not in a "it's so boring, it's hip" kind of way. Andre throws out an idea: what if the site somehow changed, depending on the time? What if it looked a certain way at noon and another at midnight? They rely on their old standby, solving problems with funny copy, and decide that the first page will be two messages; one telling what Andre does at that time of day and the other telling what Dan does. All of a sudden a seemingly boring design seems decently cool.

Andre gets his buddy Jon to code the site. After a few months of work, dress code is alive on the World Wide Web (www.dresscodeny.com, if you mess around with them internets). They get linked on a few design blogs and overnight receive hundreds of thousands of hits. It's a success and will be their most valuable tool for self-promotion, aside from their drunken nights out. They post a link for employment, to appear bigger than they are.

On the net it's easy to look like a big agency with lots of employees, when in reality you are just two guys with day jobs. Andre posts his cell phone as the office number and often gets funny phone calls. A lady from Australia calls asking for dress code's HR department. A salesman for pizza box ads keeps asking to come over. Frank prank calls by pretending to be a client referred to them by Stefan

Sagmeister. And there's always the occasional student calling for an interview or advice about life.

A lady from Showtime emails dress code asking for their reel. Andre and Dan do not have one. Andre spends a few sleepless nights editing their work, but the final cut really isn't spectacular. Instead they decide to put all of their pieces back to back and send one giant movie. Dan buys a cheesy steel DVD case and they put a sticker on the CD. Andre is uneasy with sending out a reel that is so half-assed, but this opportunity might be too good to pass up. Showtime never calls back.

THE BIG TEN

Dan is envious that Andre is getting to direct big shoots and animators, while he is designing printed stuff for MTV. He is itching to get more responsibility, but there is little room to move up since everyone is pretty talented. Out of frustration, Dan makes it clear to Jim that he is interested in getting more experience as an art director. Coincidentally, Jim is looking to appoint someone to art direct MTV DVDs and is considering Dan for the job. But, it might take a while to work out the details, so Dan will have to wait.

Romy asks Dan to pitch an opening for The Big Ten, a show for the ten most popular videos on MTV. Dan has never made storyboards before, but loves the challenge since he isn't good in Photoshop nor can he make things glow, have lens flares, or look very cool. This is how Andre woos people, so Dan figures it is expected of him too. Romy isn't impressed with his ideas and keeps making him start again. Finally she and Jeffrey tell Dan to just come up with a good idea. When Dan presents, Jeffrey combines two of his ideas into a much stronger one, where kids are mesmerized by something golden.

Suddenly, Dan is preparing to direct his first shoot. Leslie will help produce. Before the shoot he gets to write briefs, cast actors and pick props. Then, at the shoot, he gets to pick outfits, eat from the craft services table and direct the actors. Rodger is in the back of the room, but he lets Dan do his thing. Dan falls in love with directing and wants to do more of it. Not just because of the hot girls, but because it is more enjoyable than life as a computer jockey. He is addicted to being out in the world, interacting with real people.

The time came for yearly reviews and Dan was more than ready, since he had been with MTV for a year and a half without a raise. Through other people in the office Dan hears that Alison, his friend and fellow designer, got the DVD art director position. He was happy for her, but envious. In the review Jim tells Dan that he has exceeded expectations and is a nice addition to the team. The only criticisms Jim has are Dan's cockiness and how he only

wants to work on his own ideas. There are possibilities for
Dan in the future as an art director since the business is
expanding, but this doesn't seem like something Dan is
willing to wait for. He trusts his gut and suddenly Dan
finds himself telling Jim that he is ready to move on and
wants to work for On-Air doing motion graphics and
directing.

Jim was a great boss and a good friend; Dan was lucky to
work for him and for the chance he took in hiring Dan. Jim
takes Dan's decision to leave very well and seems happy
Dan is staying with the company and moving up internally,
rather then just cutting his losses and leaving bitter.

DISCOVER AND DOWNLOAD

Like Spankin' New Music Week, Andre is asked to design three
different promos for Discover and Download. This time,
each open is for one of the main MTV channels: MTV, mtvU
and MTV 2. Andre likes the idea of discovery, but can't
figure out how to fit the stupid orb into his ideas again.
He boards a few elaborate ideas where people find the orb in
the "wild" or stumble upon it in their apartments. The ideas
are fine and all, yet again, seem to be over budget.

Andre has to quickly come up with a cost effective solution.
So, he simplifies one of his boards, where the orb activates
musical instruments. Jeffrey also has an idea of his own;
he wants a giant eyeball in the orb. There is nothing Andre
can do, so he makes the orb a Cyclops.

Rodger is out of town and Andre is directing by himself for
the first time. On the shoot there are three main people:
Leslie, the producer; Kip, the director of photography who
operates the camera; and Charles, the prop guy who makes all
of the instruments come alive. Andre has to talk to everyone
and make sure they are doing what they are supposed to,
but spends most of the time talking to Kip about the shots
they need to get.

Sometimes the simplest things are the hardest. Even though
the shots seem easy, every time the camera moves, the
lighting has to move also. This repositioning takes a lot
of people and direction. Andre has to give up certain
shots and move on. Time is running out and they still need
to shoot tons more. Leslie pressures Andre to abandon more
shots and he leaves worried about having enough footage.

After the shoot, Andre starts working with Chris, another
3D animator. Chris nails the eye; it definitely looks creepy
and weird. Andre starts editing and puts down an Aphex
Twin track to edit to. He shows the initial edit to Jeffrey
as a heads up. This is a mistake because Jeffrey falls in
love with the track and later Andre will have to work with
the sound studio to produce a similar track.

SOME NAMES TO DROP
—

BOB GILL

ROBERT BROWNJOHN

MULLER+HESS

M/M PARIS

ALAN FLETCHER

STORM THORGERSON

JOHN BIELENBERG

KESSEL KRAMER

MR. BIERUT

YOKOLAND

STEFAN

CHARLES HARPER

ED RUSCHA

FUEL

JON SANTOS

TONY YAYO

Andre continues to edit the rest of the opens, but quickly realizes that he doesn't have enough shots. David, MTV's art director, advises him to bring a digital camera to shoots and snap photos that he can later use in his edit. If only he knew that from the beginning...

THE VIDEO MUSIC AWARDS PART DEUX

Since Dan won the Video Music Awards logo in 2005, he is asked to pitch logos again the next spring. The new concept is using all the screens MTV owned to simultaneously broadcast the show on the web, on-air, mobile devices or any other "multiplatform." Dan starts most projects with an exhaustive search for visual inspiration. This year he moves beyond traditional logo design into some fine art and form based stuff. Dan presents twelve logo concepts, four of which make it to the final round. Maybe this is because he has gotten a bit better at logos or it might be because he actually pays attention to the brief.

One of Dan's logos is "inspired" by a poster that he sees in a design book. He asks his co-workers if using this is cool and they say not to worry about it. Plus Dan doesn't think the odds of this logo getting picked were very high. He was wrong. The producers pick Dan's "inspired" logo and for the second year in a row he won. Dan feels guilty. Is this ok? Should he tell someone? Dan isn't sure what to do, so he just rolls with it. He has struggled with the debate about plagiarism versus inspiration before, after studying graphic design history, and spent countless hours in the library, stumbling upon countless designer rip-offs through the ages. He even recalls a quote on the back of an old trademark book where Paula Scher said, "I have ripped off from this book more in the past year than any other. Please send me another copy..."

Dan is in charge of designing and directing the On-Air redesign that's taking place during the VMAs. This seems like an opportunity to evolve his "inspired" logo into something he could call his own. He has an idea to create spots where his logo comes up through the ground and takes over New York City. Everyone loves the idea and tells Dan that it is pretty much good to go. He starts scouting locations, the 3D animators start doing motion tests and the producers budget for a big shoot. Jeffrey shows it to the head of marketing as an FYI, and she pulls the plug.

Apparently, out of the blue, the show now has a new theme of celebrity and excess. Dan can bitch, but bitching won't do anything. He goes back to the drawing board. Rodger comes in to save the day because he knows Dan is about to go off the deep end. Together they come up with a concept where Dan's logo will be animated, revealing abstract crops of celebrity footage. It isn't amazing, but it isn't horrible. Dan will have to make the best of something that he isn't into.

IT'S NOT GOING TO HAPPEN THE WAY YOU THINK IT WILL (BUT IT'S BETTER THAT WAY)

Wyeth Hansen

Halfway into the first eight-hour drawing class of my freshman year at art school, I realized something very important: my life as an artist was not going to unfold the way I had visualized. Chances were I wasn't going to be the youngest and most successful painter in New York, the Talking Heads were no longer a band and could therefore not be my flatmates, and the Beat poets were either dead or west coast. Perhaps more realistically, I realized that my abilities with paint were inadequate at best, and I sensed that this pursuit had largely become an outdated social convention in which I didn't care to participate. Basically, it wasn't looking like I'd ever see one of my paintings hanging in a New York gallery.

While it's always a disappointment to see your daydreams dispelled, I was beginning to feel excited about living without a set plan. I decided to enroll in graphic design because I considered myself a man of letters (I had no idea how literally that term would soon apply) and because I had an affinity for album covers and music posters. I found that studying design was supported by three of my chief personal attributes: being and acting smart; an ability to create dense and overambitious projects; and a need to control them at the most minute, obsessive level.

Fast forward to post-graduation, June of 2003. I am driving a U-Haul truck containing the sum total worldly possessions of myself and two roommates to our new home in Brooklyn, with enough money in my pocket for three months of living. My sole goal in that time is to find work in order to survive. I had never done an internship, had no professional connections or any way to display my work other than the one hand-bound portfolio that represented the fruits of my print design education and, secretly, a five-minute animated film I made during my senior year in order to teach myself After Effects and Pro Tools. I didn't really consider this a true 'design' project, however. Little did I know that it would turn out to be my sideline pursuits — making short animations and recording music — which would get me work.

In three months time I was broke and broken, reduced to eating crackers for dinner, doing my laundry in the bathtub, and being turned down even from Craigslist jobs. Sitting on the roof after an unsuccessful interview, at the end of a sweltering summer, with an empty Old English in my hand, my old dreams felt far, far away. In fact, far from being a famous artist, I couldn't get work as a hack designer.

But, out of the blue, I heard from a friend who knew someone who knew someone who was looking for someone who could animate in After Effects and had good design skills. I overdrew the hell out of my already dry bank account to buy a website to post my movie, and to get some half decent jeans for the interview. The person that needed to see my movie saw it, I had the interview, and in a week I had my first freelance job. And though my animation skills were found severely lacking, their combination with my rigorous print design background made me stand out. I started to sense the potential of this new world. It was extremely nerve-racking at first. I was all thumbs at the keyboard when I needed to be an octopus. But after a few challenging jobs, the learning curve flattened out enough for me to feel comfortable.

Motion design is a field ripe for exploration by young designers with an aptitude for technology and rhythm and a desire to do things differently. Good motion designers are, in a sense, trilingual. They are able to

speak to sophisticated, refined design sensibilities as well as to boundary pushing animation fanatics while occupying their own unique visual space. Motion designers with strong conceptual skills will go far, as there is a general tendency amongst hard-core animators to focus safely on the technical aspects of a project without addressing the larger problems or exploring possible solutions. A strong idea done simply is a good approach in any field.

Personally, I have had the pleasure of working with both more traditional design clients branching into motion for the first time as well as more established animation companies seeking a refined design style. People working in motion design tend to be multitalented and branch out into other areas. Through my motion work, I've been afforded many opportunities, from recording music and doing sound design to directing music videos, doing print work, illustrating for magazines, contributing to books, designing apparel, working on documentary films and creating personal work for gallery exhibitions. It was at one of these gallery shows that I first realized I had somehow stumbled into my old daydream: there is a painting on the wall with my name on it; I'm in New York City (well, Brooklyn, but close enough). But the reality has turned out to be so much more interesting for its unpredictability and variety than the old straight-line vision of success. By accepting the challenge of working in a new field, I was afforded chances I would never have otherwise received and I expanded the potential reach of my creative work.

Wyeth Hansen was born and raised in Fresno, California until moving to attend college at the Rhode Island School of Design, from which he graduated in 2003. While in school, Wyeth began experimenting with combining animation, music, literature and installation, out of which his current work as a freelance designer has grown. He currently works in a collective design/silkscreen studio in Brooklyn that he helped establish with several friends.

QUESTIONS + ANSWERS

Why did you decide to become an entrepreneur?
—

Rudo Krascenic

Thanks for the questions Rudo! We started because we didn't want to work for someone else and we had ideas of our own.

What was the biggest challenge while planning and starting your business?

Coming up with a good name was hard. Getting enough money where we could sustain ourselves for at least a year was also tough. The biggest hurdle was the legalities of the business; things like taxes, invoicing, contracts, etc.

Was there anything that you would have done differently?

Could have stayed in touch with more people.

Did you consider (at any point) quitting your entrepreneurial career?

No, starting our own business has been our dream since we were students.

What would be your advice to designers wanting to start their own business?

Partnering up with someone who has the same work ethic, but different skills and sensibility.

What were the most important considerations when deciding your business name and logo? Did you base the business identity on any particular philosophy/ principle/idea or was it a result of "evolution?"

We sat around our kitchen tossing around names one night. We saw a book on the shelf called *Dress Codes* and it seemed appropriate. There was no philosophy other than we liked the name. The bullshit answer is that design is like dressing up. Sometimes we have to design for punk kids, sometimes for financial companies, sometimes for friends, sometimes it's a logo, sometimes it's a movie — we adapt to fit the situation.

Do you think your identity has any impact on the success of the studio?

Yes, it's huge. We really love designing our identity stuff. The main goals are to try and make ourselves laugh and be weird. Too many design companies take their identities for granted. Standing out is crucial.

Have you changed your business identity often (or at all)? If yes, what were the reasons?

We haven't changed our logo, our website hasn't changed (other than updates) but we keep redesigning our business cards. We take business cards for companies like Kinkos or dog-walking people and recreate the cards with our info on them.

A STUDIO
WHERE
YOU
SLEEP

A SLEEP WHERE YOU STUDIO

Andre goes to Bulgaria for the first time in 3 years.
Grandma doesn't recognize him at the airport and Krassimir
gives him a hug. Bulgaria hasn't changed much from the last
time. Change is good. It's much weirder to visit a place
where everything is always the same. Andre is excited to see
his friends, many of whom he hasn't seen for over six years.
He doesn't have any phone numbers, so he starts knocking on
a few doors. His childhood friends are all there, still
living where he remembers. There is some bad news; a few of
his good friends have died from overdoses, car crashes and
one murder. His once happy neighborhood is now eerie and
quiet. Andre spends the rest of his two-week vacation eating
quality food, playing soccer and drinking.

When Andre comes back to the States, their apartment lease
is up. They will have to sign up for another year or move
out. Andre, Ali and Dan decide to look for a bigger space
in Brooklyn. Brooklyn is much like the Mission in San
Francisco. A lively neighborhood mixed with art school kids
and people from Central America. They find a large, new
apartment that Andre and Dan can also use as an office. The
living room is spacious enough to house both of their
computers, plus two bookshelves and Herb the plant. This
flat is more expensive than the previous one, but Andre and
Dan justify the price by being able to use it as an actual
office, one where they can sleep.

The first thing they do in their new studio is set a date
when they will quit MTV and start dress code full-time.
They decide on June 15th, 2007, exactly two years later.
They write it big on a piece of paper and stick it on the
wall. The paper becomes a constant reminder of something
to look forward to.

WAYNE AND THE NYCOLLECTIVE

Jimm Lasser, Dan's friend from Project M is a quirky guy
who wears different colored shoes, likes the Chicago bears
and looks a bit bear-like himself. Jimm did a shirt for
Fila through an organization called New York Collective
for the Arts, run by the Wayne Kasserman. Dan and Andre
meet Wayne at Jimm's going to Portland chili cook-off, but
sadly, because of points deducted for heckling their
"chilisaurus rex," does not take the title. Once again
they are cardless in the face of a networking opportunity.
Luckily, Wayne is not. He is looking for new designers
to start the next phase of an ongoing series of tee designs
for Fila.

Fila needs to increase their hipness and they are doing so by issuing short runs of shirts by designers, illustrators and artists. Wayne picks three people to do two shirts each. Andre and Dan are excited to get their fashion on. They think spending money out of pocket to hire some help will make them look like they've done more work than they actually have and bring a new style into the mix. A few weeks prior, a guy called Drew Heffron sends them an email asking for work. Drew's work is weird and Andre likes his persistence. Dan is only mildly impressed. Soon enough Drew is working on the project, for five hundred dollars.

Drew sends in his illustrations, Andre likes them, but Dan is still skeptical. Wayne shows their work to Fila and they love it. One of the other contributors to the project bails out and Fila decides to give five out of six shirts in the series to dress code. Months and months later the job ends up falling through because Fila decides to stop producing the series. Dan and Andre lose cash money on the project but build a solid relationship with Wayne. He will be giving them a lot of work in the future, but he still pronounces Dan's last name wrong (Dan doesn't have the heart to tell him, maybe someday).

THINKING OF THE BOOK

Andre and Dan start thinking of ideas for self-initiated projects to help them get famous. The most obvious one is to write a book, something they have no idea how to do. They like the challenge of doing something way outside of their comfort zone on a subject they know nothing about. After a few brainstorming sessions they come to the sad conclusion that they don't know much about anything other than graphic design. Writing a book on design is not a fresh idea — their bookshelf is filled with books on the subject and producing yet another one may be a waste of time. There are so many great books, like Tibor's, Sagmeister's, karlssonwilker's, or Logo's and Letterhead's 3. How would theirs be any different — or any better?

They decide to write about what they have just experienced — graduating and finding a job. There is very little information about transitioning from being a student to working as a professional. Even when in school, they felt the topic has been largely overlooked. So they write up a short proposal with a few images and press clippings and start looking for publishers. Andre comes across a small company upstate, de.MO. It's run by an Italian called Giorgio, who is a CCA alum. Andre shoots him an email asking for advice on their proposal. Giorgio likes their work and sets up a meeting.

Dan and Andre pack their bags and laptops to travel a few hours to a tiny town with not so tiny people. Giorgio runs his studio from a renovated horse stable. He has kept the horse stalls and instead of having horses, he has designers. Dan first met Giorgio at the Art Directors Club and Giorgio

even wrote, offering a job (he now denies this ever happened).
Andre and Dan chat up their idea for a book and Giorgio
gives them a few references. The books he publishes are mostly
about photojournalism, and even though they are beautifully
designed, they are for a different market.

Andre and Dan return home to find an email from Giorgio
waiting in their inbox. He says it was nice to meet them
and that he'd like to publish their book. Andre can't
believe that they have found a publisher. It seems too
good to be true, but Giorgio is cool and they are excited
to work with him.

CMT IS GIANT

Leslie from MTV moves back to Nashville to get her country
on. She likes Andre and Dan enough to recommend them to her
new employer. CMT calls for a logo for their new show Giants,
celebrating the superstars of country. Andre and Dan do not
listen to country, in fact they have never even watched CMT,
but this could be a good client. They start working on the
logo, Andre likes the job because he loves doing over-stylized
Photoshop logos. He puts at least three lens flairs and two
gradients in each logo. CMT loves their presentation and
congratulates them on winning the pitch. They ask if dress
code would like to do the show's packaging. Since the logo
they chose was not the greatest, Andre and Dan do not see
much potential in this project. CMT asks for the open to be
done in HD, and dress code uses that as an excuse to back
out of the job.

Soon enough, CMT calls again with another package, this
time for a show called 40 Greatest Albums. Andre and Dan
start brainstorming what the boards should be, but the
ideas don't flow. They feel like they have to take the job,
since they already turned down one show open, getting a
third offer might not happen. The deadline is tight and
the deliverable list is quite long. Dan and Andre do three
mediocre storyboards and the creative directors aren't
happy — they don't understand what's happening in the
boards. There is no time for another round, so they ask
which idea Andre and Dan would like to do.

They settle on a virtual jukebox, where the 40 greatest
album covers are floating in space, flipping from one to the
next. The whole job is 3D. They hire Eban to animate the
open while they take care of the small stuff. Andre and Dan
promise Eban a big chunk of their budget because a lot of
the pressure is on him. The second largest chunk of money
goes to do sound. Dan and Andre figure that they would
rather spend more money on production than do everything
themselves and have the quality suffer.

After three grueling weeks of non-stop work, the package is
finally done. It's not their best work, but it's fine, given
the circumstances. Since CMT is a Viacom company, Andre and
Dan get paid through payroll and their money is heavily

THE LIST

Frank DeRose

1. Made money.
2. Made mistakes.
3. Made enemies.
4. Made breakfast.
5. Made up.
6. Hated my job.
7. Quit my job.
8. Got jealous of other people's jobs.
9. Felt like I should have their job.
10. Used Helvetica.
11. Used Helvetica Neue.
12. Used Universe.
13. Did not use Copperplate.
14. Watched TV.
15. Surfed the web.
16. Touched myself.
17. Got wasted.
18. Did drugs.
19. Promised myself I wouldn't do it again.
20. Did it again.
21. Felt guilty.
22. Felt bored.
23. Felt depressed.
24. Felt up my wife.
25. Felt up your future wife (before I had a wife).
26. Specced type.
27. Complained about clients.
28. Complained about co-workers.
29. Drank with co-workers.
30. Complained about co-workers while I drank with co-workers.
31. Talked about starting my own studio.
32. Sat at home in the middle of the day without a job.
33. Had a panic attack.
34. Called my girl while I was having a panic attack.
35. Thought about how to be a calmer person.
36. Played Snood.
37. Surfed the web.
38. Smoked trees.
39. Took a nap.
40. Smoked cigarettes.
41. Quit cigarettes.
42. Started smoking cigarettes.
43. Quit smoking cigarettes (we'll see).
44. Wished I were back in school.
45. Stole ideas that I had in school.
46. Had an affair with your favorite designer.
47. Cross-referenced porn stars from web site to web site, and then to bit torrent programs.
48. Ate dinner.
49. Overslept.
50. Overstayed my welcome.
51. Overestimated my opponent.
52. Over-tipped (when I was wasted).
53. Second-guessed myself.
54. Worked hard.
55. Worked not so hard.
56. Acted hard.
57. Got hard.
58. Said incredibly dumb things.
59. Followed up by acting upon the dumb thing I just said.
60. Ate lunch.
61. Played basketball.
62. Beat Dandre in basketball.
63. Did freelance work with Dandre.
64. Got drunk and harassed Dandre.
65. Apologized.
66. Felt successful.
67. Felt like a total loser.
68. Felt it again.
69. Met my hero.
70. Had a good idea.
71. Didn't follow it up.
72. Had a good idea.
73. Sort of followed it up.
74. Had a good idea.
75. Gave three weeks notice.
76. Told someone to fuck off.
77. Got told to fuck off.
78. Got stitches.
79. Got the runs.
80. Got a fever.
81. Got oral.
82. Farted, and a little poop came out.
83. Decided I wanted to work for BIG.
84. Decided I wanted to work for Pentagram.
85. Decided I wanted to work for Base.
86. Didn't.
87. Went to the movies.
88. Went to Bogotá.
89. Went to town.
90. Hated the player.
91. Hated the game.
92. Lent money.
93. Got paid back.
94. Got stiffed for freelance.
95. Undercharged for freelance.

96. Made progress.
97. Took a step back.
98. Redesigned the *Penthouse* magazine logo.
99. Learned that making it doesn't mean the client planned well.
100. Designed the Modern Bank logo.
101. Learned that just because you have the idea and do the initial design doesn't mean you get to finish it.
102. Went postal.
103. Got to work early.
104. Got home late.
105. Compared myself to 156 other 22-29 year old designers.
106. Did not apply for the *PRINT 20* under 30 or whatever the fuck...
107. Did not get into *PRINT 16* under 105 or whatever the fuck...
108. Watched my mom get her hip replaced.
109. Watched her get better from it.
110. Watched her have a biopsy.
111. Watched her get a tumor removed.
112. Decided that "design" isn't shit.
113. Worked a few 15-hour days.
114. Worked a few 18-hour days.
115. Called in sick.
116. Ate peyote with Paul Rand.
117. Got a hand-job from Ryan Seacrest.
118. Saw some concerts.
119. Freestyled with my friends.
120. Decided I really do like the Arcade Fire.
121. Decided that I really do not like R.E.M.
122. Moved from the city back to Queens.
123. Rode my bike into the city.
124. Beat Andre 15-2 in ping pong.
125. Lost to Names 15-5 in ping pong.
126. Watched George Bush do a great job!
127. Hoped Donald Rumsfeld would get assassinated.
128. Hoped Dick Cheney would be collateral damage in Rumsfeld's assassination.
129. Ignored politics, mostly.
130. Got stiffed on my Christmas bonus because I quit, even though I had been the go-to guy in the office from May to December.
131. Kicked Dan's ass with a pick axe.
132. Lost my keys.
133. Fucked up a job.
134. Covered my ass.
135. Sent approximately 3,500 emails.
136. Generated 168 gb of digital info.
137. Pulled off the highway to use a public restroom.
138. Rented a movie.
139. Returned a movie.
140. Decided that *Only Built 4 Cuban Links* is the best Wu Tang solo album...or maybe it is *Supreme Clientele.*
141. Bought $150 sneakers.
142. Discovered that Greek yogurt is much better than regular yogurt.
143. Added honey to my tea.
144. Welcomed my wife home from a night of drinking.
145. Teased her the next day.
146. Fought with her.

147. Had make-up sex.
148. Plotted ways to have more sex.
149. Regretted what I wrote.
150. Started making a blog.
151. Started writing a book.
152. Went to the movies.
153. Decided that going to the movies alone is good.
154. Decided that going out to dinner alone is okay.
155. Decided that going to a bar alone is bad.
156. Designed my portfolio twice.
157. Went on more interviews.
158. Did it again.

There are approximately 4 things in this list that I did not actually do. See if you can figure out which they are.

———————————————————————————

Frank DeRose is.

ZINES

AVANT GARDE

RIPPING OFF MODERNIST
DESIGNERS

BEING A NEW, YOUNG
DESIGNER

TAKING YOURSELF VERY
SERIOUSLY

RENDERING TYPE IN SPACE

BEING FUNNY

QUOTING FRENCH
PHILOSOPHERS

DJING PARTIES

DESIGN COLLECTIVES

ACTING LIKE AN ASSHOLE

LOOKING LIKE A DESIGNER

PRETENDING YOU ARE
SMART

WRITING A BOOK ABOUT
YOURSELF

taxed. From a budget of twenty-five thousand, they walk away with fifteen hundred each. CMT does not call back, but they do send Dan and Andre a funny Christmas card.

In a worldwide competition for the best up and coming creative talent, the Art Directors Club names dress code "Young Guns." This is a pretty big deal and they both feel lucky to be chosen, as many of their more talented friends weren't. The ADC throws a party and publishes a book with some nice work in it. They are excited to take a night off and celebrate this rite of passage with hilarious neon sashes. Instead of "networking," Andre and Dan get wasted off of free beers.

Andre
is watering
Herb the plant

Dan
is repping big
diamonds &
lotsa cash

Dan
is dropping
science

Andre
is preparing
to take it up
a big notch

Dan
is talking to
robocop 3D
guy thing

dress code
does design.

news work about contact

**Andre
is training for
FC Bulgaria**

**Dan
is chewing on
Andre's pen**

5:10
Good Day.

Andre
is "working"
in his room.

Dan
is beating
off to Suicide
Girls.

Andre
is not having
a cigarette

Dan
is talking
to sprinkles

Andre
is experiencing
teenwolf envy

Dan
is cursing
his late 90's
computer

Andre
is digesting
vegetables

Dan
is trapped
between
two dreams

Andre
is wondering
beard or
no beard

Dan
is aligning his
shampoos

Andre
is drinking
the coffee

Dan
is fighting
dyslexia

217

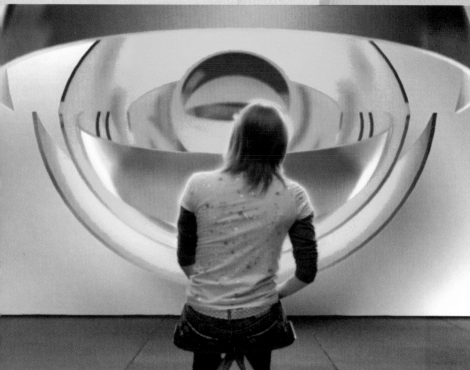

218

THE BIG TEN

MTV

DRESS CODE DOES DESIGN

www. DRESSCODENY.COM

www. DRESSCODENY.COM

www. DRESSCODENY.COM

WE MADE THESE HANG TAGS WITH OUR LEFT HANDS. IT'S SURPRISINGLY HARD TO DRAW LIKE THIS.

dress code
does design

kinkos!

dress code

OUR CARDS. PRINTED AT KINKO'S!

219

SOME STILLS FROM THE OKEY DOKEY OPEN WE DID FOR CMT.

A REDESIGN OF TRUE LIFE, THE ONLY MTV PROJECT I ANIMATED ALL ALONE. - A

TO MAKE YOUR CLIENT FEEL GOOD ABOUT SPENDING A LOT OF MONEY ON A LOGO MAKE SURE TO PUT A LOT OF GRADIENTS AND LENS FLAIRS IN IT. - A

VOLUME (−dB)

CG DID A GOOD JOB AT THE 3D EYE ON THIS JOB. ALSO,
NOTICE ALL OF THESE SHOTS HAVE A BLUE DETAIL. - A

221

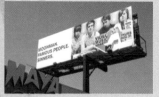

THE "INSPIRED" LOGO. - D

THE ANIMATION WE MADE WHEN THE COOLER
IDEA GOT KILLED. - D

THIS CD WAS NEVER PRODUCED BECAUSE THE BAND RAN OUT OF MONEY. THIS HAPPENS TO US MORE OFTEN THAN NOT.

EVEN WITH THE HELP OF THE LENS
FLAIR WE COULDN'T WIN THIS LOGO.

THE ONLY WEDDING INVITE WE'VE DONE SO FAR. WE
SCREENPRINTED IT AT OUR TINY APARTMENT STUDIO.
THIS WAS A CHALLENGE WITH 8 POINT SCRIPT TYPE.

QUESTIONS + ANSWERS

A lot of times, people talk about graphic design being "commercial art," but there are lots of projects designers do that aren't commercial or necessarily marketable. The question that a lot of students ask is whether something that's not commercial is still considered "graphic design," or if it starts to become "art."

—

Nelson Ng

Nelson, to me art is when I am servicing my own agenda and there is no client involved. Graphic design or commercial art is when I am doing a project for other people, I can still have an agenda, and most often do, in graphics, but the end product is for someone else and they give us money, opinions, or a pat on the back. To be honest, the art versus design debate doesn't concerns us much. We try to make good work and hopefully make ourselves laugh, no need to put a label on it. Milton Glaser and Stefan Sagmeister have both written on this subject and are much smarter.

What are the challenges involved in working on your own products as compared to working on projects for clients?

—

Jacqueline C.L. Law

This is a great question Jacqueline and something we have dealt with a lot in the process of creating both this book and our documentary. Doing self-initiated projects is what we love more than anything else since there is the opportunity for complete creative control and to actually say something. We get excited anytime there is a chance to create the content rather than just packaging it. The problems or challenges are:

Creative control can be a blessing and a curse. When you work for someone else it is easy to say that they are making the wrong decisions, or to blame bad projects on clients. The moment you can say or do anything you realize how valuable constraints or other people's opinions are. A way around this is to talk about the work with people whose opinions you value and respect, or to impose constraints on yourself.

Most of the time you have to rely on people to get large self-initiated projects done. This is easier said than done. Convincing them to invest time and energy into things with little to no budget can be tricky. People will usually agree because they are your friends, they believe in the project, they owe you a favor (thanks Wayne and Gibson), or because they can use the final product to promote themselves. The trick is to find people who you can count on, who share the same work ethic, and who are not totally established but looking to make a name for themselves. Even if they are your friends, make sure you sign a contract; things can get dicey.

Securing funding can be an arduous process; we paid for most of our movie out of pocket. For the book we made a proposal and shopped it around till we found someone who was interested. Usually if you believe in something, have a pretty solid idea and a nice presentation, you can make anything happen as long as you are persistent. These things take time though; we have worked on both this book and our documentary for more than a year.

sup

on the phone with wes

ok

i was on the phone with bulgaria...

i need a few more

like at 1?

k call me

ill be around

k

so

so

did you see what i wrote

put three funny words in circles in the beggining?

yeah

on the first page

haha

take out the last sentence

sounds bitter

Sorry Dan, I'm just better at winning.

2:33 AM

, i cannot wait to
e howard's place
o myself

haha

party zone

3:04 AM

bold

whatever

can change la

same thing

ye

nobody will notice but

3:05 AM

my lady gets in town tomorra

might make a late nite run

haha ni

we almost had the discussion

ha

good luck with th

when? otnig

sat

3:10 AM

i'm tryin to dodge it, but whatever man, some things are too good to pass up

tota

WE DID THIS PROJECT FOR NO MONEY, IN FACT WE LOST
MONEY BECAUSE WE BOUGHT 1000 BALLOONS. DAN IS
HOLDING THE P BECAUSE IT KEPT FALLING OVER.

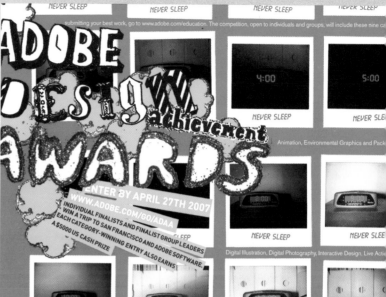

NEVER SLEEP NEVER SLEEP NEVER SLEEP NEVER SLE

submitting your best work, go to www.adobe.com/education. The competition, open to individuals and groups, will include these nine ca

Animation, Environmental Graphics and Pack

Digital Illustration, Digital Photography, Interactive Design, Live Acti

THE ADOBE DESIGN ACHIEVEMENT AWARDS
ENTER BY APRIL 27TH 2007 WWW.ADOBE.COM/GO/ADAA
INDIVIDUAL FINALISTS AND FINALIST GROUP LEADERS WIN A TRIP TO
SAN FRANCISCO AND ADOBE SOFTWARE. EACH CATEGORY-WINNING
ENTRY ALSO EARNS A $5000 US CASH PRIZE

TRYING TOO HARD CAN HURT

THE ADOBE DESIGN ACHIEVEMENT AWARDS
ENTER BY APRIL 27TH 2007 WWW.ADOBE.COM/GO/ADAA
INDIVIDUAL FINALISTS AND FINALIST GROUP LEADERS WIN A TRIP TO
SAN FRANCISCO AND ADOBE SOFTWARE. EACH CATEGORY-WINNING
ENTRY ALSO EARNS A $5000 US CASH PRIZE

SUCCESS IS RELATIVE

THE ADOBE DESIGN ACHIEVEMENT AWARDS
ENTER BY APRIL 27TH 2007 WWW.ADOBE.COM/GO/ADAA
INDIVIDUAL FINALISTS AND FINALIST GROUP LEADERS WIN A TRIP TO
SAN FRANCISCO AND ADOBE SOFTWARE. EACH CATEGORY-WINNING
ENTRY ALSO EARNS A $5000 US CASH PRIZE

DREAMING IS OK

ADOBE DID NOT PICK THESE IDEAS, THOUGH THIS ONE MADE IT TO THE FINALS.
WE WERE EDGED OUT BY A SQUIGGLY LINE.

229

WE WANTED TO MAKE THIS REALLY WEIRD. A SNOW GLOBE FILLED WITH EXPLOSIONS IN A MIDWESTERN HOUSE DURING THE COLD WAR AND A VOICE OVER IN BULGARIAN. DAN AND HIS BROTHER ARE IN THE FRAMES.

SAY COMPO, READ CAMPO. OUR NICE CLIENT ALMOST WENT TO JAIL OVER THIS CARD.

(say hello)

115 WEST 29TH ST, 4TH FLOOR, NEW YORK, NY 10001
T 212 629 9004 F 212 629 9007
hello@saycampo.com www.saycampo.com

ALISON BAILEY
(say manager)

115 WEST 29TH ST, 4TH FLOOR, NEW YORK, NY 10001
T 212 629 9004 F 212 629 9007
alison@saycampo.com www.saycampo.com

CAMPO DIGITAL
(say compo)

ACROSS THE FIELD

<u>OH-IO</u>

During his previous life as a frat boy, Dan was surrounded by friends who were fanatical about sports. He loved being an athlete, but he always thought memorizing statistics was a waste of time. Ohio State football was legendary and every year the campus would transform during football season. Football was the only thing on anyone's mind. His frat bros would wake up in the wee hours of the morning to "prepare" for the games by getting wasted. Ohio State fans are known for their devotion to the team, to the game, but also for their drinking, fighting and rioting.

Dan goes back home to Ohio for a change of pace and to visit some friends. It just so happens that Ohio State is playing a huge game against Texas. Dan brings his new digital camera to document the madness, since most people in New York don't understand how obsessive OSU fans are.

Dan comes back to New York with the photos and Andre is amazed. To Andre, this devotion to a team and to the state of Ohio is reminiscent of the nationalism of European nations surrounding soccer. Dan has wanted to document OSU football fans for a few years, but doesn't know how or why. Tom, a friend of Andre's from San Francisco, comes to New York to watch a film of his that is part of the Tribeca Film Festival. He takes Dan and Andre to a screening of documentary shorts. Andre and Dan are only mildly impressed by two of the films. They both think they could do better, even if they don't have much experience with film.

Dan thinks a documentary will be the perfect medium for properly introducing OSU football fanatics to the world. MTV gives five thousand dollar grants to help fund dreams and after years of presenting ideas, Andre and Dan have honed their talent of pitching dreams. They sometimes even introduce themselves as professional pitch artists. Coming up with ideas and communicating them is what separates designers from Photoshop gurus or scrapbook Moms.

Dan and Andre start researching and buy all the necessary equipment to make a documentary, spending about ten grand total. After overseeing a few shoots at MTV they decide that directing is the next major step in their careers. Like anything large, they need a team. An old friend, Eric, from the graffiti days is going to help Dan produce, and Tom and Andre are going to shoot it. None of them have any idea what the hell they are doing except Tom, kind of. They get a Netflix membership and watch four documentaries a week to start training.

Ohio State plays Michigan the last game of the regular season and this year Ohio State is ranked number one in the country, Michigan number two. ESPN calls this the greatest rivalry in sports history. Dan and Andre call this the perfect weekend to shoot their movie. They build a website with ten questions to attract and filter fanatics. With an overwhelming response to the survey thanks to Craigslist, Dan and Eric set up interviews with the most intense fans and with other influential people from Columbus. They are surprised how easy it is to gain access to people of power, like the mayor, if you have an official-looking letter of intent, a website and make a few persistent phone calls. Organizing all the logistics is stressful and Dan is more worried than ever about the project. He thinks they are going to fail, for sure.

They print and laminate fake press passes and carry their MTV building ID cards. As soon as people see that they have credentials, they gain access to clubs, bars, parties, the stadium and many other places they shouldn't have been. Game day comes and after not sleeping for three days, running after drunken fans and trying to stay sober, the crew is incredibly tired. They go out for one last day of shooting.

Andre is worried about what might happen after the game. People say that if the Buckeyes win, there will be riots all night and if they loose, probably the same. OSU fans are notorious for setting cars and dumpsters on fire after major games. The Buckeyes win and everyone spills out on the streets for a party. There are cops and giant floodlights on every corner — having such a large police presence makes fans think twice.

Nothing major happens after the game. In fact, it's a bit anti-climactic. The four get in the car and drive back to the house. They turn a corner and see a bunch of people spilling out of a bar. Andre and Dan get out of the car and start filming. About five or six security guards are pummeling a drunk guy. The scene lasts about five minutes. The guy is lying on the ground in a puddle of his own blood and looks dead. Finally the cops come and break up the fight. When they lift the guy from the ground his face is covered in blood and he is missing skin. Andre and Dan give their info to the cops. Unfortunately, after a few days of having fun and meeting new people they have to leave with this violent memory.

They go back to New York with the footage and make notes about the 45 hours of footage they shot. Dan draws up a contract where all four of the friends each own a quarter of the film and they send a hard drive to Tom to start editing. There is a contemporary arts center in Columbus called the Wexner that's interested in screening the final cut, but they need to see something before finalizing the date. Tom agrees on a deadline and starts working on the edit.

A few months pass and the deadline for the Wexner is approaching fast. There is no word from Tom on the status. Andre and Dan try emailing, calling and asking friends about what might have happened to Tom. Dan decides to email a few people at Tom's job. Tom responds with a short note telling them never to contact his co-workers again and wishes them good luck with the rest of the movie. After missing the deadline, Andre and Dan have nobody to edit the movie and nowhere to screen it.

Another few months pass and their friend David is willing to edit. They still haven't talked to Tom despite numerous attempts to get in touch. It's the first time that work has come between a friendship and it teaches them a very important lesson. Regardless of what happens to the movie, Andre and Dan are sad to loose a good friend.

UTICA

Pratt has a campus upstate in the small town of Utica. Utica holds lectures a few times during the year, and it's mainly artists from New York that come to speak. One of the lecturers has canceled and they need a last minute replacement. Andre and Dan decide that they should pursue every opportunity to talk and take the day off for the drive to Utica.

Their hotel is in the seedy part of town, on the same block as two strip clubs. There isn't much to do in Utica. Andre and Dan like wandering around the school campus and the local art museum. Andre even finds an Eastern Orthodox church. They put together some stills from their site and practice the night before. Andre is convinced that they can wing it, but Dan is worried that they have under prepared. Their first slide is a photo of Paul Wall with a shirt that says "I HU$TLE." They play a Swishahouse mixtape while everyone is getting seated.

Some of the faculty ask if Dan is the person in the photo. People have a hard time understanding the image, but it's quite simple, really — design is a hustle. Andre and Dan think of lecturing as a performance rather than a monologue about their work. Because there are two of them it's much easier to make jokes or say things that don't make sense. The kids like what they hear and see, many of them confess that it's the first lecture they've stayed awake for. Andre and Dan are happy, until one kid comes up and asks them what they do for a living. The president of the school loves their lecture and invites them to come back whenever they want.

BALLOONS

A British designer called David emails dress code asking them to design a logo for his company, Accept and Proceed. His clever idea is to get talented designers to create the ever-changing splash page of his site. He already has a roster of impressive names and dress code accepts. They

I LOVE THEM...
I LOVE THEM NOT...
I LOVE THEM...

Ali Bailey

HAPPY DRESS CODE MEMORIES:

- Falling in love (with Andre, not Dan)
- Seeing Andre get a job at MTV and spring break 2005
- B-B-Qing on our deck in the East Village
- Watching Dan and Andre teach for the first time and seeing how well they commanded authority
- Discovering how much they learn on the fly (as in how much they fake it till they make it!)
- Watching *The OC* with Dan and *SVU* with Andre
- Getting my first real job, through Dan
- Turning the living room into a beauty parlor
- Helping create really great projects
- Having two amazing friends who I love despite:

NOT SO HAPPY DRESS CODE MEMORIES:

- Watching Dan hire a stripper for Andre's 21st birthday
- Having a breakdown during a screenprinting marathon (brown is a hard color to mix)
- Realizing (four years after he told me) that Andre was serious when he said work will always come first
- Being called "Tape Lady" - as in the girl whose job it is to make tape balls to hang posters
- NOT being cast in a spot for MTV
- Waking up in the middle of the night to "Pocker" matches
- Being the only one not acknowledged at Andre's thesis award ceremony
- Not getting credited as the illustrator for the Ancille packaging (it's my drawing on Kelly's arm!)
- Feeling lesser because I wasn't ready to be an artist
- Floundering while they were succeeding
- Keeping track of Dan's girlfriends

Ali recently moved to Minneapolis to produce her TV show, The Alison Rose Bailey Show, at the Minneapolis Television Network. When she is not tap dancing, jazz handsing, lip synching or hi-fiving, she is working for Fox Television. Seriously.

come up with the idea of doing the logo out of balloons. Seems like a simple enough idea, but they want to make the logo huge. They buy 1000 balloons and blow them up with hand pumps to make the letters "A" and "P."

They carry the massive balloon structures to a nearby abandoned pool. After spending the whole day preparing the project, the sunlight is starting to run out. Dan secures the "A" with fishing line, but has to hold up the "P." Andre runs around taking hundreds of photographs. The letters look weird and imperfect, but it is cool. This project is a new way of working for them. Instead of coming up with a solution for a problem, they come up with a restraint that produces cool results.

SUITS AND TEE SHIRTS

Wayne from the NYCOLLECTIVE calls again. He has another big project in the works. Wayne is pitching a marketing proposal to a big financial company called Deloitte. The company is looking for a way to unify their 50,000 worldwide employees and develop a "creative" corporate culture. Since YouTube is so hot right now the idea is to make a film festival where employees can enter homemade movies and win big prizes. Andre and Dan like Wayne, so they decide to join forces with the Collective.

They go to Deloitte for the pitch. There are 19 suits in a boardroom waiting for their presentation. Andre zips open his backpack and puts a boom box on the table. They hand out printouts of their presentation and press play. The recording is of Wayne telling the story of the collective and then narrating each idea as the suits followed along in their handouts. The potential for disaster is high, but the Collective is not sure if they even want the job, so what the hell. Deloitte loves it. This is exactly what they are looking for. They are laughing, cracking jokes and decide to choose the Collective over some very big branding firms. One of the people at the table works regularly with John Bielenberg and Andre makes the connection; it's a small world after all.

Andre and Dan debate taking the job. It doesn't seem like the most fun client in the world, but they will make some decent money. At first, Andre thinks that they should pass, but since the two are about to start a new business and look for an office, it could end up helping. They set a price high enough that the job will be worth doing. After numerous revisions, the job is a go and they start working with the Collective for big boy cash.

SCHOOL DID NOT MARK THE END OF THE ALL-NIGHTER.

THE STUDIO IS MUCH FASTER PACED THAN SCHOOL.

FREELANCING ON THE SIDE ISN'T A BAD WAY TO GET YOUR CHOPS UP.

A SMALL OFFICE WILL MOST LIKELY MEAN MORE RESPONSIBILITY AND INTERACTION WITH CLIENTS.

A BIGGER OFFICE WILL HAVE LARGER PROJECTS, AUDIENCES, BUDGETS AND LOTS OF OPINIONS.

IF YOU DON'T KNOW HOW TO NEGOTIATE A PROPER SALARY, PUT IT BACK ON THEM.

IT'S NOT UNCOMMON TO JUMP AROUND A LOT IN THE FIRST FEW YEARS.

THE FIRST JOBS WILL ESTABLISH YOU AND YOUR WORK.

DON'T PASS ON A FREELANCE GIG IF THE SPOT IS GOOD. FREELANCE CAN LEAD TO PERMANENT.

JOB TITLES ARE INVENTED TO MAKE PEOPLE FEEL BETTER.

DON'T GET PIGEON HOLED UNLESS YOU REALLY REALLY WANT TO.

BEING ABLE TO SELL YOURSELF, YOUR WORK AND YOUR IDEAS WILL HELP YOU LATER.

COLLABORATE WITH PEOPLE WHO ARE BETTER THAN YOU.

EVEN THOUGH YOU WERE THE SHIT IN SCHOOL, YOU START FROM SCRATCH.

IF YOU ARE NOT CHALLENGED, FIND ANOTHER JOB.

THE CLIENT DOESN'T ALWAYS KNOW WHAT THEY WANT.

DESIGN IS A BUSINESS.

BEING INTO OTHER STUFF IS BETTER THAN TALKING DESIGN ALL THE TIME.

IT'S JUST GRAPHIC DESIGN, DON'T TAKE THINGS PERSONALLY.

I DON'T PLAY VIDEO GAMES EXCEPT MORTAL COMBAT. THE BOARD I PITCHED IS BELOW, THE SHOW PRODUCER THOUGHT IT LOOKED LIKE MODERN EXPRESSIONISM. - A

237

I TOOK ONE OF DAN'S OLD VMA LOGOS AND USED IT FOR A THEORETICAL OPEN. IT'S THE LAST PROJECT I DID AT MTV. - A

TIME TO MOVE ON

LIFE WITHOUT PANTS

June comes fast for Dan and Andre. They don't have time for self-promotion, but are getting asked to work on bigger jobs and do speaking engagements every now and then. This is the perfect time to begin looking for an office and to quit MTV. Working for the channel has been a pleasure, shaping them as designers while giving them a name, but they are ready to go at it on their own. Andre and Dan tell Rodger that they can stay till August, leaving plenty of time to find replacements. Rodger lets them know that their last day will be June 15th. This coincidentally is the random date Dan and Andre had picked years prior for quitting.

With the money they have saved, dress code can operate for a year without clients. It is a risky move as Dan and Andre are a combined age of forty-eight and have little experience. But, somehow, it feels right.

This is the last chapter of the book because we don't know what will happen next. Andre and Dan might spend all their savings before the summer ends, or they could make more money than ever. They could hire an intern or hire twenty people. An amazing client could call or they might be stuck working on crap projects. Regardless, there will certainly be many setbacks and failures ahead, but hopefully a few successes as well. What the hell do they have to lose?

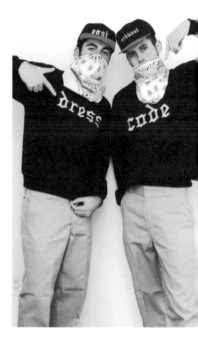

JOBQUITTING

Frank Derose

What I would like to holler at you all about is something called "jobquitting;" one word, lower case. Very simple — 11 letters, lots of t's and i's (and here's a secret: I made it up for this little essay.)

It is appropriate, however, to this particular book for several reasons: one, it is what I have been doing since I finished my degree and, two, it is what I did at the end of December 2006, which has allowed me to put off writing this essay until now- March 6, 2007, which is 6 days later than when Dan wanted it. (Whatever, Dan. You are not my boss!)

Anyway, I am sure you can imagine what "jobquitting" is. It is pretty much self-explanatory. But, the psychology it elicits is not always so obvious.

This psychology comes replete with some self-doubt; maybe even some self-loathing (not to mention no money). This past time (and I have done it x3 since I finished my degree in December '04) because of the aforementioned self-doubt and insecurity, it has occasioned some fighting with my wife (Hola Nena!). Sometimes I have trouble keeping these emotions in check and I take them out on her. Of course, I know this is not fair; but it is half the fun! You will, in your jobquitting, undoubtedly discover some new things about yourself and some of them will suck. A lot of them might suck, actually.

Sounds shitty, right? It is.

It is definitely shitty to throw away a paycheck and have nothing concrete to replace it with (imagine throwing money away...), and it is kind of shitty to stay at home all day (Dan asked me to mention how I sit around in my underwear a lot). It is also extremely shitty to spend a vast amount of time worrying that you will never get another job, or find another client. Thereby rendering yourself a pretty poor designer.

But (and you had to know this was coming):

There is definitely something empowering and, one might even argue, a little noble, in jobquitting. The thing to keep in mind is that slavery was abolished in 1865. You don't have to do what you don't want to do; or what doesn't make you happy. I mean, like, totally, absolutely, all the way happy. There is very little reason to keep a job you don't like. In fact, fuck it.

If you can figure out a way to either save some paper or earn a little paper in the meantime, you too can practice the technique of jobquitting. Embracing your idealism can stand you in good stead. It does require some guts and a little tenacity, but perhaps it will lead to something greater than a paycheck, like doing what you believe in (this is what I sound like when I am on my high horse... and I know it's a little vainglorious, but it feels so good).

And the thing that it might allow you, just as it allows me — and which is utterly important — is hope. Now, when I wake up, mixed in with the fear and stomachaches is a little silver of hope: "Maybe today *Insert hero designer's name here* will remember the day I showed him my portfolio, and he will call me up and offer me a job. Or, maybe I will find the perfect freelance client. Or, maybe, I will finally be able to dunk a basketball."

Whatever it might be... there is now the possibility... there is the time... for something like this to happen (but not the basketball, I am pretty sure that is a physiological thing).

I can take the time to try again. And again. And again. And I can keep getting a little bit better and, eventually, I'll get the job or start the studio that makes me happy and keeps me satisfied. And that is why the past two years have been all about jobquitting.

Frank DeRose is.

Epilogue:
Some Things

—

The process of making this book has been intense, to say the least, since neither of us has ever worked on such a huge project. In one way or another we have been working on this book since the winter of 2005, when we first got the idea. The final due date has come and gone many times, and as of now we are over deadline by five months. Needless to say, we now hold more respect for anyone who works in a field where projects take years to complete. Writing has been the biggest challenge, since neither of us are talented in that respect (but we are sure you are well aware of this by now). To look back at the past objectively and analyze how we got where we are was also a struggle; what was important, what was meaningless, and what would people care to read about? Hopefully our time hasn't been wasted and someone can draw inspiration from our story. At least you bought it, or maybe you are a library reader. Thanks!

We will be finished with our film around the same time the book goes to press, and like the book, it has been a taxing process. We had no idea what we were doing, which is actually the way we prefer it. Our dream is that *Across the Field* will do well on the film festival circuit and get picked up for distribution, letting a huge audience see into the world of Ohio State football fanatics.

In the future, we hope to work on more self initiated projects and fill our days with a combination of both client and personal work, and to get our voices heard by more and more people, while still having control over

what we do. Now we have a real office, with real chairs, more than enough space and a decent view. The idea that we would work less by doing dress code full time turned out to be laughable, but we are enjoying ourselves. Our biggest fear, that we wouldn't have enough money or clients to keep the lights on, has not been a problem and we actually have had to turn some work away.

As of now, we have no desire to expand into a giant sweatshop and like keeping things on the small side. The next few months will tell a lot, though, since we have no idea how either this book or our film will be received — or if the work will keep coming.

Till the next book,
—
dress code

CREDITS

(24-25)
Crazy Pit – Medium: *Pencil* Class: *Sophomore Drawing* Year: *1996*

Very Serious Self Portrait – Medium: *Pencil* Class: *A.P. Art* Teacher: *Mrs. Copfer* Year: *1999*

Australian Tourism Poster – Medium: *Airbrush* Class: *Graphic Design* Teacher: *Mr. Inwood* Year: *1997*

Beth Graffiti – Medium: *Airbrush* Class: *Self Initiated* Year: *1998*

Sculpture – Medium: *Stone* Class: *A.P. Art* Teacher: *Mrs. Copfer* Year: *1999*

Abstract Self Portrait – Medium: *Tempra Paint* Class: *Sophomore Drawing* Year: *1997*

(26-27)
City Collage – Medium: *Mixed* Class: *A.P. Art* Teacher: *Mrs. Copfer* Year: *1999*

Pride Graffiti – Medium: *Colored Pencil* Class: *A.P. Art* Teacher: *Mrs. Copfer* Year: *1999*

Hello My Name Is – Medium: *Colored Pencil* Class: *A.P. Art* Teacher: *Mrs. Copfer* Year: *1999*

Devious – Medium: *Photo* Class: *A.P. Photo* Teacher: *Mr. Gregory* Year: *1999*

Can – Medium: *Photo* Class: *A.P. Photo* Teacher: *Mr. Gregory* Year: *1999*

Mist Study – Medium: *Cut Paper* Class: *A.P. Art* Year: *1999* Teacher: *Mrs. Copfer*

3D Beth – Medium: *Colored Pencil* Class: *Self Initiated* Year: *1999*

(34-35)
Teliatics – Medium: *Website* Class: *Self Initiated* Year: *1999*

Weapon – Medium: *Poster* Class: *Self Initiated* Teacher: Year: *1999*

And2And V2 – Medium: *Website* Class: *Self Initiated* Teacher: Year: *1999*

Word Cutter – Medium: *Photocopy Collage* Class: *Self Initiated* Year: *2001*

Self Identity – Medium: *Logo* Class: *Self Initiated* Teacher: *Krassimir Andreev* Year: *2001*

And2And V1 – Medium: *Website* Class: *Self Initiated* Year: *1998*

(36-37)
Exit – Medium: *Collage* Class: *Self Initiated* Year: *2001*

Calendar – Medium: *Typography* Class: *Self Initiated* Teacher: *Krassimir Andreev* Year: *2001*

3D Experiment – Medium: *3D* Class: *Self Initiated* Year: *2000*

Pollution – Medium: *Poster* Class: *Self Initiated* Teacher: *Krassimir Andreev* Year: *2001*

Comps for Photoshop class – Medium: *Photoshop* Class: *Advanced Photoshop* Year: *2001*

Pet Love – Medium: *Illustration* Class: *Color Theory* Year: *2001*

Broken TV – Medium: *Sculpture* Class: *Self Initiated* Year: *2000*

(38-39)
Misc. Photos from Seattle – Medium: *Photography* Class: *Self Initiated* Year: *2000-2002*

Where I'm From – Medium: *Poster* Class: *Self Initiated* Year: *2002*

Shapes – Medium: *Zine* Class: *Self Initiated* Year: *2002*

(51)
Emcee – Medium: *Pencil* Class: *OSU Entrance Exam* Year: *2001*

Sub City – Medium: *Logo Redesign* Class: *OSU Entrance Exam* Year: *2001*

Cowgirls and Indians – Medium: *Flyer* Client: *Phusion Projects* Year: *2001*

Voyage – Medium: *Flyer* Client: *Phusion Projects* Year: *2001*

Springfest – Medium: *Poster* Client: *The Underground* Year: *2001*

(52)
Pay Us To Kill You – Medium: *Poster* Class: *Graphic Design 1* Teacher: *Mark Fox* Year: *2002*

US – Medium: *Vector Drawing* Class: *Self Initiated* Year: *2000*

Type Studies – Medium: *Logo* Class: *Type 2* Teacher: *Michele Wetherbee* Year: *2002*

Prey – Medium: *Poster* Class: *Graphic Agitation* Teacher: *Michele Wetherbee* Year: *2002*

GD Monogram – Medium: *Logo* Class: *Graphic Design 1* Teacher: *Mark Fox* Year: *2002*

(62-63)
Covert – Medium: *Logo* Class: *Graphic Design 1* Teacher: *Mark Fox* Year: *2002*

From The Ground – Medium: *Logo* Client: *Joe Jahnigen* Year: *2002*

Altria – Medium: *Poster* Class: *Graphic Agitation* Teacher: *Michele Wetherbee* Year: *2002*

The Architecture of Funk – Medium: *Poster and Sketch* Class: *Type 2* Teacher: *Michele Wetherbee* Year: *2002*

Love – Medium: *Poster* Class: *Graphic Design 2* Teacher: *Doug Akagi* Year: *2002*

Amnesia – Medium: *Logo* Class: *Graphic Design 2* Teacher: *Doug Akagi* Year: *2002*

OK Monogram – Medium: *Logo* Class: *Type 2* Teacher: *Michele Wetherbee* Year: *2002*

Amnesia Logotype – Medium: *Logo* Class: *Graphic Design 2* Teacher: *Doug Akagi* Year: *2002*

(64-65)
Herb – Medium: *Stickers, Posters* Client: *Self Initiated* Year: *2002*

(72-73)
Poetry – Medium: *Posters* Class: *Type 3* Teacher: *Nola Berger* Year: *2003*

Static – Medium: *Book, Film* Class: *Graphic Design 3* Teacher: *Max Kisman* Year: *2003*

Motion Series – Medium: *Studies* Class: *Graphic Design 3* Teacher: *Max Kisman* Year: *2003*

Muse – Medium: *Book* Class: *Graphic Design 3* Teacher: *Max Kisman* Year: *2003*

(74-75)
Drugs – Medium: *Book* Class: *Type 3* Teacher: *Nola Berger* Year: *2003*

Rehearsal – Medium: *Video* Class: *Intro to Video* Teacher: *Barney* Year: *2003*

Some Illustration – Medium: *Illustration* Class: *Self Initiated* Year: *2003*

Self Promo – Medium: *Postcard* Class: *Graphic Design 3* Teacher: *Max Kisman* Year: *2003*

(78-79)
Senior Show – Medium: *Poster* Client: *Alison Bailey* Year: *2003*

Tree – Medium: *Record Cover* Client: *AIGA* Year: *2003*

Hoodie – Medium: *Hoodie* Client: *CCA* Year: *2003*

Alcatraz Tours – Medium: *brochure* Client: *Alcatraz Tours* Year: *2003*

Play Control – Medium: *Website, Tee Shirt* Client: *Self Initiated* Year: *2003*

(80-81)
Nike Soccer Tape – Medium: *Website* Role: *Design, Concepting, Illustration* Studio: *odopod* Creative Direction: *Jaquie Moss, Tim Barber, David Bliss* Year: *2003*

Nike Skateboarding – Medium: *Website* Role: *Design, Concepting, Photography* Studio: *odopod* Creative Direction: *Jaquie Moss, Tim Barber, David Bliss* Year: *2004*

Nike Womens Soccer – Medium: *Website* Role: *Design* Studio: *odopod* Creative Direction: *Jaquie Moss, Tim Barber, David Bliss* Year: *2003*

(82-83)
Soul Provider – Medium: *Book* Role: *Design, Illustration* Studio: *Vehicle* Creative Direction: *Dennis Crowe* Year: *2002*

Dark/Light – Medium: *Program Guide, Logo, Titles* Class: *Graphic Design 3* Teacher: *Eric Heiman* Year: *2003*

Swingers – Medium: *Logo Concept* Role: *Design* Studio: *Vehicle* Creative Direction: *Dennis Crowe* Year: *2002*

(84-85)
TeknaRok – Medium: *Logo* Client: *TeknaRok Records* Year: *2002*

Donor Card – Medium: *Collateral* Class: *Sputnik* Teacher: *Bob Aufuldish, Erin Lampe* Year: *2003*

CCAC Pre College – Medium: *Logo* Class: *Sputnik* Teacher: *Bob Aufuldish, Erin Lampe* Year: *2003*

S – Medium: *Letter* Client: *Holland Fonts* Year: *2002*

Nutura – Medium: *Animation* Class: *Digital Studio 4* Teacher: *Steve* Year: *2003*

Relativity – Medium: *Photo Sequence* Class: *Graphic Design 4* Teacher: *Jim Kenney* Year: *2003*

(103)
Repeater – Medium: *Tee Shirt* Role: *Design* Studio: *Xlarge* Creative Direction: *Eli Bonerz* Year: *2003*

Some Assembly Required – Medium: *Tee Shirt* Role: *Design* Studio: *Xlarge* Creative Direction: *Eli Bonerz* Year: *2003*

X-Squared – Medium: *Tee Shirt* Role: *Design* Studio: *Xlarge* Creative Direction: *Eli Bonerz* Year: *2003*

X'ills – Medium: *Tee Shirt* Role: *Design* Studio: *Xlarge* Creative Direction: *Eli Bonerz* Year: *2003*

(104-105)
Project M Book – Medium: *Book* Role: *Photography, Design* Studio: *Project M* Creative Direction: *John Bielenberg* Designers: *John Bielenberg, Nic Taylor, Jimm Lasser, Christian Helms, Rachel Celenesi, Bonnie Berry, Satoru Nihei* Year: *2003*

(106-107)
Streetwise – Medium: *Book Cover* Class: *Type 3* Teacher: *Nola Berger* Year: *2003*

Objectus – Medium: *Poster* Class: *Type 4* Teacher: *Jeremy Mende* Year: *2003*

Flower Power – Medium: *Screen Printed Poster* Class: *Self Initiated* Year: *2003*

Killer Whale – Medium: *Screen Printed Poster* Class: *Self Initiated* Year: *2003*

Let's Be Friends – Medium: *Record Cover* Client: *AIGA* Year: *2003*

Relativity – Medium: *Website* Class: *Graphic Design 4* Teacher: *Jim Kenney* Year: *2003*

(108-109)
Permanent Haircuts – Medium: *Poster, Sketch* Class: *Type 4* Teacher: *Jeremy Mende* Year: *2003*

Type Studies – Medium: *Photocopy* Class: *Type 4* Teacher: *Jeremy Mende* Year: *2003*

Ancille – Medium: *CD, Poster, Website* Client: *Kelly Aiken* Year: *2003*

(117)
Jarr – Medium: *Screenprinted Poster* Class: *Sputnik* Teacher: *Eric Heiman, Erin Lampe* Year: *2004*

Financial Aid – Medium: *Catalog* Class: *Sputnik* Teacher: *Eric Heiman, Erin Lampe* Year: *2004*

Virtual Tour – Medium: *Website* Class: *Laika* Teacher: *Stell Lai* Year: *2003*

Hilarious Power Point – Medium: *Power Point Presentation* Client: *Some Guy* Year: *2004*

(118-119)
Andrew WK – Medium: *Screenprinted Posters* Client: *Kelly Aiken* Year: *2004*

Past Tense – Medium: *CD* Client: *Snow Cuts Glass* Year: *2004*

(120-121)
Built To Spill – Medium: *Screenprinted Poster* Client: *Kelly Aiken* Year: *2004*

Lonely For Stereo – Medium: *CD* Client: *Trevor Bassett* Illustrator: *Ali Bailey* Year: *2004*

Shera – Medium: *CD* Client: *Can I Be Shera* Year: *2004*

No low Trio – Medium: *Screen Printed Poster* Client: *Joe Jahnighen* Year: *2004*

(124-125)
Project M Guide – Medium: *Brochure* Role: *Photography, Design* Studio: *Project M* Creative Direction: *John Bielenberg* Additional Design: *Bryce Howlitson* Copy Writing: *Preston Noon* Year: *2004*

U.S.E. – Medium: *Screenprinted Poster* Client: *Kelly Aiken* Year: *2004*

RAW 5 – Medium: *Postcard* Class: *Sputnik* Teacher: *Eric Heiman, Erin Lampe* Year: *2004*

Dinh Q Le – Medium: *Poster* Class: *Sputnik* Teacher: *Eric Heiman, Erin Lampe* Year: *2004*

Hope – Medium: *Logo* Client: *John Bielenberg* Year: *2004*

Art Plus – Medium: *Identity and Card* Client: *Svetlana Metodieva* Year: *2004*

(126)
No Low Trio 2 – Medium: *Screenprinted Poster* Client: *Joe Jahnighen* Year: *2004*

Urban Street Advisors – Medium: *Logo Sketch, Business Card* Client: *Roger Gordon* Year: *2004*

(131-132)
Graphic Design Is – Medium: *Book* Class: *Senior Thesis* Teacher: *Michael Vanderbyl, Jennifer Morla, Jennifer Steriling* Year: *2004*

(139)
Giant Resume – Medium: *Resume* Client: *Self Promotion* Year: *2004*

(147)
Sagmeister – Medium: *Screenprinted Poster* Client: *Self Promotion* Year: *2004*

God Hates Techno – Medium: *Tee Shirt* Client: *Threadless* Concept: *Jim Covert* Year: *2004*

(148)
Not So Giant Resume – Medium: *Resume* Client: *Self Promotion* Year: *2005*

(153-155)
Process to Progress – Medium: *Books* Class: *Senior Thesis* Teacher: *Michael Vanderbyl, Jennifer Morla, Jennifer Steriling* Year: *2005*

(160-161)
Epic – Medium: *Identity, Postcard, Brochure, Signage* Client: *Southern Exposure* Year: *2004*

Graphic Designer – Medium: *Business Card* Client: *Self Promotion* Year: *2004*

The Pale – Medium: *Screenprinted Poster* Client: *Kelly Aiken* Year: *2004*

Blood Is The New Black – Medium: *Website Concept* Client: *Blood is the New Black* Year: *2004*

(162)
Register to Rock! – Medium: *Screenprinted Poster* Client: *Joe Jahnighen* Year: *2004*

(171)
Hattler – Medium: *CD* Role: *Design* Studio *karlssonwilker inc,* Creative Direction: *Hjalti Karlsson, Jan Wilker* Year: *2004*

MTV Books – Medium: *Logo* Role: *Design* Studio: *MTV Off-Air Creative* Creative Direction: *Jeffrey Keyton, Deklah Polansky, Lance Rusoff* Year: *2004*

(172-173)
Van Stationary – Medium: *Stationary System* Role: *Design, Copy Writing* Studio: *MTV Off-Air Creative* Creative Direction: *Jeffrey Keyton, Jim deBarros, Christopher Truch* Additional Copy Writing: *Nick Sonderup* Year: *2004*

Desi – Medium: *Logo* Role: *Design* Studio: *MTV Off-Air Creative* Creative Direction: *Jeffrey Keyton, Romy Mann, Rodger Belknap* Additional Design: *Cara Brower* Year: *2004*

Fresh – Medium: *Note Cube* Role: *Design* Studio: *MTV Off-Air Creative* Creative Direction: *Jeffrey Keyton, Deklah Polansky* Year: *2004*

VJ Search – Medium: *Poster* Role: *Design* Studio: *MTV Off-Air Creative* Creative Direction: *Jeffrey Keyton, Jim deBarros* Photography: *Sam Comen* Year: *2004*

(174-175)
MTV2.com – Medium: *Website* Role: *Design* Studio: *MTV Off-Air Creative* Creative Direction: *Jeffrey Keyton, Jim deBarros* Year: *2005*

MHD – Medium: *Logo* Role: *Design* Studio: *MTV Off-Air Creative* Creative Direction: *Jeffrey Keyton, Jim deBarros, Lance Rusoff, Thomas Berger* Year: *2005*

Lightning – Medium: *Tee Shirt* Role: *Design* Studio: *MTV Off-Air Creative* Creative Direction: *Jeffrey Keyton, Deklah Polansky* Year: *2005*

Skull – Medium: *Tee Shirt* Role: *Design* Studio: *MTV Off-Air Creative* Creative Direction: *Jeffrey Keyton, Deklah Polansky* Year: *2005*

This Is Not – Medium: *Tee Shirt* Role: *Design* Studio: *MTV Off-Air Creative* Creative Direction: *Jeffrey Keyton, Jim deBarros, Rich Browd* Year: *2005*

Times $quare – Medium: *Tee Shirt* Role: *Design* Studio: *MTV Off-Air Creative* Creative Direction: *Jeffrey Keyton, Deklah Polansky* Year: *2004*

MTV DMC – Medium: *Tee Shirt* Role: *Design* Studio: *MTV Off-Air Creative* Creative Direction: *Jeffrey Keyton, Jim deBarros, Rich Browd* Year: *2006*

B and B – Medium: *DVD Cover Concept* Role: *Design* Studio: *MTV Off-Air Creative* Creative Direction: *Jeffrey Keyton, Jim deBarros* Year: *2005*

(184-185)
VMA 05 Logo – Medium: *Logo* Role: *Design* Studio: *MTV Off-Air Creative* Creative Direction: *Jeffrey Keyton, Jim deBarros, Stacy Drummond* Year: *2005*

VMA Tchotchkies – Medium: *Assorted Tchotchkies* Role: *Design* Studio: *MTV Off-Air Creative* Creative Direction: *Jeffrey Keyton, Jim deBarros, Deklah Polansky, Christopher Truch* Year: *2005*

VMA Campaign – Medium: *Advertising Campaign* Role: *Design* Studio: *MTV Off-Air Creative* Creative Direction: *Jeffrey Keyton, Jim deBarros, Christopher Truch* Photography: *Matthias Clamer* Year: *2005*

(186-187)
VMA Category Opens – Medium: *Video* Role: *Direction* Studio: *MTV On-Air Design* Creative Direction: *Jeffrey Keyton, Romy Mann, Rodger Belknap* Director of Photography: *Ric Frazier* Producer: *Leslie Legare* Year: *2005*

VMA Ancillary – Medium: *Show Opens* Role: *Direction* Studio: *MTV On-Air Design* Creative Direction: *Jeffrey Keyton, Romy Mann, Rodger Belknap* Producer: *Leslie Legare* Animation: *Luke Choi, Ellen Chi* Year: *2005*

(193)
Spankin' New – Medium: *Show Opens, Logos* Role: *Direction* Studio: *MTV On-Air Design* Creative Direction: *Jeffrey Keyton, Romy Mann, Rodger Belknap* 3D: *Eban Byrne* Illustration: *Daim, Rich Browd* Producer: *Leslie Legare* Year: *2005*

(194-195)
Woodies – Medium: *Poster, Concept* Role: *Design* Studio: *MTV Off-Air Creative* Creative Direction: *Jeffrey Keyton, Jim deBarros* Year: *2005*

$2 Bill – Medium: *Proposed Poster* Role: *Design* Studio: *MTV Off-Air Creative* Creative Direction: *Jeffrey Keyton, Jim deBarros* Year: *2005*

Westminster – Medium: *Logo* Client: *Westminster Social Club* Year: *2005*

Glow Bike – Medium: *Catalog Photos* Role: *Art Direction* Client: *Westminster Social Club* Photographer: *John Kealey* Year: *2005*

Direct Effect – Medium: *Logo* Role: *Design* Studio: *MTV On Air Design* Creative Direction: *Jeffrey Keyton, Romy Mann, Rodger Belknap* Year: *2005*

COCA – Medium: *Ad Campaign* Client: *Cincinnati Council on Child Abuse* Year: *2005*

(196-197)
I Am – Medium: *Poster* Role: *Concept* Studio: *MTV Off-Air Creative* Creative Direction: *Jeffrey Keyton, Jim deBarros, Thomas Berger* Design: *New York City Public High School Students* Client: *The Cooper-Hewitt* Year: *2005*

Viacom – Medium: *Logo Sketches* Role: *Design* Studio: *MTV Off-Air Creative* Creative Direction: *Jeffrey Keyton, Jim deBarros, Romy Mann, Rodger Belknap, Christopher Truch, Lance Rusoff* Type: *Lance Rusoff* Year: *2006*

(198-199)
GoodHuman – Medium: *Logo, Website, Stickers, Business Card* Client: *GoodHuman Magazine* Site Developer: *Jon Dacuag* Year: *2005-2006*

Ski Mask – Medium: *Tee Shirt* Client: *Empire State* Art Direction: *Frank DeRose* Year: *2006*

Blocks – Medium: *Tee Shirt* Client: *Shook Ones* Year: *2006*

Five Mics – Medium: *Tee Shirt (Front and Back)* Client: *Empire State* Art Direction: *Frank DeRose* Year: *2006*

Zilla – Medium: *Tee Shirt* Client: *Empire State* Art Direction: *Frank DeRose* Year: *2006*

Balloons – Medium: *Tee Shirt* Client: *Def Jux* Art Direction: *Frank DeRose* Year: *2006*

(217)
dresscodeny.com – Medium: *Website* Client: *Self Promotion* Site Developer: *Jon Dacuag* Year: *2005*

(218-219)
The Big Ten – Medium: *Show Opens* Role: *Direction* Studio: *MTV On-Air Design* Creative Direction: *Jeffrey Keyton, Romy Mann, Rodger Belknap* 3D: *Eban Byrne, Chris Ghallagher* Editor: *Yurika Abe* Producer: *Leslie Legare* Year: *2006*

Fila Play Too – Medium: *Tee Shirts, Hang Tags* Client: *Fila, NYCOLLECTIVE* Additional Design: *Drew Heffron* Year: *2005*

Kinkos! – Medium: *Card* Client: *Self Promotion* Year: *2006*

(220-221)
40 Greatest – Medium: *Show Open, Logo* Client: *CMT* 3D: *Eban Byrne* Year: *2006*

Giants – Medium: *Logo* Client: *CMT* Year: *2006*

Discover and Download – Medium: *Show Open, Logo* Role: *Direction* Studio: *MTV On-Air Design* Creative Direction: *Jeffrey Keyton, Romy Mann, Rodger Belknap* 3D: *Chris Ghallagher* Producer: *Susanne Barr* Year: *2006*

True Life – Medium: *Show Open, Logo* Role: *Direction* Studio: *MTV On-Air Design* Creative Direction: *Jeffrey Keyton, Romy Mann, Rodger Belknap* Producer: *Janet Shaw* Year: *2006*

(222-223)
VMA 06 Logo – Medium: *Logo, Applications* Role: *Design* Studio: *MTV On-Air Design* Creative Direction: *Jeffrey Keyton, Romy Mann, Jim deBarros, Christopher Truch, Rodger Belknap* Additional Design: *MTV Off-Air Creative (Print Application)* Year: *2006*

The Author and The Animal – Medium: *CD* Client: *Snow Cuts Glass* Illustration: *Nicole Grazioso* Year: *2006*

VMA Ancillary – Medium: *Show Opens* Role: *Direction* Studio: *MTV On-Air Design* Creative Direction: *Jeffrey Keyton, Romy Mann, Rodger Belknap* 3D: *Eban Byrne, Brit, Chris Ghallagher* Year: *2006*

(224)
Legendary – Medium: *Logo Sketches* Client: *Legendary Pictures* Year: *2006*

Outside Indoors – Medium: *Wedding Invite* Client: *Joe and Rebecca Jahnighen* Year: *2006*

(228-229)
AP – Medium: *Logo Design* Client: *Accept and Proceed* Year: *2006*

ADAA – Medium: *Ad Campaign Concepts* Client: *Adobe* Additional Design: *Priyanka Pandit, John Berming* Year: *2006*

(230-231)
Shart – Medium: *Video* Role: *Direction* Studio: *MTV On-Air Design* Creative Direction: *Jeffrey Keyton, Romy Mann, Rodger Belknap, David McElwaine* 3D: *Chris Ghallagher* Producer: *Susanne Barr* Director of Photography: *Eric Robins* Year: *2006*

Dew Circuit Breakout – Medium: *Show Open* Role: *Direction* Studio: *MTV On-Air Design* Creative Direction: *Jeffrey Keyton, Romy Mann, Rodger Belknap, David McElwaine* Producer: *Janet Shaw* 3D: *Sony* Year: *2006*

Sputnik X – Medium: *Poster* Client: *California College of the Arts* Year: *2006*

Campo – Medium: *Logo, Business Cards* Client: *Ali Bailey* Year: *2006*

(237)
Gamers Week – Medium: *Show Open, Logo* Role: *Direction* Studio: *MTV On-Air Design* Creative Direction: *Jeffrey Keyton, Romy Mann, Rodger Belknap* 3D: *Eban Byrne, Kunle* Producer: *Ross Jeffcoat* Year: *2006*

(238-239)
YouRL – Medium: *Show Open Concept, Logo* Role: *Direction* Studio: *MTV On-Air Design* Creative Direction: *Jeffrey Keyton, Romy Mann, Rodger Belknap* 3D: *Eban Byrne, David Martin, Kunle* Producer: *Ross Jeffcoat* Year: *2007*

Future – Medium: *Poster* Client: *JGS* Year: *2007*

Thanks

—

Thanks to our families: who gave us life, helped get us through school and continue to give us love and support: Mom, Dad, Lisa, Peter, Grammy, Grandpa, Tootsie Grandma, Jim, Bess, Krassimir, Svetlana, Andrey, Mariana, Vera, Stoyan, Gosho and Vasa.

A million thanks to the man who made this happen: Giorgio Baravalle and de.MO publishing, who took a chance and published a book by two kids who can't write. This would not have been possible without his guidance and kindness.

Thanks to our main man: Michael Vanderbyl for writing a fantastic intro and teaching us how to think.

Tons of thanks to MTV: who made us who we are, taught us how to be real designers and became great friends: Jeffrey Keyton, Jim deBarros, Romy Mann, Rodger Belknap, Chris Truch, Kevin Serapilio, David McElwaine, Chie Araki, Suzanne Barr, Thomas Berger, Lena Beug, Rich Browd, Eban Byrne, Taseal Cho, Luke Choi, Melanie Coleman, Crobin, Eric Eckelman, Eduardo, Gina Fortunato, Chris Gallagher, Michael Greenblatt, Georgie Greville, Sarah James, Ross Jeffcoat, Nicole Killiam, Leslie Legare, Kevin Mackall, Kyle McDonald, Jordan Mellk, Pam Miller, Susannah Nilosek, Sandra Pena, Adam Palmer, Deklah Polansky, Alison Roberto, Lance Rusoff, Nick Sonderup, Janet Shaw, Chris Thom, Mosheer Wahba and Karen Weiss.

A very special thanks: to the talented and beautiful Melissa Scott, who designed most of this book and didn't yell at one of us for being a bad boyfriend. And to Michael Greenblatt for helping us rationalize setting a book in Arial.

A giant thanks: Wayne Kasserman and Gibson Knott for making us sound better and keeping our pockets full.

Thanks to our amazing teachers: who taught us how to act
smart and make stuff look cool: Doug Akagi, Bob Aufuldish,
Leslie Becker, Mrs. Copfer, Mr D., Mark Fox, Eric Heiman,
Brian Huffines, Mr. Inwood, Max Kisman, Jim Kenny,
Stella Lai, Erin Lampe, Marc Le Sueur, "The" Jeremy Mende,
Jennifer Morla, Alysha Naples, Steve Reoutt, Jon Santos,
Jennifer Sterling, Michele Wetherbee and Michael Vanderbyl.

Thanks to our old non-MTV bosses who we owe a lot: Tim Barber,
Eli Bonerz, John Bielenberg, David Bliss, Eric Cox, Dennis Crowe,
Greg Galle, Jennifer Morla, Jaquie Moss, Karlsson and Wilker.

Thanks to all the people who contributed essays: Kelly Aiken,
Bob Aufuldish, Alison Bailey, John Bielenberg, Cara Brower
Kathleen Creighton, Tom Danielson, Frank DeRose, Justin Fines,
Wyeth Hansen, Eric Heiman, Jimm Lasser, Paul Nini and
Emmi Salonen.

Thanks to the ever expanding Project M crew and the always
dapper John Bielenberg for pushing the envelope.

Thanks to our first clients: Kelly Aiken, Emily Aldredge,
Ellen Beckerman, Nicole Betancourt, Claire Erwin, Rich Frankel,
Howard Grandison, Leona Guidace, Scott Hirsch, Wayne
Kasserman, Jim Lasser, Amy Nguyen, Joe and Becca Jahnigen,
Emilie Schnick and Aaron Tapscott.

Thanks to Pratt for taking a chance on us: Cecilia Almeida,
Peter Barna, Kathleen Creighton, Bruce Duhan, Dick Eiger, Philip
Graziano, Kelly Shea, and to our students.

Thanks to the people who have recognized our work: Adobe,
The Art Directors Club, Communication Arts, CMYK, Graphis,
How, I.D. Magazine, Metropolis, Print, Step Inside Design,
The Type Directors Club, Rebecca Bedrossian, Curt Clarkson,
Patrick Coyne, Chris Hill, Heidi and everyone at the Summit,
Julie Lasky, Dana Lechtenberg, Alice Twemlow and Alissa Walker.

Thanks to all the people who have helped us make our
work with a smile and didn't mind when we couldn't pay you
tons: Caleb Everitt, Jon Dacuag, Tom Green, Drew Heffron,
Wes Kull, David Perlick-Molinari, Matt Owen and Kate Prucnal.

Shout outs:

Ohio peeps: PJ Afrasiabi, Marisa Buchakjian, Jeff Clemens, Eric Frystak, Sami Gendelman, Tyler Griebling, Joe and Becca Jahnigen, Blake Kaplan, Brett Livingston, Erik Mauer, John May, Beth Montgomery, Eric Scherch and Garrett Wright.

Bulgaria peeps: Martin, Mario, Buchkata, Moni & Krasi, Slavi, Sasho and everyone from Struma block.

Seattle peeps: Jon (you on IM bitch?) and the whole Dacuag family, Jerris, Jansen, Kelly and the Shook Ones, Chris Watt and his mom, Jesse, AJ, Jew, Josh, Zack, Matt (read that GED book homie), Zarbo and Inna Peck.

SF peeps: Brady Baltezore, Bonnie Berry, Andy Hawgood, Mike and Michelle Hurd, Akiko Ito, Sarah Lindsey, Anne Olsen, Tessa O'Donnell, Signe Jensen, Michael Morris, Katie Repine, Martine Workman, Taylor Wright, Michael Lordi and the CCA library.

NY peeps: Benny, Colleen, CG, Dickey, Frank and Lorena DeRose, Eban, the GoodHumans, Howard aka P, Jen Hung, John Keals, Jimm Lasser, Jason "the real" McKoy, Kiji McCafferty, Caitlin "Bunnie" McCann, Kyle McDonald, Crazy Preston, Randy, Nic and Jen Taylor and everyone on BC United (still undefeated).

Love and respect to Steve Reoutt who taught and inspired us both so much. You will be missed.

RIP: Lilov (see you soon friend), Koncheto and Dinio.

Big ups to Ohio and Bulgaria for birthing us.

Sorry to anyone we forgot!